ELSIE DRIGGS

The Quick
and the Classical

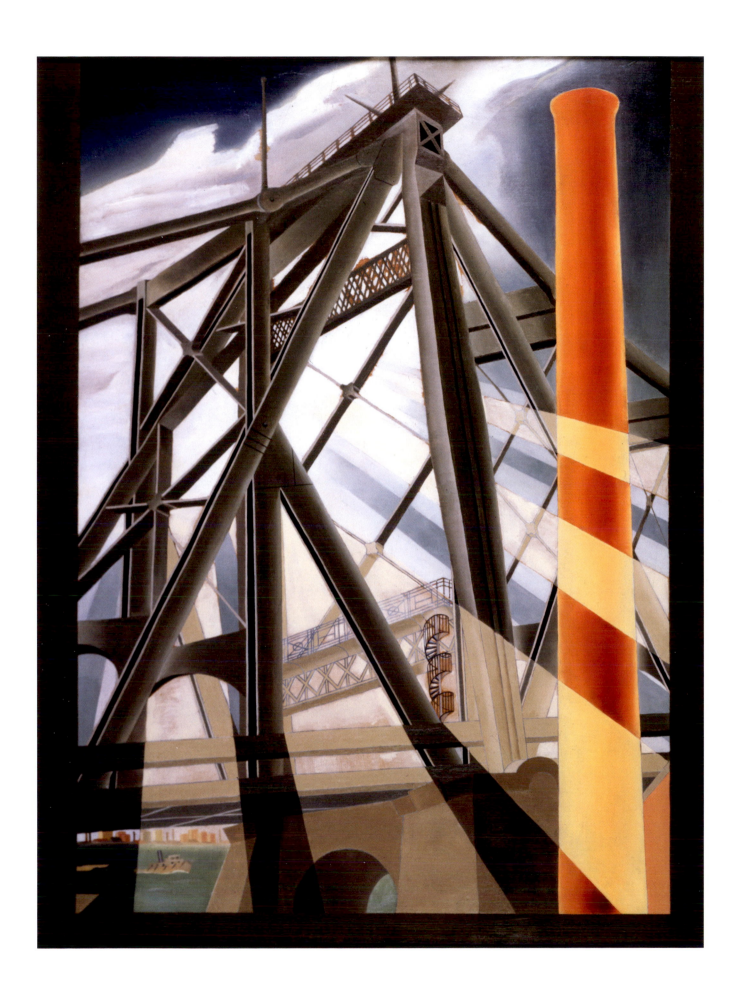

ELSIE DRIGGS

The Quick
and the Classical

Constance Kimmerle

James A. Michener Art Museum
Bucks County, Pennsylvania

University of Pennsylvania Press
Philadelphia

This book accompanies the exhibition
Elsie Driggs: The Quick and the Classical
at the James A. Michener Art Museum
January 19–April 13, 2008.

Copyright © 2008 James A. Michener Art Museum
138 S. Pine Street
Doylestown, Pennsylvania 18901
(215) 340-9800
www.michenerartmuseum.org

Copublished by the James A. Michener Art Museum
and the University of Pennsylvania Press
3905 Spruce Street
Philadelphia, Pennsylvania 19104-4112
www.upenn.edu/pennpress

A Cataloging-in-Publication Data Record is available
from the Library of Congress.
ISBN-13: 978–0–8122–4104–4
ISBN-10: 0–8122–4104–5

Designed by Becotte Design
Edited by Paula Brisco
Proofread by Sharon Rose Vonasch and Anita Oliva

Principal photography by Will Brown, Randi Bye,
George Holzer, Robert Lorenzson, and Bruce
McCandless

Printed by Brilliant Graphics

Frontispiece: *Queensborough Bridge*, 1927 (see cat. 23)

Catalogue plates (details):
p. 7, *Who Killed Cock Robin?*, 1936 (see cat. 31)
p. 11, *Gloxinia*, 1925 (see cat. 6)
p. 27, *The Battle of Anghiari*, ca. 1925 (see cat. 8)
p. 30, *Study for Pittsburgh*, 1927 (see cat. 21)

Contents

Sponsors

This publication was made possible by a major lead gift from Carolyn Calkins Smith, as well as funding provided by the Judith Rothschild Foundation and the National Endowment for the Arts, a federal agency.

Major support was provided by Marguerite and Gerry Lenfest; The Warwick Foundation of Bucks County; and former Senator Joe Conti, Bucks and Montgomery Counties.

The Michener Art Museum's research and publication activities are supported by the Virginia B. and William D. Williams Endowment Fund.

Sponsors:
Avery Galleries
Thomas and Karen Buckley
The Hortulus Farm Foundation Museum
Lee and Barbara Maimon
Elizabeth Leith-Ross Mow
Bonnie J. O'Boyle
Penn Color
The Pfundt Foundation
Mike and Marika Sienkiewicz
In memory of Abigail Adams Silvers, M.D.
Barbara and David Stoller
Gordon and Katharine Taylor
The Barrie and Deedee Wigmore Foundation
Mary and David Wolff

Additional support was provided by Robert and Amy Welch; an anonymous donor; J. Lawrence Grim Jr. and Kathleen O'Dea; and Thomas C. Folk.

Foreword

Elsie Driggs came to prominence in New York during the 1920s when it was difficult for women artists to sell or even exhibit their work. When she first submitted her work to the Daniel Gallery in 1924, gallery assistant Alanson Hartpence advised her not to sign her name, fearful that Charles Daniel would be prejudiced against the work of a female. To his credit, Daniel accepted her painting and continued to exhibit her work alongside that of other contemporary artists such as Charles Demuth, Charles Sheeler, and Man Ray. Supported by the Whitney Studio Club, the New York Society of Women Artists, and the Daniel Gallery, Driggs's work was purchased by important collectors including Gertrude Vanderbilt Whitney, Ferdinand Howald, and Edward W. Root.

Else Driggs married fellow artist Lee Gatch in 1935. Shortly thereafter the couple settled in Lambertville, New Jersey, where they lived in a primitive three-room stone house in an isolated area on the outskirts of town. Having no studio of her own, Driggs created highly imaginative watercolors and collages on the kitchen table and exhibited her work only sporadically during most of her married life. Even after Lee died in 1968 and Elsie returned to live in New York, her reputation was largely defined by her earlier work as a precisionist painter of industrial subjects. It was not until 1980, when Martin Diamond Fine Arts brought together an overview of her artistic career, that the depth and range of her work began to be appreciated. Not unlike other female artists of her time, Elsie placed her own artistic career in the shadow of her more widely known husband, Lee Gatch. In recent years those roles have begun to reverse, as interest in Elsie's work continues to grow.

The James A. Michener Art Museum is pleased to present the work of Elsie Driggs in an exhibition and publication that shed new light on a major twentieth-century American artist. Driggs was an adventuresome artist who remained open to change throughout her long career, eagerly awaiting, as she noted, "the next turn." We believe that this exhibition and catalogue, charting Driggs's entire career and the rich diversity of her work,

further develop one of the Michener Art Museum's primary goals: encouraging research about artists from this region to widen the understanding of artists, their creations, and their society. In today's world, museums are seen as entertainment centers, as economic engines, as educational centers, and as palaces of culture, but research—which is a primary function—can be easily overlooked and forgotten. In our own modest way, the Michener Art Museum has maintained an ongoing effort to support research by allowing our curators to commit the necessary time and effort to produce new publications and exhibitions. This publication and its accompanying exhibition are one more step in that scholarly journey.

We are extremely proud of the scholarly efforts of our able Curator of Collections Dr. Constance Kimmerle, whose tireless efforts over the past three years have produced this exhibition and catalogue. Connie's quiet and professional manner, reinforced by her serious research and the unique ability to uncover facts often overlooked by earlier investigators, allows her to add important new information and insights to the collective body of knowledge about artists from this region. Many other members of the museum staff have helped with this project, as they have with every aspect of this institution. More than twenty-four individuals and institutions lent works to the exhibition, and a strong collection of individuals, foundations, and government agencies all made financial contributions to make this project possible.

Finally, we offer our thanks and praise to Elsie Driggs, another of the many artists who have lived in our community and who, with their creative efforts, have helped us to better understand our world and our collective human experience.

Acknowledgments

I am always filled with a respect and wonder over the enthusiasm of collectors. Often they seem to get greater happiness out of paintings than the artist. The ticket is to make art look easy. The reality is . . . that which appears effortless has often caused the most problems. You are glad to see it go. Then, meeting it years later, you become friends again, and say, "Yes that is a good one."

—Elsie Driggs to Martin Diamond, n.d.

OVER THE COURSE OF MY RESEARCH on the life and work of Elsie Driggs, I have been constantly inspired by the artist's adventuresome spirit and the resilient manner in which she confronted life's difficulties. Although she often took the unbeaten path, she was always mindful of how the past persists into the present and of how creativity is dependent upon being able to draw on the experience of others.

This exhibition and its catalogue reflect the support of many individuals who have shared their time, knowledge, works in their collections, and personal resources for the project. I would like first to express my gratitude for the generous financial support provided by the individuals and institutions listed in the front of this book. I am immensely grateful to Carolyn Calkins Smith for her early substantial support. Many of the sponsors of this catalogue have been the Michener's partners in other projects, and I appreciate their continued commitment to the museum. I also wish to acknowledge the Judith Rothschild Foundation and the National Endowment for the Arts for their support of the catalogue and exhibition.

A special thanks must go to the exhibition sponsors. I am indebted to the lenders to this exhibition, all of whom are cited in the front of this catalogue. I am especially grateful to Martin and Judy Stogniew and an anonymous lender for their loan of a large body of works from their collections.

I am fortunate to have had the enthusiastic support of Martin and Harriette Diamond, who provided information on Driggs's body of work and access to a broad range of archival material both in their personal collection and in the Martin and Harriette Diamond Collection of American Art in the Special Collections and University Archives of the Rutgers University Libraries. Merriman Gatch, the artist's daughter, was exceptionally cooperative in sharing her time, memories, artwork, and archival materials. I thank her for her generous support.

My warm thanks go to Thomas Folk, who has been a vital help during the research and writing of this book and who contributed an essay for this

catalogue. His research, scholarship, and earlier publication on Driggs were invaluable to my work on this project. I am grateful to Luciano Cheles for sharing his current research on the influence of Piero della Francesca on American modernism. I would also like to thank Ferol Smith for providing an illuminating collection of source materials for the catalogue and Ogden Kruger, who shared information from the archives of Peggy Lewis.

Indispensable to my research are a number of individuals who have given their time to make Driggs's research material in their collections available for the catalogue. I am most grateful to Amy Ballmer, Ryerson and Burnham Libraries, Art Institute of Chicago; Emily Rafferty, Baltimore Museum of Art Archives; Louis V. Adrean and Hillary Bober, Ingalls Library and Archives, Cleveland Museum of Art; Linda Seckelson, Thomas J. Watson Library, Metropolitan Museum of Art; Michelle Harvey, Kevin Madill, and Thomas Grischkowsky, Museum of Modern Art Library and Archives; Jeffrey V. Moy, Newark Museum Archives; Karen Schneider and Mark Weiner, The Phillips Collection; Fernanda Perrone, Special Collections and University Archives, Rutgers University Libraries; Judith E. Throm, Elizabeth Batten, and Wendy Hurlock-Baker, Archives of American Art, Smithsonian Institution; and Kristen N. Leipert, Frances Mulhall Achilles Library, Whitney Museum of American Art.

I am especially grateful to Paula Brisco for her sensitive editing, to Anita Oliva and Sharon Rose Vonasch for their careful proofreading, and to Diane Becotte for the particular care that she has given to the handsome design and layout of this publication. A note of thanks needs to be extended to Will Brown, Randi Bye, George Holzer, Robert Lorenzson, and Bruce McCandless for their photography. I am also grateful to Brilliant Graphics for their beautiful production. Working with Jo Joslyn at the University of Pennsylvania Press was a pleasure, and I thank her for her support.

This catalogue and exhibition would not have been possible without the assistance of the capable and dedicated staff of the James A. Michener Art Museum. A special note of appreciation to Faith McClellan for her careful handling and professional support in securing loans for the exhibition and overseeing packing, insurance, and transportation. I also want to recognize Bryan Brems for ensuring the careful and thoughtful installation of the exhibition.

The Driggs catalogue and exhibition are the result of the collaborative efforts of a number of other talented staff of the Michener. I extend my thanks to Brian Peterson for sharing his insights and expertise throughout the project. A note of appreciation goes to librarian Birgitta Bond for her assistance in locating primary source material, which has enriched this project. My sincere thanks go to Sara Hesdon Buehler and Matthew Pruden for their generous and broad-based assistance. I am also grateful to Zoriana Siokalo and Adrienne Romano for devising and managing educational programming in support of the exhibition; Keri Smotrich and Emily Irwin for their handling of public relations; and Kathleen McSherry for her marketing expertise.

I count myself fortunate and am enormously grateful to have the enthusiastic support of Bruce Katsiff, the Michener's director, for every aspect of the project. Without his able leadership and encouragement, this exhibition and catalogue would not have been possible.

Finally, on a personal note, I would like to dedicate this catalogue to my husband, Chris, for his continuing encouragement and support of this project.

Lenders to the Exhibition

Mary Lou and Andrew Abruzzese

Allentown Art Museum

Robert and Jan Anderson

The Baltimore Museum of Art

Citigroup

Columbus Museum of Art

Corcoran Gallery of Art

Dr. Tom Folk Gallery

Tom Folk

Peter Franko

Merriman Gatch

Heckscher Museum of Art

Margery and Maurice Katz

The Metropolitan Museum of Art

Marcy and Michael Monheit

Montclair Art Museum

Roy and Jennifer Pedersen

The Phillips Collection

Private collections

Sheldon Memorial Art Gallery and
Sculpture Garden

Martin and Judy Stogniew

Syracuse University Art Collection

Chris Walther and Susan Stockton

Whitney Museum of American Art,
New York

Figure 1
Elsie Driggs, 1927. Elsa Schmidt Neumann, photographer.
Courtesy of the Elsie Driggs Papers, 1924–1979,
Archives of American Art, Smithsonian Institution.

"SOMETHING IN THE AIR"

Life is an offensive against the repetitive mechanisms of nature.
—A. N. Whitehead[1]

Constance Kimmerle

Curator of Collections
James A. Michener Art Museum

TO DATE THE WORK OF ELSIE DRIGGS has been celebrated mainly for its precise craftsmanship, wit, and delicate beauty, while little attention has been focused on its ideological and emotional richness. Although best known for her precisionist paintings of industrial subjects produced during the 1920s, Driggs explored a diverse range of styles and subject matter throughout her long career. When asked if there were a thread running between the themes and subject matter of her work, she mentioned the old-masters' principles of composition that imparted structure, order, and simplicity but then noted, "I want chemistry—something happening."[2] She characterized these qualities as "the quick and the classical":

> I am always talking about the quick and the classical. I like the eye to be put at ease with composition and something quiet, and then I like something to turn . . . and I am satisfying the two sides of my desires in creative art: the one for the quiet and the orderly and then the movement.[3]

Throughout her long career, Driggs sought to capture an experience of the "livingness" of things, a quality suggestive of a thing's inclination, movement, or interior force.[4] Interest in the vital forces driving living organisms to develop into new forms was in fact an idea popularized by a number of British and American philosophers and scientists of the late nineteenth and early twentieth centuries in reaction to theories that explained the behavior of man and animals in terms of purely mechanical reflex-type actions.[5] Modernist painter Marsden Hartley offered his own evaluation of these forces in his 1921 book *Adventures in the Arts*, where he described the impact of Cézanne's discovery of the "living-ness of things" in the work of El Greco:

> He saw that here was a possible and applicable architectonic suited to the objects of his newly conceived principles, he felt in Greco the magnetic tendency of one thing toward another in nature . . . He felt the "palpitancy," the breathing of all things,

the urge outward of all life toward the light which helps it create and recreate itself. He felt this "movement" in and about things, and this it is that gives his pictures that sensitive life quality which lifts them beyond the aspect of picture-making or even mere representation. They are not cold studies of inanimate things, they are pulsing realizations of living substances striving toward each other, lending each other their individual activities until his canvases become, as one might name them, ensembles of animation, orchestrated life.[6]

The "livingness" or movement of things revealed emotion and intentionality: the vital drive that connects one living thing to another and creates order out of feeling and motion. In much the same manner, Driggs was fascinated by the dynamic pulsings and temporalities of things around her and acknowledged that her first painting of a cabbage, completed as a young student in Italy, was "very much influenced by Cézanne."[7]

Elsie Driggs described the period of the early 1920s as the beginning of a new era of art in America, an era defined by the tendency to blend "the quick and the classical."[8] Great artists did not copy art of the past; they worked to establish a way to assimilate past traditions to the concerns of the present. For Driggs, the "quick" referred not only to forms in the process of motion and development but to a decentered and destabilized mode of perception and mobility of mind that allowed artists to free their thoughts and deepen their responses to sensations of the ordinary world. Both her artistic life and the world of her art were never static but always embodied or suggested change. At the age of eighty-six, Driggs commented on the shifts in style, subject matter, and materials that had characterized her career:

> I think that I change a great deal in my work. I'm an experimenter . . . I think it's because the women in the family, on my mother's side, were artists. But on my father's side, my father . . . my brother . . .

my uncle was an inventor and my grandfather. I think that is why I've experimented a lot. I have a group of art works that I've etched on Lucite . . . I did standing collage . . . I like to experiment with new materials . . . I like movement; I'm always trying to satisfy it.[9]

Growing up in New Rochelle, New York, in an age of rapid industrialization and urbanization, Driggs, like many American artists of the early decades of the twentieth century, shaped the content of her art to respond to the awesome dynamic forces that were transforming the American landscape. Prompted by a series of scientific discoveries that supported the conception of reality as a dynamic continuum, many artists of the era began searching for forms to express the dynamic fluidity of modern experience.[10] Later in her career, Driggs acknowledged how the social energies of an era find a conduit in particular artists even when they may not fully comprehend these energies:

> As I've said about the Precisionist movement, each one of us—it was not a group. We never got together and said now we will be different. It was not devised. Each one of us came to it in our own way and on our own time. It was just that everything came together at one point because there was something in the air . . . They may not know what it has come from in the beginning, but something is motivating them to see something differently.[11]

As Driggs suggests and art historian Milton Brown earlier proposed, the precisionist movement was not a school with a manifesto or conscious program. It was a recognizable and influential American style utilized by artists for their own ends.[12] Most critics of the era characterized the precisionist vision as reflecting the cool, dispassionate aesthetic of the machine age. In the recent publication accompanying the exhibition *Precisionism in America, 1915–1941: Reordering Reality*, Gail Stavitsky notes that contemporary critics interpreted the precisionist "sober, matter-of-fact mode of perception"

as "distinctively American." She astutely observes that the aspirations and conflicts embodied in the "zeitgeist of the 1910s to the early 1940s" are expressed in the range of attitudes conveyed in the precisionists' works.[13] While, as Stavitsky suggests, the work of these artists was often described during their lifetime as manifesting an uncomplicated, factual worldview, bereft of feeling or personal expression, recent scholars have begun to explore the ideological and emotional richness of the work of such artists associated with the precisionist movement as Charles Sheeler and Charles Demuth.[14]

For Driggs, art was first and foremost an instrument of insight and discovery. Not interested in transcribing an exact record of what she saw, she honed her sensibilities to approach things with an openness and spontaneity that allowed her to make the familiar evocative. Elsie's aesthetic philosophy was shaped in part by her friendship with collector Leo Stein during her studies in Italy from late 1922 until early 1924. Stein viewed the fundamental role of art as the practice of creating perceptible forms expressive of human feeling. In the opening paragraph of his monograph *Appreciation, Painting, Poetry and Prose*, Stein cites British philosopher A. N. Whitehead's description of life as "an offensive against the repetitive mechanisms of nature."[15] Like Whitehead, Stein envisioned man's progress as intimately connected to his imagination and flexibility. He described modern man's quest to understand the structure and operations of the natural world as beginning with his own experience:

> Structurally man is just one of the facts of the universe, but compositionally he is its center. *His* feelings, *his* desires, *his* hopes cause him to arrange things so that he can get at least a moment's satisfaction from these interests.[16]

For both Stein and Driggs, art was a process of discovery and experimentation. Elsie described her line in automatic terms as a "wandering wire."[17] When asked to elaborate on the term, she explained "[I] just let my hand flow with the pencil . . . it would loop and continue."[18] When asked about her

watercolors, Driggs explained: "I love the automatic line. I love using watercolor because it is so responsive to the every movement."[19] Art historian Susan Fillin-Yeh has suggested that Driggs's wiry line functions as a "narrative on the possibilities of form."[20] In relating the experience of creating *Pittsburgh* (1927; cat. 1), her first major precisionist work, Driggs described a duality in her work that transformed the familiar into the mystical and evocative:

> All the shapes related so beautifully, I made some changes. I didn't like all the smokestacks at an even distribution. All the other Precisionists made exact records of what they saw, but I introduced guide-wires for compositional reasons and curling smoke because whenever I have done something Precisionist or formal or classical, I have always wanted to introduce movement too.[21]

Driggs attributed her fondness for "the quick and the classical" to her early study of Cézanne and the old masters in Italy, particularly Piero della Francesca, as well as her later attraction to the work of Francis Bacon:

> Well, I would say right now that it's probably Bacon more than anyone else. I have this quarrel with myself. I do love classical and I do love order. On the other hand, I like movement. That's always been the argument with me. Now in my painting, I call it the quickened classical. This is what Bacon has. He'll do a structure that is like a skeletal cage, very, very simple, with lines that are compositional and simple . . . Then suddenly something is turning.[22]

In her search for forms and techniques to express the dynamics of the world around her, Driggs's approach to art seems closely aligned to Paul Klee's automatic approach to painting and his view of art as a process of discovery. Klee described his method as one of creating "an [artistic] order from feeling and, going still further, from motion."[23] Like Klee, Driggs celebrated the automatic line that was sensitive to the subtle suggestions of the

nervous system and responsive to unconscious associations. For Klee and Driggs, the automatic line functions as a psychological analogue for the vital drive that connects one living thing to another and creates order out of feeling and motion.

Driggs's fascination with the structure and ever-shifting dynamics of reality was shared by her husband, abstract artist Lee Gatch. In describing his own stone collages, Gatch alluded to the capacity of the stone to evoke the timeless and the accidental:

> My art is one of simple terms: the relation between the organized and the disorganized: the one wedded with the other to build a single integrated entity within the pictorial space. The stone introduces the accidental . . . the foil and the counterpoint of the geometry of abstract forms . . . One lends the other its logic and validity of design. The contrast is the texture and timelessness of stone and the material and the expression of contemporary thought.[24]

In her essay "The Stones of Lee Gatch," Elsie mentions the influence of fluid, organic concepts of time and space on her husband's work:

> Among his books were the writings of Rainer Maria Rilke and Jacques Maritain. Such expressions as "the after-ring of memory" were duly noted. He was not afraid of the poetical implication, drawing on stored images for inspiration or grasping the immediate. Crosses and telephone poles intermingle; the light of a hurricane lamp fathers a stream of suns; hidden within one of his "neutrals," *The Lover*, is the rugged profile of Dick Tracy. But on these elements he kept a close rein, never wishing them to obtrude or preempt the primary functions of the work, composition and organization, tempered by surface change which accomplished the transition of form into form.[25]

Elsie might just as well have been writing about her own view of art as a vehicle of conception or mental process that weaves together thought, emotion, imagination, and sense perception into a world resonating with life and significance. In a review of Driggs's exhibition of watercolors at the Rehn Galleries in 1938, critic Margaret Breuning described Driggs as a painter who made definite demands on the observer as she presents original conceptions with gaiety and wit:

> To call Miss Driggs witty and gay is not to imply that she is frivolous. Her approach to art is serious. The incisive linear patterns that cut through the fusing planes of exquisite color make firm armatures for her fluent designs. She gives back to us her imaginative ideas on her own terms, for she can afford to let us forget about her solution of technical problems.[26]

When asked to describe when she first realized that she was an artist, Elsie recalled an early childhood experience of an image morphing into a magical form as a result of an accidental water spill:

> I think it was when I was about 5 years old. I was in kindergarten making watercolors for the first time. I guess I accidentally spilled some water on there. The tree ran . . . I had just painted a tree and the tree ran and it repeated itself and I had a reflection.[27]

The heightened sense of "livingness" so often associated with the work of Elsie Driggs is in fact related to the illusion (imaginative, magical effects) she creates as she divests the object of the habitual associations we bring to it. Herbert Read described this quality in his 1936 *Meaning of Art* as an artistic achievement aimed at disclosing a unique aspect of an object with a clarity and distinctiveness beyond ordinary perception. Poet Alanson Hartpence, who worked as an assistant at the Daniel Gallery in New York, alluded to this quality in *Chou* (1923; cat. 2), the first painting that Driggs brought to the Daniel Gallery in 1924, when he described it as creating real interest with its "quite subtle and disturbing meaning."[28]

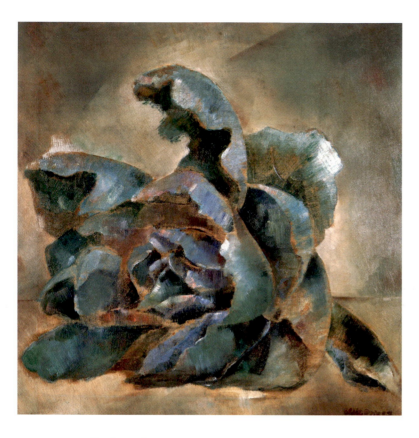

Catalogue 2
Elsie Driggs, *Chou*, 1923

Poet Rainer Maria Rilke (1875–1926) described how the artist sees things freshly by divesting them of old ideas and sentiments and by embracing impermanence for its beauty and its terror:

> We of the here and now are not satisfied for one moment in the time-world nor attached to it; we constantly exceed it and pass over to earlier ones, to our origins, and to those that seem to come after us . . . Transience everywhere plunges into a deep being. And thus all of the forms found here are to be used not only within temporal limits but as far as possible to be placed by us into those superior realms of significance in which we participate . . . in a purely earthly . . . consciousness . . . it is our task to place what we see and touch here into the wider and widest context . . . It is thus our task . . . because of the transience which we have in common with it, to comprehend and transform with an innermost consciousness these appearances and things . . . Yes, for it is our task to impress this provisional, transient earth upon ourselves so deeply, so agonizingly, and so passionately that its essence rises up again "invisibly" within us. *We are the bees of the invisible. We ceaselessly gather the honey of the visible to store it in the great golden hive of the Invisible.*[29]

Like Rilke, Driggs was fascinated by both visual and conceptual levels of reality. In focusing on forms of growth, motion, and development, Driggs disclosed the transitoriness of things as central to their being as she envisioned things creating and being created by their environment. Intent on extracting the vitality of the moment, she was intrigued by the inherent magic of the appearance of the world as it took shape around her.

Notes

Figure 2
Elsie Driggs's cat, ca. 1964. Courtesy of the Lee Gatch
Papers, 1925–1979, Archives of American Art, Smithsonian
Institution. Elsie noted on the back of the photograph:
"Elsie's cat. Isn't this a nice abstract pattern."

1. A. N. Whitehead, quoted in Leo Stein, "Forward," *Appreciation, Painting, Poetry and Prose* (New York: Crown, 1947), 7.

2. Elsie Driggs, transcribed audiotaped interview by Francine Tyler for the Archives of American Art, October 30–December 5, 1985, Smithsonian Institution (hereafter cited as Tyler interview), November 21, 1985, 84.

3. Tyler interview, November 8, 1985, 3.

4. Livingness: the state or quality of being alive; possession of energy or vigor; animation; quickening; as defined in *Webster's Revised Unabridged Dictionary* (Springfield, Mass.: G. & C. Merriam, 1913), http://machaut.uchicago.edu/websters.

5. D. C. Phillips, "Organicism in the Late Nineteenth and Early Twentieth Centuries," *Journal of the History of Ideas* 31, no. 3 (July–September 1970): 421–425. Reactions against mechanism took many forms, with supporters of biological organicism assuming that the highest and most developed organisms potentially have the most independence from mechanical reactions to environmental stimuli, acting creatively in a free and autonomous manner rather than reactively in a habitual manner.

6. Marsden Hartley, *Adventures in the Arts; Informal Chapters on Painters, Vaudeville, and Poets* (New York: Boni and Liveright, 1921), 32–33.

7. Tyler interview, November 8, 1985, 12.

8. Elsie Driggs, "The Search for Piero della Francesca," 3. Typescript draft of an essay written in the late 1970s for a class at New York University, Elsie Driggs Papers, 1924–1979, Archives of American Art, Smithsonian Institution (hereafter cited as AAA, Elsie Driggs Papers).

9. Elsie Driggs, videotranscript of interview by Merriman Gatch, n.d., 6, in Lily Harmon Papers, 1930–1996, Archives of American Art (hereafter cited as Gatch interview, Harmon Papers).

10. Scientists and philosophers began shifting their attention from hypothesizing on the nature of entities to observing the changing constellations of forces that connect masses over time. Developments in atomic physics and chemistry challenged earlier conceptions of matter as discrete material bodies existing in an empty space that is unrelated and indifferent to the objects it contains. They offered instead notions of reality as a dynamic, ongoing process where space and bodies became parts of a continuous flow. A. N. Whitehead described each organism as an entity not confined within the solid body but as permeating into all other organisms. An organism

was essentially a field of coherent activities, drawing on its experience of other organisms to realize and maintain its existence.

11. Tyler interview, November 21, 1985, 86.

12. Milton Brown, "Cubist-Realism: An American Style," *Marsayas* 3, no. 5 (1943–45): 146. This article was actually part of Milton Brown's earlier doctoral dissertation, which was published later in 1955 as *American Painting from the Armory Show to the Depression* (Princeton, N.J.: Princeton University Press, 1955).

13. Gail Stavitsky, "Reordering Reality: Precisionist Directions in American Art, 1915–1941," in *Precisionism in America, 1915–1941: Reordering Reality* (New York: Harry N. Abrams in association with the Montclair Art Museum, 1994), 34–35.

14. As early as 1954 William Carlos Williams cited the emotional power of Sheeler's paintings in his "Postscript by a Poet," *Art in America* 42 (October 1954): 214–215. More recent scholars include Susan Fillin-Yeh, "Charles Sheeler and the Machine Age" (Ph.D. diss., City University of New York, 1981) and *The Precisionist Painters 1916–1949: Interpretations of a Mechanical Age* (Huntington, N.Y.: Heckscher Museum, 1978); Carol Troyen and Erica E. Hirshler, *Charles Sheeler: Paintings and Drawings* (Boston: Museum of Fine Arts, Boston, 1987); Carol Troyen, "Photography, Painting and Charles Sheeler's *View of New York*," *Art Bulletin* 87, no. 4 (December 2004): 731–749; Karen Lucic, *Charles Sheeler and the Cult of the Machine* (Cambridge, Mass.: Harvard University Press, 1991); Charles Brock, *Charles Sheeler: Across Media* (Washington, D.C.: National Gallery of Art in association with University of California Press, 2006); and Barbara Haskell, *Charles Demuth* (New York: Whitney Museum of American Art in association with Harry N. Abrams, 1987).

15. Whitehead, in Stein, *Appreciation, Painting, Poetry and Prose*, 7.

16. Stein, *Appreciation, Painting, Poetry and Prose*, 53.

17. Tyler interview, November 21, 1985, 82.

18. Tyler interview, November 8, 1985, 7.

19. Elsie Driggs, videotaped interview at opening of exhibition *Elsie Driggs: A Woman of Genius* at the Phillips Collection, January 26, 1991.

20. Susan Fillin-Yeh, "Elsie Driggs," *Arts* 54, no. 9 (May 1980): 3.

21. Elsie Driggs, quoted in Cindy Lyle, "An Interview with Elsie Driggs: Return from 30 Years 'at the Edge of a Ravine,'" *Women Artists News* 6, no. 1 (May 1980): 4–5.

22. Gatch interview, Harmon Papers, 2.

23. "Paul Klee, September 1914," quoted in front matter, Paul Klee, *The Thinking Eye*, ed. Jürg Spiller, trans. Ralph Manheim (New York: George Wittenborn, 1961), n.p.

24. Lee Gatch in letter dated December 2, 1962, to Phillip Bruno, director of Staempli Galleries, in Elsie Driggs, "The Stones of Lee Gatch," 2, in AAA, Elsie Driggs Papers (hereafter cited as "The Stones of Lee Gatch").

25. Driggs, "The Stones of Lee Gatch," 1.

26. Margaret Breuning, "Art in New York," *Parnassus* 10, no. 4 (April 1938): 25–26.

27. Gatch interview, Harmon Papers, 1.

28. Alanson Hartpence, letter to Elsie Driggs, February 9, 1924, AAA, Elsie Driggs Papers, microfilm reel D160.

29. Rainer Maria Rilke, letter to Witold Hulewicz, November 13, 1925, in Rilke's *Letters on Life*, trans. and ed. Ulrich Baer (New York: Modern Library, 2006), 22–23.

ELSIE DRIGGS

Constance Kimmerle

Figure 3
Elsie Driggs, ca. 1903. Courtesy of Merriman Gatch.

opposite, clockwise from upper left:

Figure 4
Roberta Whiting Driggs, Louis Labadie Driggs Jr. (twelve years old), Elizabeth Hale Driggs (ten years old), and Elsie Belknap Driggs (eight years old); Christmas 1906. Photo: The Perell Studio, 107 West State Street, Sharon, Pa. Courtesy of Merriman Gatch.

Figure 5
Elsie Belknap Driggs, ca. 1912. Photograph by Arnold Guenther. Courtesy of Merriman Gatch.

Figure 6
Elsie Driggs, ca. 1902, with members of the Tom Thumb family: Count and Countess Magri (left) and Baron Magri (right). Courtesy of Merriman Gatch.

Figure 7
Elizabeth Hale Driggs, ca. 1912. Photograph by Arnold Guenther. Courtesy of Merriman Gatch.

G IVEN HER FAMILY BACKGROUND, it is not at all surprising that Elsie Belknap Driggs would gain recognition as a painter focusing on modern industrial forms. Born August 5, 1898, in a farmhouse in Hartford, Connecticut, Elsie lived the first five years of her life in the Driggs family's New York apartment, located in Central Park West. From her early childhood, Elsie was exposed to designs of the machine age. Her father, Louis Labadie Driggs, was an engineer and inventor who created designs for the steel industry. He also collected American art, routinely purchasing paintings from annual exhibitions at the National Academy of Design. Louis was not the only member of the family interested in art; his wife, Roberta Whiting Driggs, was an artist prior to her marriage. In her later years, Elsie noted that "All that art business came from my mother's family . . . they were all women. And they were all very talented."[1]

In 1903 Louis and Roberta moved to Philadelphia with their children Louis Jr., Elizabeth, and Elsie. A year later they relocated to Sharon, Pennsylvania, where Louis worked for a steel company. In 1907 the family moved from Sharon to New Rochelle, New York. Louis headed the Driggs Ordnance and Engineering Company in New York City, where he earned millions of dollars negotiating an arms deal with Russia during World War I. During grammar school Elsie and her sister took lessons in watercolor from the mother of one of her friends. They continued their art studies at New Rochelle Public High School, taking painting lessons with George Glenn Newell. During the summer of 1914, Elsie and Elizabeth studied with Newell on a farm in Dover Plains, New York.[2] For a brief period, Elsie and Elizabeth studied nursing at the New York Post Graduate Medical School and Hospital.[3] During the flu epidemic of 1916, the Driggs sisters traveled to Santa Fe, New Mexico, to paint the desert landscape. Although the Driggs family lived lavishly in New Rochelle in a large home with servants and owned a yacht and full crew, her father lost a good portion of his money promoting some ill-conceived inventions. Commenting on the unstable financial situation of her family, Elsie would later recall, "the money went by our ears so fast, you could hear it whistle."[4]

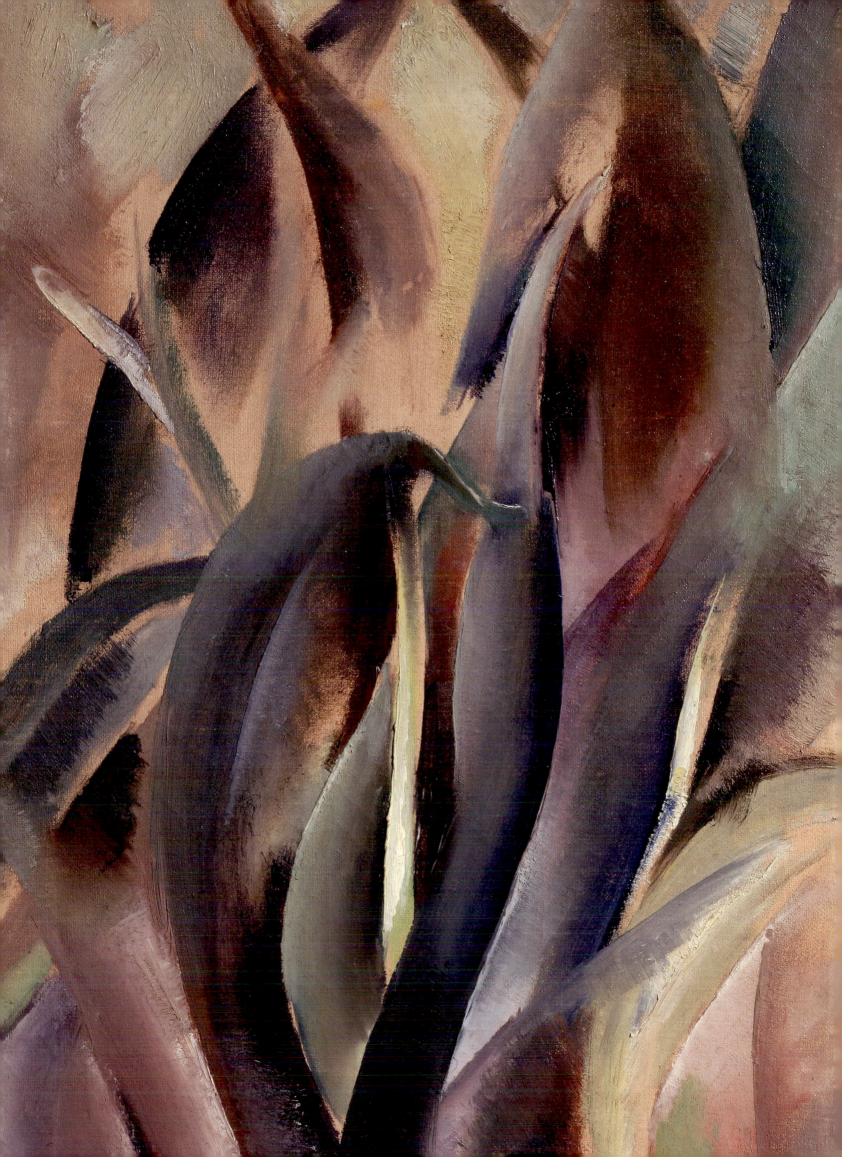

Plant Life Paintings and Drawings

opposite:

Catalogue 4

Elsie Driggs, *Leaf Forms*, 1918 (detail)

Figure 9

John Sloan, *Six O'Clock, Winter*, 1912, oil on canvas, 26 ⅛ x 32 inches. The Phillips Collection, Washington, D.C.

Elsie's earliest surviving paintings, *Lilacs* (cat. 3) and *Leaf Forms* (cat. 4), which date to 1918, are closely aligned to the contemporaneous still lifes of Charles Sheeler and Charles Demuth in their modernist design.[5] In these early still lifes, duality of space and matter give way to a continuously modulated picture surface as Driggs flattens space by severely limiting spatial perspective. She focuses on the plants' organic structure and expansive potential as she depicts their outwardly probing leaves with sparse definition. The brown squiggly lines outlining the blossoms and leaves of *Lilacs* suggest the presence of an energy force emanating from the painting's forms and determining their ongoing appearance.

From December 1918 until the spring of 1922, Driggs studied at the Art Students League with Frank Vincent DuMond, George B. Bridgman, George Luks, Robert Henri, and Maurice Sterne. George Bridgman taught drawing from plaster casts, and Elsie would later recall that he liked to make "curlicue lines and striking shadows," urging his students to "make it sporty."[6] Driggs was careful to note that "she learned more from John Sloan" than anyone else, even though she did not take classes with him at the league. She attended his private criticism class held at his studio at 88 Washington Place in Greenwich Village, which in her words "stressed composition . . . through the old masters and on up to the impressionists, sort of skipped the impressionists, picked up again by the

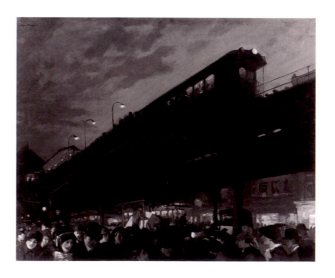

postimpressionists . . . through Cézanne."[7] Driggs recalled that Sloan emphasized compositional principles shared by all these artists: "a line would sweep in from the corner . . . carry your eyes to the center, there would be a perpendicular . . . slightly to the left or to the right, a parallel to the bottom."[8]

During December 1921 Elsie began studying with modernist painter Maurice Sterne, who would prove to be a decisive influence on the young artist, introducing her to the work of Cézanne and the old masters. While studying at the Art Students League, Elsie "prowled the galleries" in the afternoons, especially Daniel Gallery, where she recalled seeing Charles Demuth's watercolors of plants and flowers as well as figure drawings of Yasuo Kuniyoshi.[9] From late 1922 until early 1923, Driggs and a group of other young women classmates from the Art Students League traveled in Italy with their instructor Maurice Sterne, who annually returned to his studio in the town of Anticoli Corrado. She would later write that if she had been given three wishes when she went to Europe as an art student, they would be:

> Let the sun shine as I go through southern
> France. Let me see Cézanne's paintings as
> I look out the window of my train, and let
> me meet Leo Stein who made the art world
> see Cézanne through his eyes, and inter-
> preted his paintings for us from his aesthetic
> experience. The sun shone as I traveled
> south and I did see the dovecots, the pines,
> and those angular fields that lie like patches
> . . . all pure Cézanne.[10]

After studying with her class in Rome during the winter of 1922–23, she traveled to Arezzo and then to Florence, where she viewed works by the old masters in museums and private collections. In Anticoli Corrado she painted *Italian Vineyard* (1923; cat. 5), a sparse and graceful landscape depicting a castle and tower with plain geometric surfaces, set on a hill and surrounded by lines of whimsical grapevines. Beyond the castle is a valley of winding roads and patchwork fields and, in the distance, a steep mountain range. Landscape elements are treated not as natural phenomena but as objective shapes functioning to create a dialogue between a vision of structure and order and that of life and movement.

Elsie's aesthetic philosophy was shaped by her acquaintance with collector-critic Leo Stein during her studies in Europe. When she arrived in Rome and took a room in the Santa Chiara Hotel, Leo and his wife, Nina Stein, had a room next to hers. She found herself in their company for two weeks in Rome and met up with them subsequently in Florence. She would later recall how impressed she was by Leo's writings and discussion of the work of Cézanne and the fifteenth-century artist Piero della Francesca. Stein noted such qualities of Piero's work as "the beauty of the classicism and the very simple sculpting of the figures, the serenity, very handsome color . . . quite cool but very handsome."[11] Driggs described how she learned from her study of Cézanne and the old masters to blend "the quick and the classical," a term she used to refer to the dynamic aspects of nature and the quiet orderliness of classical form.[12]

While studying in Italy in 1923, Driggs created *Chou* (1923; cat. 2), a delicate, softly textured oil on fabric study of an Italian cabbage, rendered in a gray-green palette with soft touches of fluid gold. A year later *Chou* was included in the first showing of Elsie's work in New York at the Daniel Gallery, where it was exhibited alongside the work of Louis Bouché, Preston Dickinson, Niles Spencer, Andrew Dasburg, Man Ray, and Yasuo Kuniyoshi. Daniel's assistant, Alanson Hartpence, who had encouraged Driggs to bring paintings to the gallery, suggested that Elsie not sign the painting until Daniel saw it, fearful that he might have prejudices against a female artist. Hartpence would later write to Driggs, describing *Chou* as "quite subtle and disturbing," noting that its exhibition created real interest among gallery visitors.[13] Driggs received positive reviews in the New York newspapers, with Forbes Watson declaring her painting of the "spread out leaves of a cabbage" as "one of the most sensitive pieces of painting in the entire exhibition."[14] Elsie would later acknowledge that

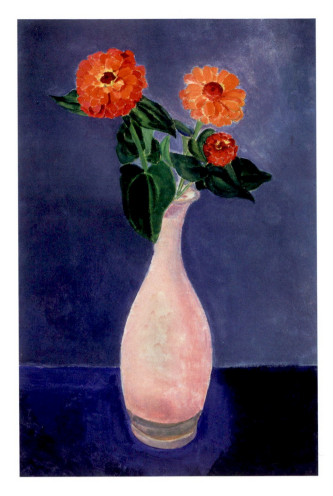

Figure 10
Charles Sheeler, *Zinnias*, 1918, watercolor on paper, 15 x 10⅖ inches. Courtesy of the Gerald Peters Gallery.

Figure 11
Charles Demuth, *Daffodils*, n.d., watercolor and graphite on paper, 13⅜ x 9⅜ inches. Collection Demuth Museum, Lancaster, Pa.

she had carefully selected only those plants for her cabbage subjects that were growing with leaves that had not "headed up yet" but were "spreading out."[15] The trembling contours and shimmering subdued color harmonies of her *Chou* express both the expansive potential and transitoriness of nature. Each leaf has an aura and correspondence to others, while the atmosphere surrounding the cabbage has its own palpable dynamic quality. In selecting a plant with a vibrant appearance, Driggs found a subject that suggested how form is in a dynamic dialogue with forces of nature and with sensory experience. She would later describe her *Chou* as being very much influenced by Cézanne.[16]

Driggs discovered in Cézanne's work a classical vision that was fresh and vibrant: a vision sensitive to changing, shimmering matter and to the manner in which objects in space take form, evoke emotions, and embody meaning. In rendering things as a system of surfaces and as planes of color, Cézanne stripped his subject matter of conventional ideas and sentiments and allowed color to function as a living entity, evoking memories, impulses, and kaleidoscopic facets of experience. His simple sculpting of form suggested an understanding of late-nineteenth-century theories of perception that addressed the process of the mind acting on things to give them a structured, constantly changing form as opposed to viewing perception as revealing or representing things themselves.[17]

Elsie's work in the next few years included a series of pastel and oil plant-form paintings. While studying at the Art Students League, she regularly visited the Daniel Gallery, where she could have seen vibrant plant-form works similar to Sheeler's *Zinnias* (1918; fig. 10) and Demuth's *Daffodils* (n.d.; fig. 11). Both Sheeler and Demuth exhibited plant-form paintings at Daniel Gallery at the same time as Driggs. As early as 1925, Driggs began using thick, loamy pastels from Paris, provided by her friend Elsa Schmidt (later the wife of dealer J. B. Neumann). She would pick up potted plants from a florist[18] and later remarked that she used only growing plants as subjects for her works, never cut flowers.[19] Critic Margaret Breuning characterized

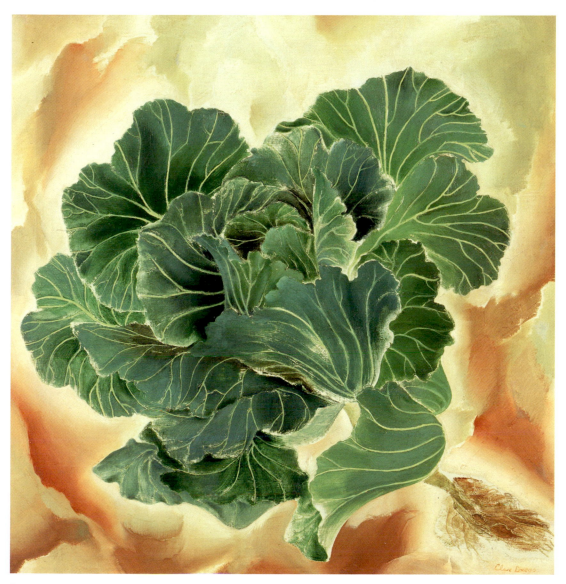

Figure 12
Elsie Driggs, *Cabbage*, 1927, oil on canvas, 24 x 34 inches.
Private collection.

the evanescent line and color of these early pastel plant-form drawings as capturing "the very essence and being of the plants."[20] Elsie described her pastel technique as "largely done with my fingers—rub[bing] it on and draw[ing] with an eraser."[21] In *Gloxinia* (1925; cat. 6), Driggs hones in on the delicate flowing network of veins in the plant's leaves, while leaving its edges somewhat unfocused. The overall effect of this technique is both linear and soft edged, resulting in an image of nature that is both energized and structured, as it appears to be expanding outward in response to a vital organic drive. The petals of *Cineraria*, another pastel dat-

ing to ca. 1926 (cat. 7), have a mechanical rhythm that radiates outward as if it were propelling the plant, while the networks of veins in its leaves lead to mysterious shadowy openings. Just three years after exhibiting her first cabbage painting at Daniel Gallery, Driggs created a second painting of a cabbage (*Cabbage*, 1927; fig. 12), portraying the plant's billowing leaves and feathery roots surging through an activated space of glowing blustery clouds. On the occasion of its exhibition at Daniel Gallery in 1927, Margaret Breuning noted how its subtle design resembled that of Chinese paintings of the same subject.[22]

26

Early Figurative Works

A S EARLY AS 1924 Elsie began making copies of the old masters at the Metropolitan Museum of Art and working as a slide assistant in the museum's lecture department.[23] She also copied the work of old masters in other collections. Later in her career, Driggs described her pencil drawing of *The Battle of Anghiari*, after the Peter Paul Rubens copy of Leonardo da Vinci's original in the Louvre (ca. 1925; cat. 8), as critical preparation for the mastery of an automatic technique that ended in her being so sure of her horse drawings that she could put her pencil on the paper, turn away, and "just with the feel of the rushing of the horses, I could draw the horses."[24]

From 1924 until 1929, Driggs exhibited her work regularly at the Daniel Gallery, alongside the works of Yasuo Kuniyoshi, Charles Sheeler, Charles Demuth, Niles Spencer, and Preston Dickinson. In addition to plant forms, her work at this time included delicate watercolors of animal and human figures. Examples of Driggs's early figurative work, likely from her studies in Italy, are two untitled oil on canvas portraits: a portrait of a young girl seated in a chair (*Untitled*, ca. 1922–25; cat. 9) and a portrait of a full-length figure standing in a landscape with a village in the background (*Untitled*, ca. 1922–25; cat. 10). The figure in the landscape dressed as a young man is likely Natalie Van Vleck, who was a fellow student in Maurice Sterne's class.[25] The simply sculpted, geometrized features of Driggs's portrait subjects recall figures in Piero della Francesca's *Adoration of the Sacred Piece of Wood*, a detail from the *Legend of the True Cross* frescos (ca. 1450–65; fig. 13) that Elsie saw in the church of San Francesco in Arezzo. She collected photographs of Piero's work while studying in Italy.[26] Driggs simplifies aspects of her subjects' forms, rendering them with a dynamic line, little surface detailing, and a cool palette. Her slightly lowered viewpoint enhances the figures' imposing presence. The orderly mechanical rhythm of the geometrized forms and contrasting spontaneous movement of the atmospheric sky and background recall similar elements in Piero's *Finding of the Three Crosses and the Verification of the True Cross*, also part of

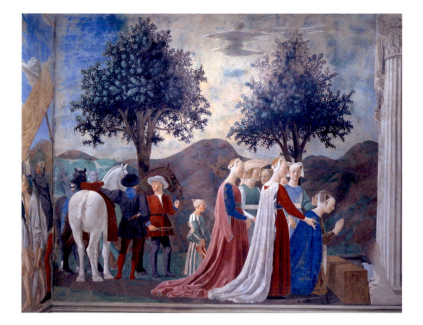

his *Legend of the True Cross* frescos in Arezzo (fig. 14).

During the mid- to late twenties, Driggs created a group of small watercolors touching on themes of crowds, mob behavior, and workers' unrest. As early as the late nineteenth century, the Union Square section of New York had become associated with labor causes; by the late 1920s and early thirties, artists were attracted to the area to sketch crowds demonstrating against unemployment. Driggs described the inspiration for this series as influenced by the social energies of the era but as more directly motivated by internal stimuli:

> There was a lot of talk about it during the depression . . . a lot of parades and strikes . . . and a good bit of violence at times.

That was before the WPA came along and began paying all those people that had been thrown out of jobs with all the factories closing and everything else.

I wasn't necessarily taking any social position. I was reporting and I liked action. It gave me plenty of chance for action . . . But it's entirely out of my head. No one is posing. It's not from a photograph. It's not from anything I'd been looking at.[27]

The manner in which Driggs's wandering line in these works not only animates shapes but also dynamically relates space and figures as part of a continuous flow suggests the influence of Maurice Sterne. Setting the figures against the white background of the paper, Driggs used a technique

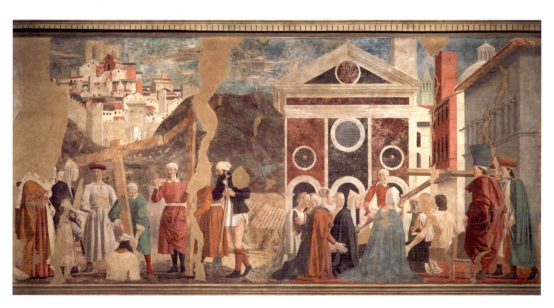

she called "spotting." By adjusting the amount of water she added to the medium, she created mottled surfaces and subtle variations of tone, which caused color to advance and recede in select areas. The "spotting" and fluid, delicate pencil line lend a dreamlike atmosphere to these scenes. In such works as *The Mob* (ca. 1925; cat. 11) and *Riot* (1929; cat. 12), intertwined figures radiate from an axis. *Walkers in the City* (ca. 1928, cat. 13), another watercolor of the group, depicts three desolate stylized figures against a background of city skyscrapers, which appear to be infused with a life of their own. The image of the figures shuffling along the sidewalk, engrossed in their own thoughts, recalls T. S. Eliot's description in *The Wasteland* (1922) of a herd of people shuffling to work "under the brown fog of a winter dawn" with each man fixing "his eyes before his feet."[28]

Another group of watercolors of the twenties and thirties have titles that suggest parallels between modern life and the medieval inferno of Dante's *Divine Comedy*. Their figures are arranged in a swirling circular format with the background space left mostly empty and white. Splotches of hazy pigment spread over and around the figures, giving the scenes an otherworldly quality and representing space, not as a container, but as a quality of objects and energy fields. When asked why she chose to focus on the subject of Dante's *Inferno* with modern-day characters, Driggs remarked that "it was imaginative," noting, "there's always something a little off-focus with the thinking" of "people in a crowd."[29] In her watercolor *Dante's Inferno* (also known as *Milling Workers*, 1925; cat. 14), the figures are dressed in contemporary workers' clothing and appear to be frantically running from a scene. The overall radial arrangement of the figures is suggestive of the modern industrial condition of individuals harnessed to a center that is indifferent to its individual parts. In other watercolors of this series like *Illustration for Dante's Inferno* (ca. 1932; cat. 15) and *Soon They Overtook Us; With Such Swiftness Moved the Mighty Crowd—Purgatory, Canto XVIII* (n.d.; cat. 16), Driggs depicts a group of figures in torn clothing caught in a whirlpool of activity, with their facial expressions, gestures, and

Catalogue 16
Elsie Driggs, *Soon They Overtook Us; With Such Swiftness Moved the Mighty Crowd—Purgatory, Canto XVIII*, n.d.

postures exhibiting various degrees of perseverance, anguish, and defeat. The title of the latter work suggests a relationship between the restlessly teeming, never-ending movement of urban industrial society that imposes standardization and anonymity on the individual and that realm of Dante's purgatory where individuals are condemned to wander aimlessly for their spiritless, slothful behavior.

During the twenties Elsie also created a series of enigmatic animal paintings like *The Oxen* (1926; cat. 18) and *Spotted Deer* (n.d.; cat. 19). The "arresting design" of Driggs's painting of "two strange, red oxen with horns like lyres" caught the attention of Margaret Breuning in her review of a show at Daniel Gallery in 1926.[30] Murdoch Pemberton characterized her treatment of the two oxen as "full of poetry and design."[31] Although it is likely that Driggs created *Spotted Deer* in the 1920s, she noted that when she and her husband later moved to Lambertville, New Jersey, they lived "an ultra quiet life" "up in the hills," sometimes stirring "up a deer that would go bouncing away from you." She would later reveal that this remote life in the country with "a ballet of deer . . . skunks calling at the back door for food . . . and . . . copperhead snakes which we had always on our minds . . . was very good for the imagination."[32]

Precisionist Paintings

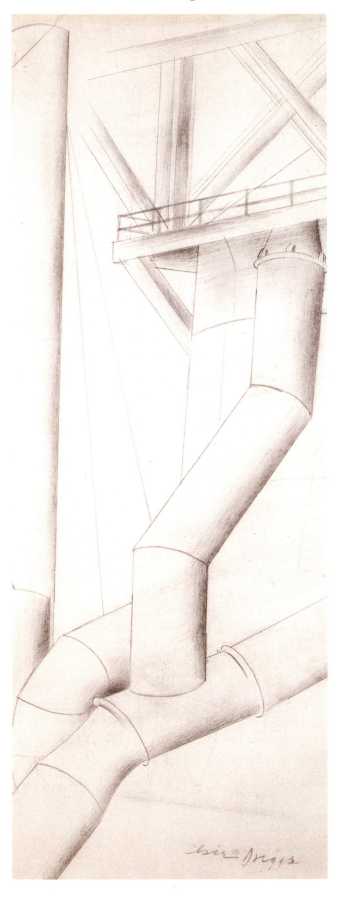

THROUGH THE 1920s the work of such artists as Charles Demuth, Charles Sheeler, Preston Dickinson, and Elsie Driggs was described in terminology drawn from the sharp-edged, simplified qualities of modern industrial forms as well as the architectonic structure and form of classical Renaissance artists. Referred to by the critics as "New Classicists," "Immaculates," or "Precisionists," these artists were consistently supported by Charles Daniel in his New York gallery. Driggs created six oil paintings that she later described as "Precisionist," all of which took their subject matter from the world of industry and engineering: *Pittsburgh* (1927), *Blast Furnaces* (1927), *Queensborough Bridge* (1927), *Aeroplane* (1928), *River Rouge Plant* (1928; destroyed in a fire), and *Saint Bartholomew's Church* (1929).[33]

During the early decades of the twentieth century, the United States had effectively become the world's leading economic and technological power. Alfred Stieglitz and his modernist community were championing a new machine-age art that focused on subjects embodying such aspects of industrialized America as its skyscrapers, factories, billboards, and products. American modernist artists began embracing industrial subjects as affirmative models of the precise craftsmanship, order, and progress that had made their country a world leader. Organizers of the 1927 Machine Age Exposition, a landmark exhibition in New York that featured modern art and products of industry, described the machine as "the religious expression of today."[34] Many artists and viewers alike regarded the modern industrial landscape as evocative of metaphysical harmonies. Driggs herself noted that during the twenties, she viewed many factories as having the same laws of proportion behind their columns and chimneys as the absolute rules laid down for the proportions of the Greek column.[35] While her images of industrial landscapes invoke a rhythm and proportion in the design of industrial and machine structure, they also evoke an anxious indefiniteness and uncertainty that suggests an influence of the surrealist aesthetic just appearing in New York at that time.

Driggs's earliest industrial painting was actually inspired by a childhood memory. Elsie lived in Sharon, Pennsylvania, as a young child, where her father worked as an engineer in a steel company. Haunted by recollections of the area's industrial pollution and a promise that she would someday return to paint the soaring flames of Pittsburgh's steel plants, the young artist traveled to the steel town in 1926. With introductions from modern-art dealer Charles Daniel and collector Duncan Phillips, Driggs returned to Pittsburgh, where she was startled by the beauty of the architectural forms of its Jones and Laughlin steel mills. The belch-fire Bessemer steel-making process she witnessed as a girl had been replaced by the less spectacular open-hearth process:

> I looked at the sky that night and it was black. For the time being, they had stopped making the high-grade steel. They had stopped using the Bessemer process that was what forced oxygen through all the steel. The sky was totally black.[36]

During her visit she created *Pittsburgh* (1927; cat. 1), her first major precisionist painting, which was purchased by Gertrude Vanderbilt Whitney in 1929 and donated to the Whitney Museum of American Art for its opening in 1931. The large painting of the Jones and Laughlin steel mills depicts a more somber sight than she remembered as a child. Four velvety smokestacks rise above a network of pipes and tanks as a long, thin, feathery cloud moves in front of the stacks. The sun is burning through a hazy atmosphere, while a steamy mist rises along the bottom of the picture, unfurling along its right edge. Elsie described how she looked directly into the mills' forms and how their forms composed into a "center still life":

> So every day when I went back to my rooming house, I passed the Jones and Laughlin mills. You don't see the mills at a distance; you're going up a hill. I was going up the hill in a bus and I was on high ground while the mill was down on the riverbank, so I looked directly into these large forms.[37]

> You looked directly . . . into these big forms, and I kept finding them beautiful and wondering why. I told myself I wasn't supposed to find a factory beautiful, but I did. And I noticed the relationship of those tall smokestacks and then the cones—and the simple cone and the fluted cone and all—and the way it [was] composed in the center, which I call the center still life.[38]

As she examined the mills' forms, she made several sketches of the scene. Her sketches (*Images of Pittsburgh*, 1927; cat. 20, and *Study for Pittsburgh*, 1927; cat. 21) and later comments reveal that she moved one of the smokestacks to avoid "the monotony of the even spacing."[39] She made other changes to enliven the scene:

> But what I have done is to have something happening. I either want to do something like the factory with the smoke going off to the side, which would not have been going there. It would have been going out of the chimneys. And the steam rising, and I don't know if the steam was there or not . . . And so I always want movement or contention or something happening.[40]

Returning to New Rochelle, Driggs created a working drawing, and then the final painting, which includes "guide wires" that she described as "compositional entirely."[41] She later noted that her use of red brown pigment outlining the smokestacks "makes a little vibration" and that her delicate glazing technique made the steam at the bottom appear to "go off in the air."[42] Driggs cleverly manipulates the image to capture the eerie effect of hazy light glowing behind the plant's velvety forms as well as the atmosphere's subtle changes of color from yellow to green to gray:

> On account of so much soot being in the air, you got a refraction of light. It was really a glowing light, not sunlight, but a

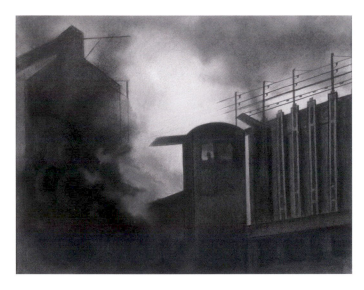

Figure 15
Joseph Stella, *The Quencher (Night Fires)*, ca. 1919, pastel on paper, 22½ x 29 inches. Milwaukee Art Museum. Gift of Friends of Art, M1978.32 Photo by Nienhuis.

glowing light behind it and then these great well-lit forms.[43]

Driggs described the technique of underpainting and building in halftones as an old-master technique she learned from a young Russian copyist at the Metropolitan.[44] A critic for *Art News* singled out *Pittsburgh* as a stunning work that surmounted all others on exhibit at the Daniel Gallery in November 1928:

> Factories, sheds, bridges and smokestacks loom large in the current Daniel showing, all rendered in the precise line, flat color and clearly defined pattern that have become trademarks of the immaculate school. The limitations of this group are obvious and in the present show it is only Elsie Driggs who in her stunning "Pittsburgh" surmounts them. Done in sooty blacks and velvety grays, she has woven her factory chimney into a beautiful pattern, truthful, yet imaginative.[45]

When Charles Daniel first saw *Pittsburgh*, he described Driggs as "one of the new classicists."[46] Elsie was careful to point out later that *Pittsburgh* had not been influenced by the work of other precisionist painters, noting that its sparse, near classical order was influenced by the fifteenth-century artist Piero della Francesca:[47]

My painting was exhibited early in 1927. It's gone into the record that I painted it in 1927. I thought that there was no point in changing it to 1926 because it's only a month—I painted it in December. It did make a difference really, because I had no chance at all to see any precisionist painting. I just happened to hit the new movement right on the nose.[48]

I looked at it one day and I thought, why did I find those forms beautiful? I thought Piero della Francesca. The simple necks of the men, the oval shapes of the heads. Everything very simple. People would say to me, how did you happen to paint that? I would say, "oh that was my Piero della Francesca."[49]

Driggs's sensitivity to the social issues posed by industrialization recalls Joseph Stella's dark and brooding images of Pennsylvania coal by-products plants created between 1918 and 1924

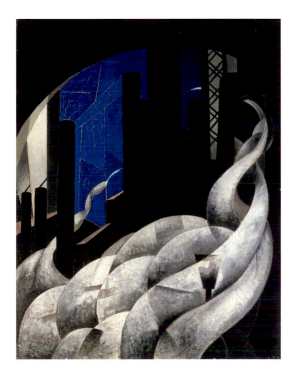

Figure 16
Charles Demuth, *Incense of a New Church*, 1921, oil on canvas, 26 x 20⅛ inches. Columbus Museum of Art, Ohio; Gift of Ferdinand Howald 1931.135.

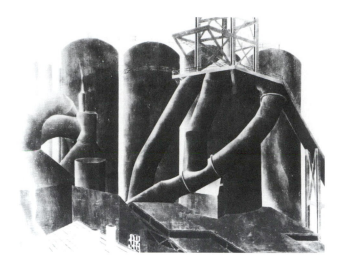

Figure 19

Elsie Driggs, *Blast Furnaces,* 1927, oil on canvas, 33 x 39 inches.
Private collection.

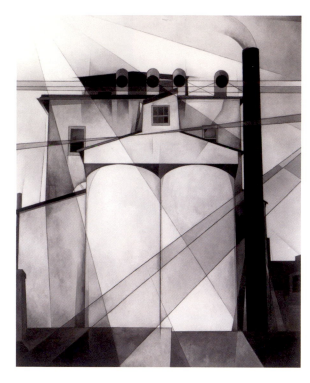

Figure 17

Charles Demuth, *My Egypt,* 1927, oil on composition board,
35¾ x 30 inches. Collection of Whitney Museum of American
Art, New York. Purchase with funds from Gertrude Vanderbilt
Whitney 31.72.

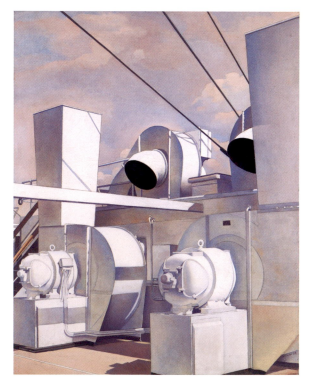

Figure 18

Charles Sheeler, *Upper Deck,* 1929, oil on canvas, 28¾ x 21¾
inches. Harvard University Art Museums, Fogg Art Museum,
Louise E. Bettens Fund, 1933.97. Photo: Allan Macintyre ©
President and Fellows of Harvard College.

(*The Quencher* [*Night Fires*], ca. 1919; fig. 15).[50]
There is no evidence to suggest that Driggs had
seen Charles Demuth's *Incense of a New Church*
(1921; fig. 16) prior to painting *Pittsburgh,* but in
later life she described how impressed she was with
Demuth's "very handsome" handling of "rolling
smoke . . . divided into bands" and his poetic title,
ironically equating the smoke of the Lukens steel-
yards with incense.[51] Unlike Charles Demuth's and
Charles Sheeler's contemporaneous images of in-
dustrial subjects characterized by meticulously ren-
dered, hard-edged crystalline shapes (Demuth, *My
Egypt,* 1927; fig. 17; Charles Sheeler, *Upper Deck,*
1929; fig. 18), feelings and expression characterize
Driggs's soft, evocative Pittsburgh painting.

After completing the large monochromatic *Pitts-
burgh,* Driggs painted *Blast Furnaces* (1927; fig.
19; *Study for Blast Furnace,* 1927; cat. 22), a more
densely packed industrial scene that she described
as "a potpourri of all the forms [of blast furnaces]
that I saw on my way into Pittsburgh."[52] In the
same year Driggs once again featured a modern
technological accomplishment in her painting
Queensborough Bridge (cat. 23). Painted from
studies taken from an apartment window over-
looking the bridge, Driggs frames her image of the
towering bridge by including the window molding
from which she viewed the scene.[53] Orderly shafts
of light course through some of the bridge's rigid
beams and a nearby smokestack, while ominous
clouds hover over the bridge's structure. Acknowl-
edging that the bridge's girders do not connect in

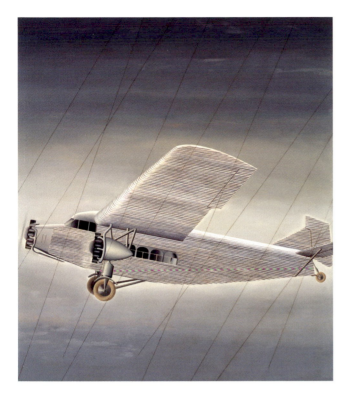

Figure 20

Elsie Driggs, *Aeroplane*, 1928, oil on canvas, 44 x 38 inches. The Museum of Fine Arts, Houston; Museum purchase with funds provided by the Brown Foundation Accessions Endowment Fund.

three-engine plane during a commercial flight from Cleveland to Detroit:

> I took a plane for the first time in my life. And the Ford factory had a shuttle run of their Ford tri-motor between Cleveland and Detroit. And . . . I loved the flying. That was a new sensation . . . the captain sent back a message, "Would I like to sit with him for awhile?" . . . And I can tell you, you do get a wonderful feeling of flying right out on the nose of one of those planes.[57]

She commemorated her first airplane ride by sketching the new planes in their hangar at Ford's new River Rouge plant, about ten miles from Detroit. Charles Sheeler had just completed a series of photographs of the River Rouge plant for N. W. Ayer and Son to promote what was then the world's most technically sophisticated manufacturing complex. Returning home to New Rochelle, Elsie created *Aeroplane* (1928; fig. 20), her tribute to a modern mode of transportation that inspired mixed emotions of wonder and awe.

Figure 21

Charles Sheeler, *Yankee Clipper*, 1939, oil on canvas, 24 1/16 x 28 1/8 inches. Museum of Art, Rhode Island School of Design, Jesse Metcalf Fund and Mary B. Jackson Fund. Photography by Erik Gould.

the painting, Driggs later explained that she was actually capturing the effect of light glare as it took over an image: "I liked the idea of the thing sort of floating and going into the glare."[54] When asked if her work ever incorporated surrealism, Driggs cited such elements as the bridge's girders that

> attached to nothing. They go into the sunlight, you know. And then I like the circular staircase or the circular ladder or whatever it is, and I make that spin by itself. I isolate it.[55]

Shortly after the painting was finished in 1927, it was exhibited in a group show at the Daniel Gallery alongside the works of Alexander Brook, Charles Sheeler, Peter Blume, Yasuo Kuniyoshi, Karl Knaths, and Niles Spencer. Critic Forbes Watson noted, "Miss Driggs waves good-by to her old master Maurice Sterne and embraces for the moment the age of machinery" as he described her painting of a portion of the Queensborough Bridge as soaring "upward in subtle transitions."[56]

In 1928 Driggs gained firsthand experience of the ubiquitous and lonely sensation of flying by joining the pilot in the cockpit of the Ford Motor Company's new

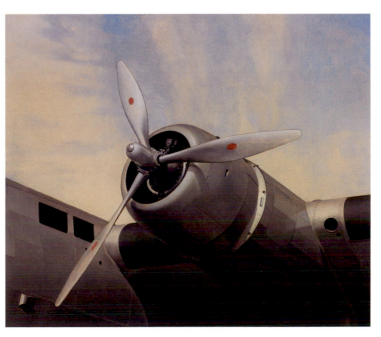

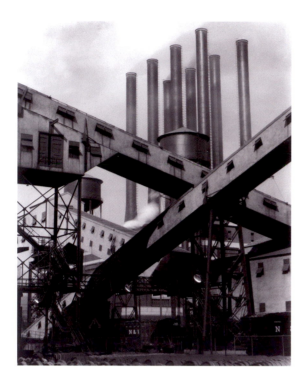

Figure 22

Charles Sheeler, *Criss-Crossed Conveyors, River Rouge Plant, Ford Motor Company*, 1927, gelatin silver print. The Metropolitan Museum of Art, Ford Motor Company Collection, Gift of Ford Motor Company and John C. Waddell, 1987 (1987.100.1). Photograph © 1994 The Metropolitan Museum of Art.

1927 (*Criss-Crossed Conveyors, River Rouge Plant, Ford Motor Company*, 1927; fig. 22).

The following year Driggs turned her attention to *Saint Bartholomew's Church* (1929; cat. 25), a stately Romanesque church on Park Avenue surrounded by commerce and industry. She renders the church in warm tones, yet the scene has a foreboding quality as bold shadows from churning clouds overhead threaten to overtake the structure. Elsie chose a vista of the church that would include in its background a series of tall modern buildings. She took liberties with the actual landscape, including in the scene dull smokestacks that are actually "further down . . . east on Park Avenue."[59] She would later describe *Saint Bartholomew's Church* as heralding her movement away from the precisionist style:

> Saint Bartholomew's has much elaborate stonework I could paint with a loaded brush. I then added movement to the sky. This was to move me away from the classicism of the precisionist painting. I originally called this painting *Park Avenue* because I have brought in . . . stacks and simple buildings.[60]

Suspended in a gray, shrouded sky, the only signs of movement coming from Driggs's *Aeroplane* are from its propellers, whirling in a soft blur. Lines of force intersect the airplane's body and anchor it in space. Although the exterior of the plane is meticulously rendered, there is no sign of human presence within its windows, which are shaped like classical archways and shrouded by darkness or white light. Oblique and puzzling, *Aeroplane* exudes a sense of haunting loneliness while suggesting the eeriness of a dreamlike experience. A decade later Charles Sheeler painted *Yankee Clipper* (1939; fig. 21, the airplane providing Pan Am's first regular nonstop transatlantic passenger service. Although both artists portray their subjects as icons of modernity, Sheeler's focus on the elegant details of the *Yankee Clipper*'s resting propeller was a more affirmative symbol of American progress.

While at the River Rouge plant, Driggs obtained photographs of the plant[58] and made graphite sketches of the plant's exterior (*Study for River Rouge Plant*, 1928; cat. 24). In New Rochelle she created *River Rouge Plant* (oil on canvas, 1928), which was destroyed in 1929 in a railcar fire while being returned from an exhibition at the Cleveland Museum of Art. The surviving working drawing for the painting appears to be an image, from a slightly different vantage point, of the same dynamic crisscrossing coke and coal conveyors that Charles Sheeler photographed in November and December

Catalogue 24
Elsie Driggs,
Study for River Rouge Plant, 1928

Driggs and the Depression Era

Her work, in fact, like the skirt of the modern woman, lifts itself well above the mire of things.

—Philadelphia Public Ledger[61]

IN HIS REVIEW OF THE NEW YORK SOCIETY of Women Artists exhibition at Anderson Galleries in May 1928, Murdoch Pemberton singled out Driggs's painting of two brown bears as one of the best things he had seen from Miss Driggs:

> It has more vigor than the perfect mullen leaves and the mystic deer and oxen that she has dwelt with all these years. Miss Driggs has a fine sensitivity and there are many who believe that she ranks among the first in this land.[62]

In 1930 Driggs was chosen as one of forty-six painters and sculptors under the age of thirty-five to be included in an exhibition at the Museum of Modern Art. Elizabeth Luther Cary in her review of the exhibition noted that Driggs's *Portrait of a Girl* was an exciting departure from her earlier "powerful and gloomy" industrial subjects:

> We can say good-bye with equanimity both to beautiful deer and austere blast furnaces in the certainty that this artist, in pursuing her way, will find fresh pleasure for us . . . in the aesthetic product obtained by much labor, thought and feeling.[63]

With the downturn of the United States economy beginning in 1929 and continuing through the 1930s, Driggs, like many of her contemporaries, found herself without support of the Daniel Gallery. In July 1930 Charles Daniel wrote to Elsie, "We are surely going through a period the like of which I have never known."[64] Daniel closed his gallery in 1932, unable to pay his rent. For the next three years, Driggs was represented by New Art Circle, a New York City gallery operated by J. B. Neumann, who spon-

Figure 23
Lee Gatch, ca. 1935. Courtesy of the Lee Gatch Papers, 1925–1979, Archives of American Art, Smithsonian Institution.

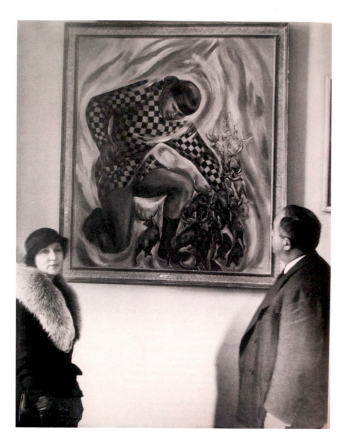

sored the work of such progressive artists as Paul Klee, Wassily Kandinsky, Max Beckmann, Arshile Gorky, Marc Chagall, and Georges Rouault.[65] In 1933 Driggs met her future husband, abstract painter Lee Gatch (1902–1968; fig. 23), at a tea honoring Georg Grosz at the New Art Circle.

By February 1934 Edward Bruce, director of the Public Works of Art Project (PWAP,

December 1933–June 1934), wrote to Driggs, asking her to participate in the federal relief program designed to employ artists during the early years of the Depression. As art historian Thomas Folk has suggested, Forbes Watson, technical director of the Public Works of Art Project, may have helped Driggs secure government support.[66] Watson's critical reviews of Driggs's work as a young artist in New York during the twenties had helped establish her reputation. Driggs created a number of watercolors for the WPA during the thirties, and in 1936 she participated in the Treasury Relief Art Project in New York, creating a mural for the Public Works Administration Housing Project that depicted animals from *Uncle Remus* for a nursery wall in the Harlem River Houses in New York City (fig. 25). Elsie would later recall:

> I chose a large mural, and painted abstractly on it in the squares but with blurred edges Uncle Remus stories of a monkey riding on a fox's back and all the rest of it in that looping line that I had.[67]

In 1939 Driggs completed another mural for the Rayville, Louisiana, post office. Commissioned by the U.S. Treasury Department, the mural (fig. 26) depicts the story of La Salle's travels just before he discovered the mouth of the Mississippi. In a letter

Figure 24

Edward Bruce and Ellen S. Woodward standing before Driggs's painting of Paul Bunyan, 1934. Photograph, courtesy of Thomas C. Folk.

Figure 25

Elsie Driggs mural in nursery of Harlem River Houses, New York City. Martin and Harriet Diamond Collection of American Art. Special Collections and University Archives, Rutgers University Libraries.

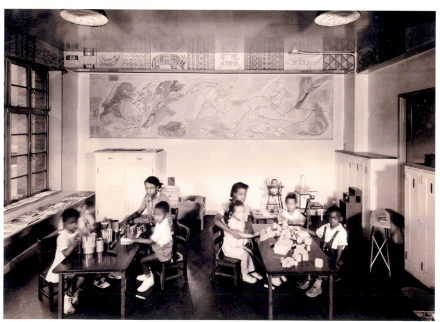

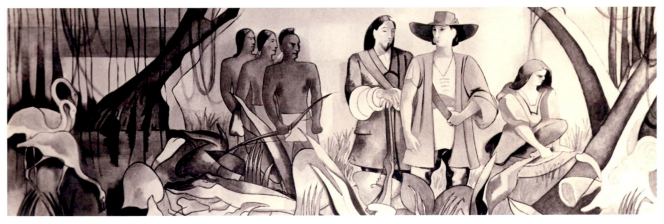

Figure 26

Elsie Driggs, *La Salle's Quest for the Mississippi*, 1939, mural for the Rayville, Louisiana, post office. Martin and Harriette Diamond Collection of American Art. Special Collections and University Archives, Rutgers University Libraries.

to Forbes Watson, Driggs explained how her mural referenced the important role that the Native Americans played in the success of La Salle's venture:

> He is shown with two of his followers in the swampy land on the west shore of the river close to the Indian town of Taensis [*sic*] now Taensis County, Louisiana. How they found luxuriant growth and killed several alligators which one story states supplied them with necessary food. The three Indians are symbolical as the assistance of the natives was a strong factor in the success of La Salle's enterprise. The attitude of the Indians of the section at first hostile became friendly and helpful due to the engaging manners, tact and goodness of La Salle.[68]

After Elsie and Lee Gatch married and settled in Lambertville, New Jersey, they worked together on a number of murals during the Depression in a space rented from the Lambertville train station.[69] One such privately commissioned oil on canvas mural depicted Native Americans working in a cornfield (fig. 27).[70] Elsie and Lee created it for a lobby in an apartment house located at 165 Seaman Avenue in the Inwood section of the Bronx, which was built on the former site of a Native American settlement.[71]

Driggs painted a number of watercolors based on literary themes rooted deeply in American culture during the 1930s. Her *Emperor Jones* series, inspired by Eugene O'Neill's play of the same title,

depicts the story of an African-American convict who escapes to a Caribbean island and becomes emperor. Louis Gruenberg adapted the play for the Metropolitan Opera House in 1933. Although not created for the WPA, the series was lost when Driggs sent it to Washington in appreciation for the federal program's support during the Depression, as she later recalled:

> When the Washington assistance stopped I naively sent them this series as a thank you for keeping us eating during the depression, not realizing that of course what they didn't need was more paintings. They were good.

Figure 27

Photograph of watercolor study for the Elsie Driggs and Lee Gatch mural, *Bronx Site of Indian Colony*, Inwood apartment building. Martin and Harriette Diamond Collection of American Art. Special Collections and University Archives, Rutgers University Libraries.

a fine, vibrant line and flowing washes of brilliant color that provide telling accents . . . One is above all conscious of terrific compression which threatens at any minute to burst the bounds imposed. We know from other works of this artist, how she is able to sing when not confined within a cage.[74]

As they had not paid for them anyone could lay claim to them.[72]

Richard Stokes's libretto *Merry Mount*, derived from Nathaniel Hawthorne's *The May-Pole Lovers of Merry Mount* (1836), inspired Driggs's 1934 watercolor *Merrymount* (cat. 26), which depicts figures in Puritan dress arranged in a swirling circular format with the background space left mostly empty and white. Opening at the Metropolitan Opera House in 1934 to an enthusiastic, record-breaking audience, the opera detailed the crushing effects of an intolerant religious community. A critic for *Art News* noted the powerful dramatic effect of *Merrymount*'s compact composition and line rhythms in his review of Driggs's first solo exhibition at Frank K. M. Rehn Galleries in February 1935:[73]

Just prior to their marriage in late 1935, both Elsie and Lee Gatch received fellowships to spend the summer at Yaddo, an artists' community in Saratoga Springs, New York. Driggs worked in watercolor that summer, creating *Negro Spiritual* (fig. 29) and *Marching Ants* (cat. 28), a work she described as inspired by both literary and natural sources:

In a dictionary, I found a detailed drawing of an ant, but superficially when you look at it, it looks like a growing plant. But actually I called it *Marching Ants*. All the ants have little red sticks. I had watched one time the battle between black ants and red ants, but these are just marching with red sticks.[75]

When seen from a little distance the effect of these curiously compact compositions is one of general liveliness, although each mass looks just like the next owing to a similarity of shape and the impossibility of distinguishing individual forms. A closer study reveals

Figure 29

Elsie Driggs, *Negro Spiritual*, 1935, watercolor and pencil on wove paper, 11 x 16⅞ inches. Courtesy of the Syracuse University Art Collection.

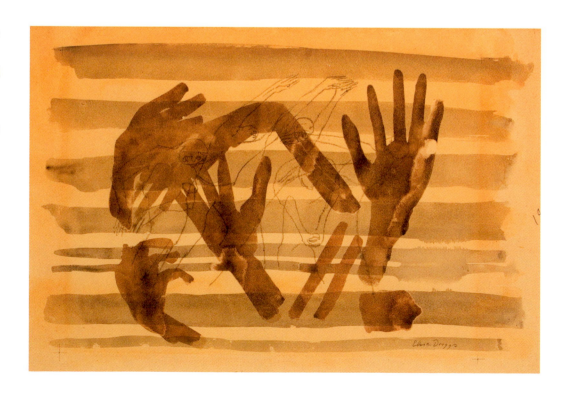

Life in Lambertville, New Jersey (1936–1969)

For some years now one of the pleasures of my life has been to climb into a small truck, stop at the store for a carton of beer and drive down the river road to the artist's colony at New Hope. Once in that inviting village, I turn left, leave it behind and cross over the Delaware River into Lambertville in New Jersey where I drive to the end of town, climb a very steep unpaved road called Coon Path and look for the last house on the left.

It seems hardly to be within a town or in this century either, for it is surrounded by a dense growth of trees and sits atop a stony perch from which one sees only woodland with the river in the distance and beyond it the splendid hills of Pennsylvania. The first thing that greets you at the house is not Lee Gatch but a group of squirrels, then some birds, then some low bushes and finally a rough-hewn patio. Obviously nature commands here.

The house is very old, small, and earthy. It seems to have been built at the same time as the rocks around it. It is a house suited for elves or the spirits that watch over the river. But when the rough door opens a very real man comes out to greet me.

. . . In the late afternoon Elsie Driggs, an artist of distinction who has been married to Gatch for thirty-one years, wanders down . . . and we talk of galleries in New York and of museums in Europe. There is much mention of books and poetry and plays and maybe toward sunset Gatch moves one painting onto the easel and we study it together for an hour or so and then I go home. It's been a four-beer afternoon.

—James Michener, quoted in *Lee Gatch: Stone Paintings* (New York: Staempli Galleries, 1965), catalogue of exhibition at Staempli Galleries, February 7–March 4, 1967

IN DECEMBER 1935, at the age of thirty-seven, Elsie married abstract artist Lee Gatch, whose work had been the subject of solo exhibitions at J. B. Neumann's New Art Circle gallery in 1932 and 1934. The couple settled into a small apartment in New York on West Ninth Street during the winters of 1936 and 1937. Elsie described the transition from her previous comfortable life to one in which she and Lee were as much transformed by their intimate surroundings as they were eager to transform them. She noted how their furnishings revealed a fondness for Greek vase painting:

> Our two burner electric stove stood on a marble top chest in one corner. To hide this Lee made a screen covering the wood with gesso and washing it with pale terracotta. On it he painted in rust black motifs from the 8th century Greek funerary vases; painting quickly and raising the brush at the end of a stroke so that the liquid dimpled exactly like the Greek artist he admired. Lee and I both copied from these vases at the Metropolitan Museum long before we met. It was our favorite period. A friend Sarñia Marquand came to dinner shortly after the screen was finished and bought it.[76]

Figure 30

Lee Gatch and James A. Michener, ca. 1950. Courtesy of the Lee Gatch Papers, 1925–1979, Archives of American Art, Smithsonian Institution.

Figure 31
Elsie Driggs, ca. 1936, in apartment number 21 on West Ninth Street, New York City. Courtesy of the Elsie Driggs Papers, 1924–1979, Archives of American Art, Smithsonian Institution.

Figure 32
Elsie Driggs and Lee Gatch's apartment, number 21 on West Ninth Street, New York City. Cooking area. Courtesy of the Lee Gatch Papers, 1925–1979, Archives of American Art, Smithsonian Institution.

Figure 33
Painted screen by Lee Gatch, ca. 1936, designed to screen off the cooking area in the apartment on West Ninth Street, New York. Courtesy of the Lee Gatch Papers, 1925–1979, Archives of American Art, Smithsonian Institution. Elsie noted that it was quickly bought by Sarñia Marquand of 220 Madison Avenue when she had tea with the Gatches.

At the beginning of the summer of 1936, the couple rented a car and headed south to find a summer rental property in the countryside. Elsie described the memorable trip to fellow painter Bill Smith:

> All was ugly and discouraging till we dropped down at the end of the day into Lambertville . . . I will never forget the view from the Lambertville Bridge in the moonlight; I have often seen it and can recapture quickly the first impression as you look down the river toward Trenton. Surely no river in the country produces a view more idealic [sic]. Then we went into New Hope and saw the sky lights—total discouragement. The last thing Lee wanted was to land in an artist colony. He recovered the next day and looking up a real estate agent, we decided to rent the farmhouse of Harry Worthington for $12 a month.
>
> We had permission from Worthington to remodel as we wished . . . our dining room and living room had impossible wallpaper, which refused to budge. We covered that

with white tempera paint, put down the red Indian rugs on the floor . . . and for the first time hung the Paul Klee colored lithograph called "Tales from Hoffman."[77]

counterclockwise from upper left:

Figure 34

Elsie Driggs at Rabbit Run Farm, 1936. Courtesy of the Elsie Driggs Papers, 1924–1979, Archives of American Art, Smithsonian Institution.

Figure 35

Paul Klee, *Tale á la Hoffmann* [*Hoffmanneske Geschichte*], 1921, watercolor, pencil and transferred printing ink on paper, bordered with metallic foil, 12¼ x 9½ inches. The Metropolitan Museum of Art. The Berggruen Klee Collection (1984.315.26) Image © The Metropolitan Museum of Art.

Figure 36

Home of Lee Gatch and Elsie Driggs in Lambertville, N.J., prior to renovations, 1937. Courtesy of the Lee Gatch Papers, 1925–1979, Archives of American Art, Smithsonian Institution.

Figure 37

Elsie Driggs's and Lee Gatch's house in Lambertville, N.J. Courtesy of the Lee Gatch Papers, 1925–1979, Archives of American Art, Smithsonian Institution.

During the summer of 1937, Elsie and Lee lived in a house on Eagle Road on Jericho Mountain outside New Hope where they "cooked by the fireplace at one end, and got . . . water from the pump outside."[78] That same year the couple bought a three-room stone house and four acres on the edge of a ravine in Lambertville, New Jersey, for $350. It needed much repair, and Lee put himself to work renovating the stones, floors, walls, and windows.

Elsie later reminisced about the primitive living conditions at Coon Path and her earliest drawings with a herringbone design:

> We didn't know that there was a terrible water situation. You could not dig a well there on account of the rocks. And Lambertville water didn't come out . . . In the beginning we found out we could pipe it down from above. There was one house above us, and there was an artist [Louis Stone] living there, and they got their water from a small reservoir. And then Caroline Stone got in touch with me one day, and she said, "You know, when you draw water for a bath, our water cuts way down, so you'll have to find another way." So then there was a little house built halfway down this ravine in front of the house—a little pump house. And then down below that there was a pipe in the stream . . . that pumped up water, and this was marvelous tasting water. It was spring water . . . I guess it was okay—until a storm would come and disrupt the whole business down there, and then we couldn't get any water—then you melted snow . . . I would take the snow, and I would put it on the stove, and I'd melt it down and do the dishes, you see. So that's the way I lived . . . I began drawing figures with a herringbone design going through everything like what the water does, you know, on a beach . . . carving it.[79]

Although life at Coon Path was challenging, Elsie was able to be positive when looking back over these difficult times:

> I spent thirty-one years in an ancient stone house on the edge of a gully in the rugged hills by the Delaware in New Jersey. There was much isolation from the art world, primitive living, also great beauty. Solitude is well enough but there should be empathy. I had the good fortune to have the companionship of one of America's greatest artists (Lee Gatch).[80]

She would later sum up her way of approaching problematic situations in life: "I let life happen to me. I don't know whether that's the way to live or not. I've had some wonderful breaks, but, you know, I'm always waiting for the next turn."[81]

Parenthood arrived in 1938 when the couple's only child was born. Elsie described the family's isolated life in Lambertville, noting how living so close to nature was good for her daughter, Merriman, who would grow up to be an actress:

> We might as well have . . . reached it by covered wagon as far as the life that we led there which was really just divorced from

Figure 38

Elsie Driggs and her daughter, Merriman, ca. 1938. Courtesy of the Lee Gatch Papers, 1925–1979, Archives of American Art, Smithsonian Institution.

Figure 39
Lee Gatch and his daughter, Merriman, ca. 1938. Courtesy of the Lee Gatch Papers, 1925–1979, Archives of American Art, Smithsonian Institution.

everything except, if Lee had an opening or anything like that in New York, then we would come up. And we would go to the Institute of Arts and Letters . . . And then we would come to New York, and then drive back to Lambertville and live this ultra, ultra quiet life . . .

Yes, I was away from those city mobs and things . . . And so I had a child that grew up in all that wildness, and it was very remote a lot of the time as far as children were concerned, which was very good for the imagination for an actress.[82]

During most of the thirty-one years that the couple resided in Lambertville, Elsie supported Lee's career, helping him through periods of depression and alcohol addiction. Having no studio of her own until about 1966,[83] she created watercolors and collages from the kitchen table. Looking back on these years, she explained, "My time was shredded . . . by working in collage, I could carry forward

in stages. I told myself that Paul Klee worked in a closet. You can always do it."[84]

Although Elsie's work was included in such prestigious venues as the Whitney Museum of American Art's opening exhibition in 1931 as well as a Museum of Modern Art exhibition in 1930, her artistic reputation in the New Hope/Lambertville area was not strong since she and Lee rarely socialized and did not exhibit locally. During her years in Lambertville, she received a second solo exhibition at the Rehn Galleries in New York in 1938 and a third, fifteen years later, in 1953. Elsie recalled how Lee was disturbed by the attention she received from "anyone who sought me out for my work" as he assumed they "must be very interested in me."[85] She described how Lee became jealous when she received a show from Frank Rehn's gallery:

> I found out that, for instance, if I had a show at the Rehn Gallery, he didn't want me to go to the opening. And he was sure Rehn must be interested in me—poor old Rehn, you know. Who knows . . . I was no femme fatale at all, but he had this vision of me that everybody must be trying to take me away from him. So he put all his guards up. And of course the way to get rid of me was to put all your guards up.[86]

She would exhibit her work sporadically over the thirty-one years that she resided in Lambertville: Art Institute of Chicago (1939, 1944); Artists Gallery (New York, 1948); Frank K. M. Rehn Galleries (1938; 1953); Metropolitan Museum of Art (1952–53); Walker Art Center (Minneapolis, 1960); Provincetown Art Association (1964); Robert Schoelkopf (New York, 1964); Newark Museum (1965).

Around the time of her marriage, Driggs began exploring the spatial and temporal characteristics of line in a series of watercolors that reveal an interest in following the path of moving bodies. Her combination of trajectory and sequential images in such works as *The Sulky* (1935; cat. 29), *Who Killed Cock Robin?* (1936; cat. 31), and *Three Bison* (1935; cat. 32) suggests multiple-exposure

Figure 40
Paul Klee, *Little Jester in a Trance*, 1929, oil and watercolor, 19¾ x 14 inches. Museum Ludwig, Cologne, Germany.

Figure 41
Cover of *Paul Klee* exhibition catalogue, the Museum of Modern Art (New York: 1930).

photography as an influence, echoing Paul Klee's *Little Jester in a Trance* (1929; fig. 40), which he described to his students as sourced in "superimposed instant views of movement."[87] In March 1938, when the Frank K. M. Rehn Galleries included *Who Killed Cock Robin?* in their second solo exhibition of Driggs's work, critic Martha Davidson compared Driggs to Paul Klee, citing the cinematographic quality of their imaginative abstractions:

> The exquisite phantasmagoria spun from the imagination of Elsie Driggs in a network of thin, wiry pencil lines and washes with tints of extraordinary delicacy creates a rare showing at Rehn Galleries. The artist with unerring taste and magnificent control comparable to Klee, the German master of lyrical abstractions, conjures up genial phantoms . . . with cinematographic rapidity.[88]

J. B. Neumann, Elsie's dealer during the early thirties, had mounted exhibitions of Klee's paintings and watercolors at the New Art Circle in March 1935. Driggs would later recall that her mother had introduced her to the work of Paul Klee and that she had owned a book on Klee, published by Neumann.[89] Driggs may have been referring to the catalogue accompanying the 1930 exhibition of Klee's work at the Museum of Modern Art, organized by J. B. Neumann and Alfred Barr (fig. 41—cover of *Paul Klee* exhibition catalogue, the Museum of Modern Art, New York, 1930). In this landmark assessment of Klee, Barr drew parallels between Klee's work and such prehistoric art as hieroglyphs, paleolithic bone carvings, and pictographs of the American Indian, as well as theatrical masks and masks in ethnographic museums.[90]

Driggs began creating a series of watercolors late in the thirties that featured delicate wavy herringbone patterns spreading over the works' surfaces, similar she noted to "what the water does . . . on a beach . . . carving it."[91] Her interest in these ephemeral patterns coincided with husband Lee's contemporaneous fascination with the "sensuous arabesque existing in nature."[92] As Driggs noted in her essay

"The Stones of Lee Gatch," after 1935 her husband was using "small forms making them vague as if out of focus or just visible" in order to achieve simplicity and animation.[93] Both Elsie's and Lee's fascination with fundamental processes and impermanent aspects of nature recalls Paul Klee's interest in paleontology and art as a means of enhancing understanding and developing a cosmological consciousness.[94] In her 1938 watercolor *Garden on Cedar Road* (cat. 33), delicate wavy lines have a rhythmic movement suggestive of the successive wing positions of birds in flight. These herringbone patterns spread over the tinted background, while delicately drawn, faintly visible organic and masklike forms emerge from the surface and join floating screens of translucent watercolor. On the occasion of the opening of her solo exhibition at the Phillips Collection in 1991, Elsie noted that her love of watercolor was directly related to her fondness for the automatic line and the medium's responsiveness to every movement.[95] Her fascination with the expressive possibilities of dynamic line brings to mind Paul Klee's description in his *Pedagogical Sketchbook* of line "moving freely, without goal" as if it were on a "walk for a walk's sake"(fig. 42).[96] She may well have seen one of Klee's dynamic labyrinthine compositions, *Or the Mocked Mocker* (1930; fig. 43), donated by J. B. Neumann to the Museum of Modern Art in 1939. One of Lee's student notebooks, which Elsie gifted to the Archives of American Art, contains a lighthearted tribute to Klee's active line and summarizes aspects of Klee's writings on the active line from his *Pedagogical Sketchbook*.[97] In a letter to art historian Emily Nathan, Elsie noted that the notebook was probably from Gatch's student days in Paris in 1924–25, "when the New York art world was scarcely aware of Klee."[98]

At least one watercolor illustration survives for *Benji-Ben-Ali-Bengal*, a children's short story written by Driggs during the mid-1930s.[99] The illustration (1936; cat. 34) depicts a tiger named Benji staring down at a broken mirror, surrounded by multiple mushroom specimens. In this imaginative story Driggs suggests how difficult it is to distinguish reality from simulations as she relates how

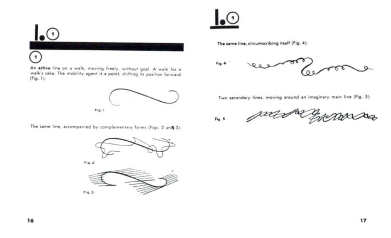

Figure 42
Paul Klee, "I.1, Active Line," in *Pedagogical Sketchbook*, trans. Sibyl Moholy-Nagy (New York: Praeger, 1953), 16–17.

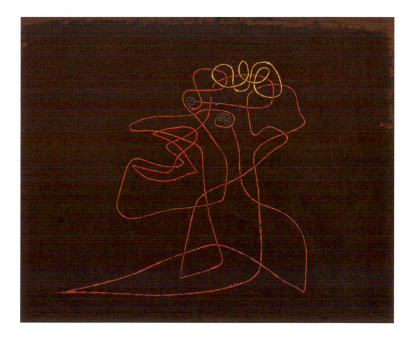

Figure 43
Paul Klee, *Or the Mocked Mocker*, 1930, oil on canvas, 17 x 20⅝ inches. The Museum of Modern Art, New York. Gift of J. B. Neumann (637.1939). Digital image © The Museum of Modern Art / Licensed by SCALA / Art Resource, NY.

Figure 44
Elsie Driggs's transcription of Emily Dickinson verses, ca. 1938.
Collection of Martin Diamond.

Figure 45
Elsie Driggs's transcription of Emily Dickinson verse on back of
I Taste a Liquor Never Brewed (1938, watercolor on paper).

Benji artfully uses reflections from a broken mirror to create harmony in a forest of warring animals (see Appendix 4, "Benji-Ben-Ali-Bengal").

A number of Driggs's watercolors were inspired by the verse of Emily Dickinson. After picking up a volume of Dickinson's poetry in 1938, she began transcribing verses and creating watercolors based on Dickinson's work.[100] Her 1938 watercolor *I Taste a Liquor Never Brewed* (cat. 35) portrays spheres of varying colors floating in a wash of pale blue. The source of inspiration is a Dickinson verse on the intoxicating effects of simple pleasures that Driggs transcribes on the back of the frame:

> I taste a liquor never brewed,
> From tankards scooped in pearl;
> Not all the vats upon the Rhine
> Yield such an alcohol!
>
> Inebriate of air am I,
> And debauchee of dew,
> Reeling, through endless summer days,
> From inns of molten blue.

In *Balloons* (1938; cat. 36), another watercolor depicting the ascent of balloons amidst line drawings of swans, Driggs deftly pictorializes an analogy made by Emily Dickinson between the stately ascent of balloons and the liquid movement of swans as they move softly upon a sea of air:

> You've seen balloons set—haven't you?
> So stately they ascend—
> It is as swans—discarded you,
> For duties diamond—
>
> Their liquid feet go softly out
> Upon a sea of blonde—
> They spurn the Air, as t'were too mean
> For creatures so renowned—[101]

Driggs began creating works incorporating what she described as "accidents."[102] One such technique involved painting in watercolor, adding areas of pastel, and then submerging the work in water so that some of the pastel floated off and other flecks remained.[103] In a letter to Eliza Rathbone, chief curator of the Phillips Collection,

Driggs described this technique, which was utilized for the Phillips' pastel and watercolor painting *At the Races* (cat. 37):

> I would paint—let the watercolor rest over night—Then soak it & when dry buff it. I would then build on that.[104]

Driggs appears to have also used a blotting technique in areas of this work before it was dry as well as stencil cutouts to lay down the figures.[105] In *Birds* (cat. 38), another undated watercolor and pastel painting, probably of the same period, Driggs plays a subtle game of hide-and seek as huddled creatures with beaklike features emerge out of their environment as though in a dream.

Elsie developed a collage technique, another "accident," from observing her daughter, Merriman, play with watercolors:

> Along in that time my daughter was born, which sort of slowed things up for awhile. But she would paint on a pad, and while it was still wet—being in a great hurry—she'd turn paper over it and paint on that paper. And one day in pulling the paper up, it tore it . . . I felt, say, I like that shape. I like that torn edge. And so then I began putting that into my paintings . . . exhibiting these things with paper pasted on them. And one critic writes, "she seems to paste pieces of paper on her watercolor. I don't know what is gained by it, but I do like the quality." So finally something had [been] gained. And then after awhile Lee began using collage. I led the way there.[106]

In Driggs's *Harlequin* (ca. 1940; cat. 39), a watercolor and pastel collage assembled from rough-edged scraps of paper, a mysterious masklike head of looping, labyrinth-like lines and planes of color appears to be floating in an ethereal wash of color.

In 1939 Driggs created the watercolor collage *From Faust* (cat. 40). Her thin, wiry line loops over itself, giving the impression in select areas of superimposed instant views of movement and in others of a dreamlike confusion. Its title suggests parallels between the story of the German magician and alchemist and the modern artist who incorporates accidental strategies of art-making to create magical effects.

Elsie's home life—and her work habits—changed for a period during the late forties. Elsie's father-in-law became ill, and Lee moved in with his mother in Baltimore to help his family. In spite of her mother-in-law's plans to have Elsie join them and teach in a Catholic school, Elsie "sneaked her way out of [the] situation" by finding employment teaching in New York at the Hewitt School, a private high school for young women on Seventy-ninth Street. For two years Elsie and her daughter lived in her sister's apartment in New York.[107] In January–February 1948 the Artists Gallery featured Driggs's work in a solo exhibition that was described in *Art News* as "her first showing in more than ten years."[108] The reviewer focused on Driggs's collages, which received positive attention:

> In most paintings, backgrounds are vaporous watercolor washes, from which the central images emerge, drawn with Klee-like sensitivity on torn, mounted scraps of paper. It is hard to say exactly what this collage technique contributes, yet the scraps, overpainted and recomposed into the picture, seem absolutely right in their intuitive shape and evocative power.[109]

In *Green Peaches* (cat. 41), a watercolor dated June 9, 1951, Driggs carefully arranges a group of intertwined, overlapping nude figures and peaches into a swirling wreath that embodies expressive power and erotic symbolism. Painting with a dry brush, Driggs intensifies the expressive power of this still life by circumscribing the centralized forms with a sweeping arc of wispy color that captures visually the tactile feel of a peach.

Driggs's work was included in the Metropolitan Museum of Art *American Watercolors, Drawings, and Prints* exhibition in December 1952. The following year, the Frank K. M. Rehn Galleries featured Driggs's work in a third solo exhibition.

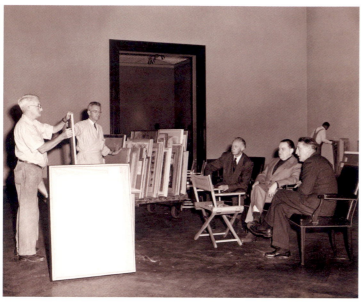

Figure 46
Jury, including Stuart Davis and Lee Gatch, for the Metropolitan Museum of Art's *American Watercolors, Drawings and Prints* exhibition, 1952. Metropolitan Museum of Art (New York, N.Y), photographer. Courtesy of the Lee Gatch Papers, 1925–1979, Archives of American Art, Smithsonian Institution.

In his review of the Rehn exhibition for the *Herald Tribune*, Carlyle Burrows noted the lyrical quality of the work:

> After some years' absence from the art shows, Elsie Driggs is showing new work at the Frank Rehn Gallery . . . Feeling and expression characterize the paintings far more than representation . . . And only with patience does one pick up the threads of form and meaning, in order to perceive a definite poetic, partially Oriental statement.[110]

The Rehn Galleries show featured eleven semi-abstract works, including *Unusual Postage* (n.d.; cat. 42), an oil on canvas that Driggs created on the floor of her Lambertville attic.[111] In this work three decorated military figures with masklike faces are rendered in a bright palette and surrounded by rectilinear frames. The framed figures appear to be floating on atmospheric panels of paint. In her review of the exhibition, Margaret Breuning noted the manner in which Driggs's "curious yet successful device of enclosing designs in painted rectilinear

or trapezoidal frames" intensified the fanciful effect of her work.[112] Another oil painting included in the Rehn show, *Dancer* (ca. 1953; cat. 43), features a glowing figure dressed in brightly colored tilted planes, who swirls on a tapered appendage.

Driggs continued creating semiabstract collages during the 1950s, emphasizing formal simplicity and texture. Using oil pigments and canvas and burlap fabrics, she produced such works as *Moonstruck Goat* (1957; cat. 44) and *Birch Image* (1957; cat. 45), which focused on themes of agitated states of mind and creativity. As her title suggests, *Moonstruck Goat* depicts the dynamic impact of the moon on a goat's mental state. *Birch Image*, another canvas collage, recalls Paul Klee's simile of the artist and the tree in his "On Modern Art." Slowly emerging within the trunk of a tree is the image of an oval head with appendages stretching out and around another form. Presented first in a student lecture in 1924, and then published in 1945, Klee used the metaphor of a tree trunk to describe the artist in the act of creation:

> May I use a simile, the simile of the tree . . . From the root the sap flows to the artist, flows through him, flows to his eye. Thus he stands as the trunk of the tree. Battered and stirred by the strength of the flow, he molds his vision into his work. As, in full view of the world, the crown of the tree unfolds and spreads in time and in space, so with his work . . . And yet standing at his appointed place, the trunk of the tree, he does nothing other than gather and pass on what comes to him from the depths. He neither serves nor rules—he transmits.[113]

When the Gatches added an extension to their Lambertville house in the early sixties, Elsie finally received her own studio space. It was invigorating. Driggs began producing a series of large oil paintings, using such watercolor techniques as diluted pigments, stenciled patterns, and sprayed backgrounds. In such works as *The Sage* (ca. 1964; cat. 47), she applied thinned paint washes onto the canvas to create forms with wandering edges and

overlapping veils of translucent color while leaving the weave of the canvas visible in select areas. In another oil painting *Calligraphy* (ca. 1965; cat. 48), a deep blue sphere floats in an orange-toned hazy atmospheric space, surrounded by trailing wispy yellow cloudlike forms. Her large *Herringbone Sky* (1965; cat. 49) incorporates a sprayed background with cut patterns.[114] Driggs returns here to the herringbone motif she had explored in a series of watercolors produced during the 1930s. In this work delicate, wavering rhythmical herringbone patterns float in front of a hazy blue sphere as they extend and join other patterns as part of a continuous flow of forms fading in and out.

Driggs's subject matter expanded in the late sixties to include a series of simply rendered, brightly colored, figurative abstract studies of women. Such works include *She Dances* (1968; cat. 51) and *Mod* (1969; cat. 52), along with portraits of figures viewed through windows: *Woman with a Pink* (1968; cat. 53) and *Passenger Figure* (ca. 1970; cat. 54). In *Madame Rivière—After Ingres* (n.d.; cat. 55), the swift curving lines of a celebrated early-nineteenth-century Jean-Auguste-Dominique Ingres portrait of Madame Rivière (oil on canvas, 1806) became the subject matter of this simply rendered abstract female figure.

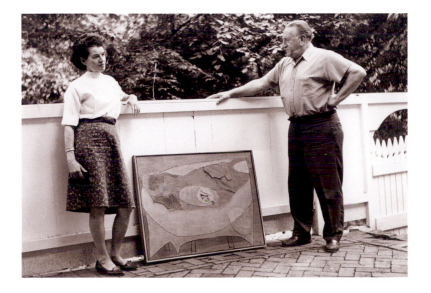

from top:

Figure 47

Elsie Driggs and Andrew Wyeth, ca. 1960. Courtesy of the Lee Gatch Papers, 1925–1979, Archives of American Art, Smithsonian Institution.

Figure 48

Elsie Driggs, Coon Path patio, n.d. Courtesy of Ogden Kruger.

Figure 49

Elsie Driggs and Lee Gatch, Coon Path, n.d. Courtesy of Ogden Kruger.

The New York Years (1969–1992)

> WHEN I CAME HERE TO NEW YORK,
> I began looking around and seeing
> the urban scene and yet, back in my mind
> was always Rome. I returned first to Italy
> in my work, and I did one that was "Re-
> turn to Assisi," and that was when I found
> the old shoe forms, and I used them as a
> presence. And I had the shoe forms walking
> by . . . a cathedral in Assisi.
> —Elsie Driggs[115]

Lee Gatch died in November 1968. Driggs and her daughter moved to New York the following year. In February 1971 La Boetie, located at 1042 Madison Avenue, featured Driggs's work in an exhibition that included examples of her "standing draw-ings" as well as her watercolors and collages and oil paintings of the sixties. Driggs began creating her series of "standing drawings" during the early seventies. Many of the works take their subject matter from historical figures and legends. Framed in shadow boxes, these drawings contain elements that are "cut out" and "stand in relief." Examples include *Signers of the Declaration of Independence* (1979), *Johnny Appleseed* (ca. 1979), and *Audubon* (ca. 1978; cat. 56). In *Audubon*, Driggs depicts the metamorphosis of a bird from egg to feathery crea-ture on a surface of cutout paper grids that appear groundless. Alongside a graphite drawing captur-ing the contour of an egg are relief cutout images of a swan poised to fly and an egg in the process of hatching. Below the swan relief is John James Audubon's flourishing signature, which echoes the curving forms of the eggs and swan. Along the bottom of the work is the inscription "John J. Audubon student with Jacques Louis David in Paris in 1800. He came to America 1803—Driggs." In referencing the transmission of artistic tradition over time and space and the developmental stages of a species in nature, Driggs suggests how progres-sive development involves being connected to the experience of others as well as open to venturing into the unknown.

Driggs repeatedly referenced classical subjects and compositions in her drawings, collages, and

Figure 51
Elsie Driggs, *Odalisque en Grisaille*, 1974, collage and watercolor,
33 x 43 inches. Private collection.

assemblages created during the seventies. *Odalisque en Grisaille,* a collage and watercolor (1974; fig. 51), incorporates a photographic negative image of Ingres's *La Grand Odalisque* (1814) with abstract patterns of cutout collage elements as well as etched lines on its Lucite case that echo and build upon Ingres's curving line.

In the late seventies, Driggs began producing assemblages in shadow boxes that included crayon drawings of classical architectural features and actual shoe forms. When a selection of these works was exhibited at Martin Diamond Fine Arts in New York in 1983 alongside a group of Driggs's watercolors from the 1930s, a review in *Arts* magazine compared the complex conceptual nature of the watercolors to the enigmatic surreal quality of her more recent multimedia pieces.[116] Driggs would later suggest that her assemblages were a means of revisiting earlier student days in Italy, particularly her memories of Rome. As she explained, the shoe forms represented "a presence returning."[117] In such boxed drawings of ancient architectural features with shoe forms like *Time* (1979), *Roman Graffiti* (1980), and *Appian Way* (1980), Driggs appears to be suggesting how her earlier student experiences in Italy are assimilated into her current art. In *Time* (fig. 52), Driggs includes a drawing of a medieval hill town, surmounted by a swinging pendulum with faint arcs in the sky that mark the moving path of the pendulum. Beneath the drawing is a mannequin's hand with a painted wristwatch, which casts a shadow on the drawing. The entire construction, encased in a shadow box, evokes associations with Italy and with the concept of time as a duration that prolongs the past into the present.

In *Cobbles* (1979; cat. 58), a cobblestone field, backed by distant rolling hillsides, is shrouded by a dense atmosphere in which some forms are clearly delineated and others barely visible. The mysterious tone of the drawing is further accentuated by

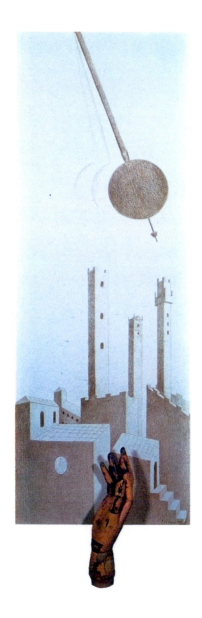

Figure 52
Elsie Driggs, *Time*, 1979, graphite and crayon on handmade paper
with found object, 41 x 16¼ x 5⅛ inches. Private collection.

the placement of wooden shoe forms in front of the drawing that suggest the presence of someone either emerging from or exiting the scene. Driggs may well have been referencing her past in Lambertville, New Jersey, a locale known for its abundant supply of very tough rock, which was sold to New York for cobblestones.

In 1980 Driggs created *The Red Cabbage* (1980; cat. 59), her final plant-form drawing, which included a cabbage resting on a plate, illuminated by a floor lamp beaming intense light on the plant. Shortly after finishing the work, Driggs described her drawing as a cabbage "with a top knot, spieling at the top."[118] She noted that the cabbage's vivid purplish-pink color presented a challenge, as she had no crayon that would touch its vivid color.[119] This work recalls Charles Sheeler's mysterious still life Conté crayon drawings of 1931 that include photographer's lamps alongside plants.[120] Whereas

Sheeler's works include lamps that are conspicuously disconnected, with bright light illuminating his subject from sources outside the picture, Driggs places her cabbage in the limelight, almost as if it is a personality, poised to perform.

The cabbage image calls to mind Driggs's early success in New York at Daniel Gallery as well as her concurrent success. As a young artist Elsie had gained attention in New York when her earliest cabbage painting became the first work she exhibited at Daniel Gallery. On that occasion poet Alanson Hartpence had informed Elsie that her *Cabbage* had created real interest, adding that he hoped sightseers "haven't fed you peanuts."[121] In 1978 on the occasion of *The Precisionist Painters 1916–1949*, organized by the Heckscher Museum, Driggs's work received a brave review in the *New York Times* as John Russell noted, "Miss Driggs, 80 this year, but still enviably spry, is one of the stars of the show."[122] In the previous year, her work had been included in shows at Hirschl and Adler, Davis and Long, the Whitney exhibition *American Art 1920–1945*, as well as *The Modern Spirit: American Painting 1908–1935*, an exhibition curated by Milton Brown that traveled to Edinburgh and London. Martin Diamond Fine Arts mounted a

Figure 53
Elsie Driggs, 1980. Photograph courtesy of Thomas C. Folk.

Figure 54
Announcement of Elsie Driggs solo show, 1980, Martin Diamond Fine Arts. Courtesy of Martin Diamond Archives.

A Tribute to

Elsie Driggs

Works from 1918 to the present

May 5– May 30

ENDLESS PIER, 1967
oil on canvas, 42″ x 36″

MARTIN DIAMOND FINE ARTS, INC.
1014 Madison Avenue
New York, N.Y. 10021
Monday — FRIDAY 11 a.m. — 5 p.m.
212 988-3600

retrospective in 1980 that brought together for the first time a comprehensive overview of her work from 1918 to the present.

In 1982 the Women's Center for Art, an affiliate society of the College Art Association (New York City) honored Driggs with a National Lifetime Achievement Award. Six years later, at the age of eighty-eight, Driggs returned to oil painting. She turned her attention to the just-completed Jacob Javits Center in New York City, producing a series of paintings inspired by the building's mirrored walls. In *The Javits Center* (1986; cat. 60), Driggs contrasts the building's hard-edge forms with the dynamic cloud patterns playing over and mirrored on its glass surfaces. In *The Javits Center Abstracted* (1986; cat. 61), she focuses on the building's glass walls mirroring the mauve tones of the twilight sky. In that same year, she created *Hoboken* (cat. 62), an elegiac oil landscape depicting buildings nestled around a Gothic-looking church in an Italian neighborhood of Hoboken, New Jersey. Driggs worked from a photograph of Hoboken taken by Anthony Nappi in the 1960s (fig. 55). She also drew heavily on recollections from her student days in Italy, creating a scene that resembles a medieval hill town. Accentuating the plain geometric surfaces of the buildings that are silhouetted against the skyline, she renders the foreground as an amorphous space with the exception of a small plant in the lower left corner. Surmounting the church spire are crisscrossed electric power lines that span the sky, conveying currents of energy through space. As Driggs acknowledged in her 1970s essay "The Search for Piero della Francesca," her student sojourn to Italy had marked the end of an era and the awakening of a new period in American art. She noted that contemporary artists were seeking inspiration from the same classical models:

> Cézanne is still great, but not as necessary to us as he was then. My awakening to the beauty of the mills . . . marked the beginning of a new era of art in America. Now there is a turning back to that period, which is in part nostalgia. But the Italian

master is divorced from that. It must be a desire for structure and order, for simplicity and strength. There is as yet, no one direction that expresses these times. My feeling is that it will be a wedding of the quick and the classical. There is too much electricity to remain benign.[123]

Uncertain of where the journey would lead, she saw contemporary artists caught in the same dynamic struggle that had motivated her exploration of the fundamental structure and accidental aspects of life at every turn:

> The way most artists operate is that they don't think . . . They have a feeling that they have to do something. And it is actually because of something in the air. They may not know what it has come from in the beginning, but something is motivating them to see something differently.[124]

The artist saw her work again reach a national audience in 1990 and 1991, when a retrospective

Figure 55

Anthony Nappi, photograph of Hoboken, 1960s. Collection of the artist. Courtesy of Thomas C. Folk.

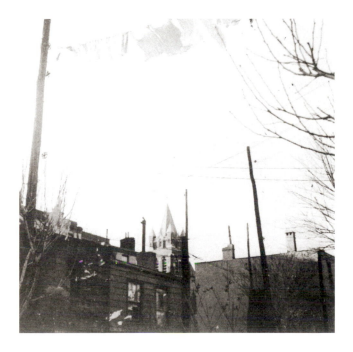

exhibition at the New Jersey State Museum traveled to the Phillips Collection. The exhibition brought together prime examples of her work and included a major publication devoted to her life and career. Her celebrated *Pittsburgh* painting was finally shown in Duncan Phillips's museum, a fitting tribute to the man who had helped arrange her 1926 visit to his nephew's Pittsburgh plant. The following year Elsie Driggs died in New York at the age of ninety-three.

Charles Sheeler compared the artist's role to "the parts of electrical equipment designed to carry the current."[125] Driggs too understood that works of art are created by the social energies of a period—as she termed it "something in the air"—that find a conduit in a particular artist. While neither Driggs nor Sheeler engaged in overt social commentary, their art incorporated compelling insights with regard to the boundaries of art and the relationship of art to nature and life. The machine age posed troubling questions for artists of the early twentieth century as it challenged them to explore not only the impact of the machine on the art-making process but on individual consciousness. Driggs's scenes of intertwined contemporary workers arranged in swirling circular formats are suggestive of the modern industrial condition of being harnessed to a center that is indifferent to its individual parts. In her *Pittsburgh* painting of a steel mill, the steamy mist rising from the bottom and sides of the painting softens the geometricized industrial forms and interrupts what might otherwise be the viewer's automatic response to a more conventional scene of smoke billowing out of the stacks of an industrial plant. *Queensborough Bridge* is, likewise, more about capturing the effect of light glare dematerializing a form than about celebrating the crisp geometry of modern technology. As Driggs noted, "I liked the idea of the thing sort of floating and going into the glare,"[126] and she selected a low vantage point that made the bridge appear to soar into the air. Both scenes evoke an anxious, uncertain mood that is out of step with those artists who were focusing on the modern industrial landscape as an outward sign of order and progress.

Just as Sheeler claimed "Photography records inalterably the single image, while painting records a plurality of images willfully directed by the artist,"[127] Driggs created her images to function on multiple levels. Viewing art as a process of discovery and experimentation, she was especially fond of watercolor techniques and of the automatic line, because these techniques allowed her to incorporate the accidental and be responsive to unconscious associations. Intrigued by forms in the process of motion and development and by the capacity of the mobile mind to engage the world as a process of becoming, she was constantly experimenting with new materials, techniques, subject matter, and ideas. She was fascinated by fluid boundaries of time and space, by the dynamic pulsings and temporalities of things around her, and by the idea that a work of art might take on a different organization at any moment. Just as the trembling contours and shimmering colors of her plant-form paintings suggest both the expansive potential and impermanence of nature, the curling steamy mist and long thin feathery clouds that move in and about her industrial pictures heighten the imaginative effects of the scene. Her lifelong desire to blend "the quick and the classical" reveals not only a fascination with the interrelationships between the impermanent aspects and fundamental structure of nature but also an enduring conviction that art should connect us to the experience of others, deepen our responses to the ordinary world, and make us eager to become actors in a theater of the artist's imagination.

Notes

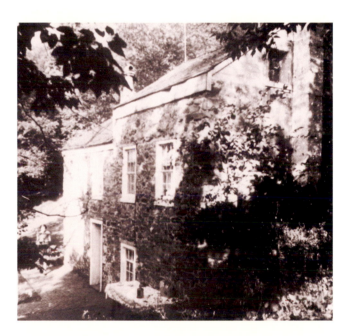

Figure 56
Home of Lee Gatch and Elsie Driggs, 1961. Courtesy of the Elsie Driggs Papers, 1924–1979, Archives of American Art, Smithsonian Institution.

1. Tyler interview, October 30, 1985, 6.

2. Ibid., 11.

3. Elsie's daughter, Merriman, has suggested that the Driggs sisters took up nursing studies during World War I to compensate for the guilt they experienced knowing that their family's affluent lifestyle came from their father's involvement in the sale of armaments during the war.

4. Driggs, quoted in Lyle, "Interview with Elsie Driggs," 5.

5. Elsie regularly visited the Charles Daniel Gallery in New York while studying at the Art Students League. Influenced by the example of Alfred Stieglitz's 291 Gallery, Charles Daniel opened his gallery in 1913, where he featured art of precisionist painters, giving solo shows to Charles Sheeler (1922), Preston Dickinson (1923, 1924, 1927, 1930), Niles Spencer (1925), and Elsie Driggs (1928). The work of Charles Demuth was exhibited at the gallery from 1914 until 1923.

6. Tyler interview, November 8, 1985, 1.

7. Tyler interview, October 30, 1985, 13.

8. Tyler interview, November 8, 1985, 2.

9. Tyler interview, October 3, 1985, 19.

10. Driggs quoted in AAA, Elsie Driggs Papers, "The Search for Piero della Francesca," 1.

11. Tyler interview, November 8, 1985, 15.

12. Tyler interview, December 5, 1985, 15–17.

13. Hartpence letter to Driggs, February 9, 1924, AAA, Elsie Driggs Papers, microfilm reel D160.

14. Forbes Watson, "Painters Form a Lively Group; an Enjoyable Exhibition of Moderns at the Daniel Gallery," (New York) *World*, February 17, 1924, metropolitan section, 7.

15. Tyler interview, November 8, 1985, 20–21.

16. Ibid., 19.

17. Cézanne revealed his preoccupation with the dynamic nature of reality to his friend Joachim Gasquet: "An art which does not have emotion as its principle is not an art . . . How can those people suppose that it's possible to capture changeable, iridescent substance with plumb-lines, academies, arbitrary rules of measurement laid down once and for all . . . But infinite diversity is nature's masterpiece." Joachim Gasquet, *Joachim Gasquet's Cézanne: A Memoir with Conversations*, trans. Christopher Pemberton, intro.

Richard Shiff (London: Thames and Hudson, 1991), 212–213. Jonathan Crary discusses Cézanne's work in terms of the artist's preoccupation with the ever-shifting intricacies of subjective vision and his interest in the ways physiology conditions sensory experience in *Suspensions of Perception: Attention, Spectacle, and Modern Culture* (Cambridge, Mass.: MIT Press, 1999; paperback edition 2001).

18. Tyler interview, November 14, 1985, 8–10.

19. Ibid., 37.

20. Margaret Breuning, "Art Season Nearing Full Swing," *New York Evening Post Literary Review* 7 (October 30, 1926): 10.

21. Tyler interview, November 14, 1985, 11.

22. Breuning, "A Group of Painters at the Daniel Gallery–French Work at Two Exhibits, Some Americans and Notes on Coming Events of the Season," *New York Evening Post*, November 12, 1927, section 3, 13.

23. Tyler interview, November 14, 1985, 9.

24. Tyler interview, November 8, 1985, 5–6.

25. In a conversation with the author on February 22, 2007, Driggs's daughter, Merriman Gatch, suggested that the subject is Natalie Van Vleck, a fellow student who studied with Maurice Sterne and often dressed in masculine clothing.

26. In her interview with Francine Tyler, Driggs mentions collecting photographs of the work of Piero as a student in Italy and recalls that while in Arezzo, she found some "very beautiful Piero della Francesca frescos" (October 30, 1985, 16–18).

27. Tyler interview, November 21, 1985, 81–82.

28. T. S. Eliot, "The Burial of the Dead" in *The Wasteland*, in *Collected Poems 1909–1962* (New York: Harcourt Brace, 1991), 55.

29. Tyler interview, November 14, 1985, 11.

30. Breuning, "Art Season Nearing Full Swing," 10.

31. Murdoch Pemberton, "The Art Galleries," *The New Yorker* (October 30, 1926): 68.

32. Tyler interview, November 21, 1985, 20, 22.

33. Elsie Driggs, letter to Martin Diamond, August 11, 1990, Martin Diamond Archives.

34. Jane Heap, "Machine Age Exposition," *The Little Review* 11, no. 1 (spring 1925): 22.

35. Tyler interview, November 14, 1985, 75.

36. Gatch interview, Harmon Papers, 4.

37. Ibid.

38. Tyler interview, October 30, 1985, 25.

39. Tyler interview, November 21, 1985, 61.

40. Tyler interview, November 14, 1985, 19.

41. Ibid., 42–43.

42. Tyler interview, November 21, 1985, 54–55. Driggs mentions that this red brown drawing around the edge of the smokestacks may have been removed with cleaning.

43. Tyler interview, November 14, 1985, 45.

44. Ibid., 54–58.

45. "Immaculate School Seen at Daniels," *Art News* 27, no. 5 (November 3, 1928): 9.

46. Tyler interview, November 14, 1985, 44.

47. Driggs letter to Diamond, August 11, 1990, Martin Diamond Archives.

48. Gatch interview, Harmon Papers, 4.

49. Ibid., 5.

50. Barbara Haskell has suggested that this group of Stella's powerful drawings of looming Pennsylvania industrial structures silhouetted against evening skies was likely created ca. 1918–24 as a result of the commission Stella received from *The Survey* magazine to document the social and political issues surrounding the use of coal and hydroelectric power. These drawings were included in a number of exhibitions soon after the article was published. Haskell, *Joseph Stella*, exhibition catalogue (New York: Whitney Museum of American Art; distributed by Harry N. Abrams, 1994), 107, note 212.

51. Tyler interview, November 14, 1985, 48.

52. Tyler interview, October 30, 1985, 26.

53. Tyler interview, November 21, 1985, 91.

54. Tyler interview, November 8, 1985, 44–45.

55. Ibid., 30.

56. Forbes Watson, "Native Moderns Hold Group Exhibit," (New York) *World,* April 3, 1927, metropolitan section, 11.

57. Tyler interview, November 21, 1985, 64.

58. In an interview with Francine Tyler, Driggs states that she obtained photographs of the River Rouge plant but did not know who had created the photographic images (December 5, 1985, 18–19).

59. Tyler interview, December 5, 1985, 45.

60. Driggs letter to Diamond, August 11, 1990, Martin Diamond Archives.

61. Quoted from critical review of work by Driggs, Preston Dickinson, and Yasuo Kuniyoshi included in an exhibit held at the Little Gallery of Contemporary Art of the New Students League, 1525 Locust Street, Philadelphia, in January 1929 ([Philadelphia] *Public Ledger,* January 20, 1929, women's section, 9).

62. Murdoch Pemberton, "The Art Galleries—A Good Run of New Spring Sap," *The New Yorker* 4 (May 5, 1928): 72.

63. Elizabeth Luther Cary, "Varied Adventures in the Local Realm of Art: The Lexicon of Youth; a Stimulating Mixed Exhibition Is Now Presented at the Museum of Modern Art," *New York Times,* April 13, 1930, section 10, 10.

64. Charles Daniel, letter to Elsie Driggs, July 22, 1930, AAA, Elsie Driggs Papers, microfilm reel D160, 211.

65. Neumann married Elsa Schmidt, one of Elsie's best friends, who was working in Anticoli when Driggs traveled there (Tyler interview, December 5, 1985, 10).

66. Thomas C. Folk, *Elsie Driggs: A Woman of Genius* (Trenton, N.J.: New Jersey State Museum, 1990), 33, exhibition catalogue published in conjunction with *Elsie Driggs: A Woman of Genius,* New Jersey State Museum, Trenton, N.J., and the Phillips Collection, Washington, D.C.

67. Tyler interview, November 21, 1985, 10.

68. Driggs, letter to Forbes Watson, March 12, 1939, Elsie Driggs artist file, Martin and Harriette Diamond Collection of American Art, Special Collections and University Archives, Rutgers University Libraries.

69. Tyler interview, November 21, 1985, 15.

70. Tyler interview, December 5, 1985, 28.

71. Tyler interview, November 21, 1985, 15–18; http://www.arch.columbia.edu/hp/research/northernHistory.html.

72. Driggs, letter to Martin Diamond, October 21, 1979, Elsie Driggs artist file, Martin and Harriette Diamond Collection of American Art, Special Collections and University Archives, Rutgers University Libraries.

73. Frank Rehn became Driggs's dealer in 1935. His gallery was located on Fifth Avenue at Fifty-fourth Street.

74. Laurie Eglington, "Elsie Driggs, Rehn Galleries," *Art News* 33, no. 21 (February 23, 1935): 13.

75. Tyler interview, December 5, 1985, 62.

76. Driggs, letter to Bill Smith, November 20, 1973. Private collection.

77. Ibid.

78. Ibid.

79. Tyler interview, November 8, 1985, 38–39.

80. Driggs quoted in 1981 Jersey City Museum Invitational exhibition catalogue, November 20, 1981, through February 28, 1982, n.p.

81. Tyler interview, November 21, 1985, 20–21.

82. Ibid.

83. Ibid., 36.

84. Driggs quoted in Lyle, "Interview with Elsie Driggs," 4.

85. Tyler interview, November 21, 1985, 40.

86. Ibid., 52.

87. Klee, *The Thinking Eye,* 130.

88. Martha Davidson, "Elsie Driggs, A Draughtsman of Rare Imagination," *Art News* 36, no. 25 (March 19, 1938): 14.

89. Tyler interview, December 5, 1985, 54; Gatch interview, Harmon Papers, 8.

90. Alfred Barr, "Introduction," Paul Klee, exhibition catalogue (New York: Museum of Modern Art, 1930), 9–10.

91. Tyler interview, November 8, 1985, 39.

92. Driggs, "The Stones of Lee Gatch," quoting a letter from Gatch to Duncan Phillips, AAA, Elsie Driggs Papers.

93. Ibid.

94. Paul Klee expressed such interests in his pedagogic writings of the early 1920s. See Klee, *The Thinking Eye*.

95. Driggs, quoted in videotaped interview at opening reception of her retrospective at the Phillips Collection, January 26, 1991.

96. Paul Klee, "I.1, Active Line," in *Pedagogical Sketchbook*, trans. Sibyl Moholy-Nagy (New York: Praeger, 1953), 16.

97. Lee Gatch student notebook in Lee Gatch Papers, 1925–1979, Archives of American Art (hereafter cited as AAA, Lee Gatch Papers).

98. Driggs, letter to Emily Nathan, August 22, 1971, 4, AAA, Lee Gatch Papers.

99. A draft for this short story is in the Elsie Driggs artist file, Martin and Harriette Diamond Collection of American Art, Special Collections and University Archives, Rutgers University Libraries. Driggs created at least two additional illustrations for this story: Monkey in the Tree and The King's Equerry (Martin Diamond Fine Arts receipt, dated August 15, 1985, in the Martin Diamond Archives).

100. In an undated note by Driggs in the Martin Diamond Archives, Driggs transcribes verses from Emily Dickinson's poetry and notes that she picked up a volume of Dickinson's verse in 1938.

101. Ibid.

102. Tyler interview, December 5, 1985, 63.

103. Driggs described this technique in her audiotaped interview with Francine Tyler, December 5, 1985, 62.

104. Driggs, letter to Eliza Rathbone, July 1, 1987, in the Phillips Collection conservation file for *At the Races*.

105. In a videotaped interview at the opening of her retrospective at the Phillips in 1991, Driggs refers to cut patterns while discussing her watercolor technique.

106. Tyler interview, November 21, 1985, 5–6.

107. Tyler interview, December 5, 1985, 30–34.

108. News clipping with inscription: "*Art News*. Jan. 1948," Elsie Driggs artist file, Martin and Harriette Diamond Collection of American Art, Special Collections and University Archives, Rutgers University Libraries.

109. Ibid.

110. Carlyle Burrows, *New York Herald Tribune*, May 3, 1953, news clipping in AAA, Elsie Driggs Papers, microfilm reel D160.

111. Folk, *Elsie Driggs: A Woman of Genius*, 39.

112. Breuning, "New York," *Art Digest* 27, no. 15 (May 1, 1953): 17.

113. Paul Klee, "On Modern Art" (1924, trans. 1948) in *Art in Theory, 1900–1950, an Anthology of Changing Ideas*, ed. Charles Harrison and Paul Wood (Oxford: Blackwell, 2000), 343–344.

114. Driggs explained the technique used in this work in a videotaped interview at the opening of her 1991 retrospective at the Phillips Collection.

115. Tyler interview, November 14, 1985, 1.

116. Ilene Susan Fort, "Three American Modernists," *Arts* 57, no. 6 (February 1983): 35.

117. Tyler interview, November 21, 1985, 23, 27.

118. Driggs, videotaped interview at the opening of her retrospective at the Phillips Collection in 1991.

119. Tyler interview, November 14, 1985, 24.

120. Thomas C. Folk notes the similarity of this work to Sheeler's crayon drawings with photographer lamps in *Elsie Driggs: A Woman of Genius*, 48, note 70.

121. Alanson Hartpence, letter to Elsie Driggs, February 9, 1924, AAA, Elsie Driggs Papers, microfilm reel D160.

122. John Russell, "L. I. Museum Celebrates Yankee Art," *New York Times*, July 21, 1978, section c, 1.

123. Driggs quoted in AAA, Elsie Driggs Papers, "The Search for Piero della Francesca," 3.

124. Tyler interview, November 21, 1985, 86.

125. Sheeler, autobiographical notes, Sheeler Papers, Archives of American Art, roll NSh1, frame 109, quoted in Lucic, *Charles Sheeler and the Cult of the Machine*, 236.

126. Tyler interview, November 8, 1945, 44–45.

127. Sheeler, quoted in Constance Rourke, *Charles Sheeler: Artist in the American Tradition* (New York: Harcourt, Brace, 1938), 119.

CATALOGUE PLATES

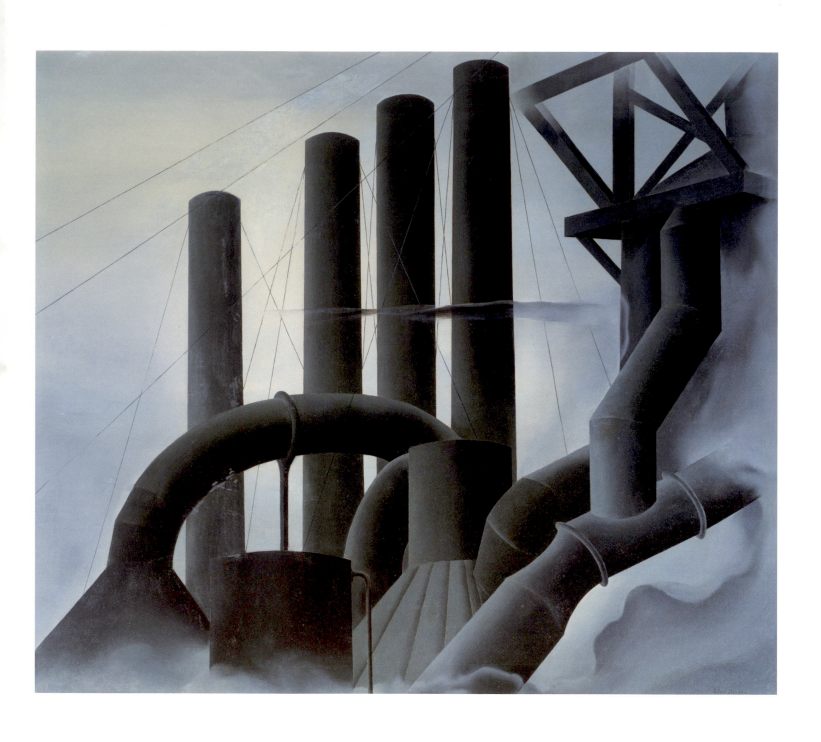

1. PITTSBURGH, 1927
 Oil on canvas
 34¼ x 40 inches
 Whitney Museum of American Art, New York.
 Gift of Gertrude Vanderbilt Whitney 31.177

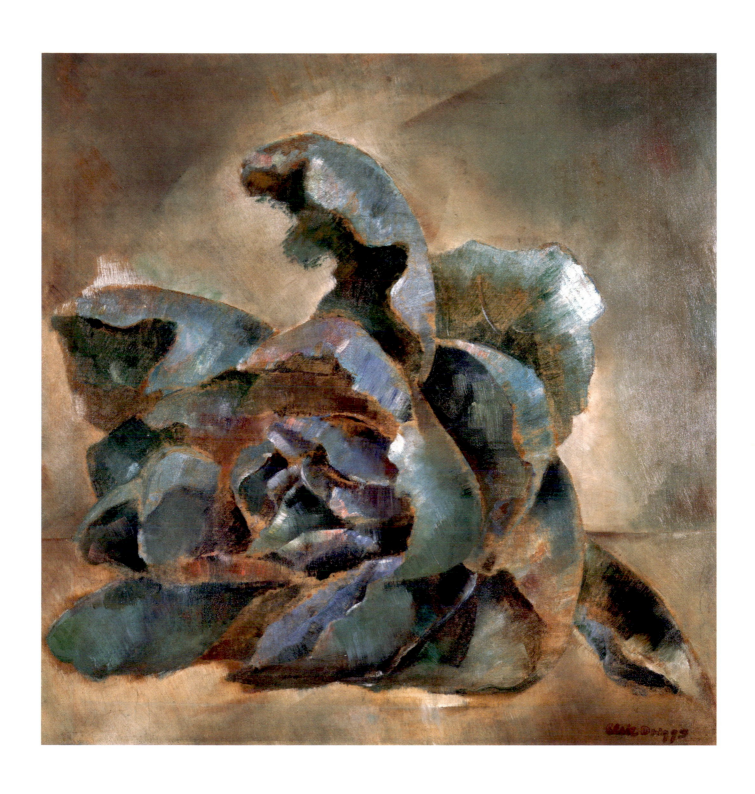

2. CHOU, 1923
 Oil on silk
 23¾ x 23¾ inches
 Collection of the Montclair Art Museum, Montclair, N.J.
 Gift of Julian Foss in memory of his wife, Eva; 1982.39

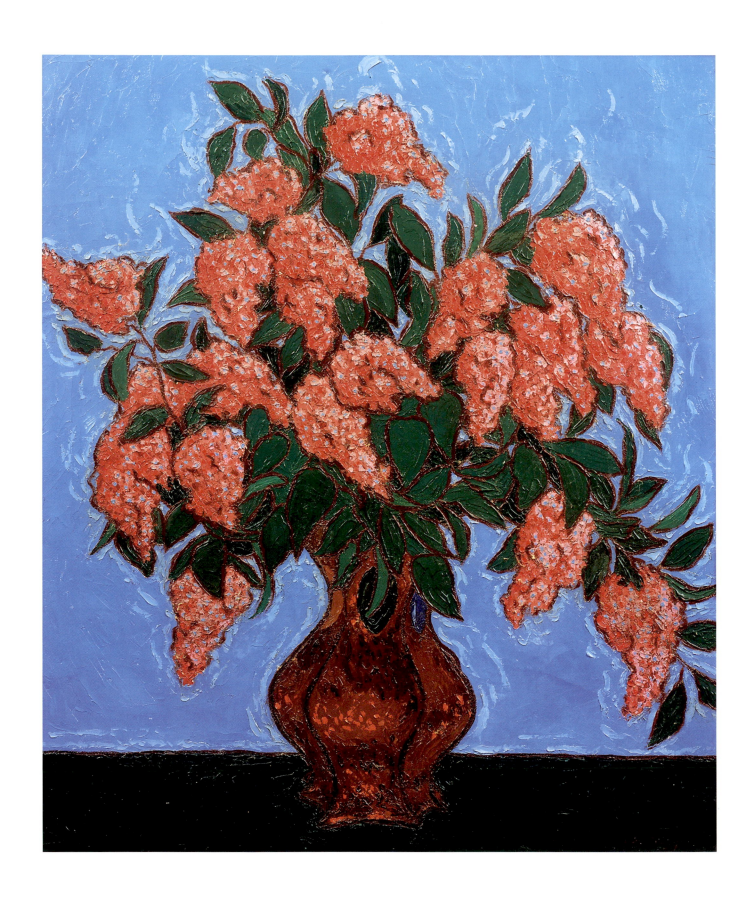

3. LILACS, 1918
 Oil on paper
 26 x 22 inches
 Collection of Martin and Judy Stogniew

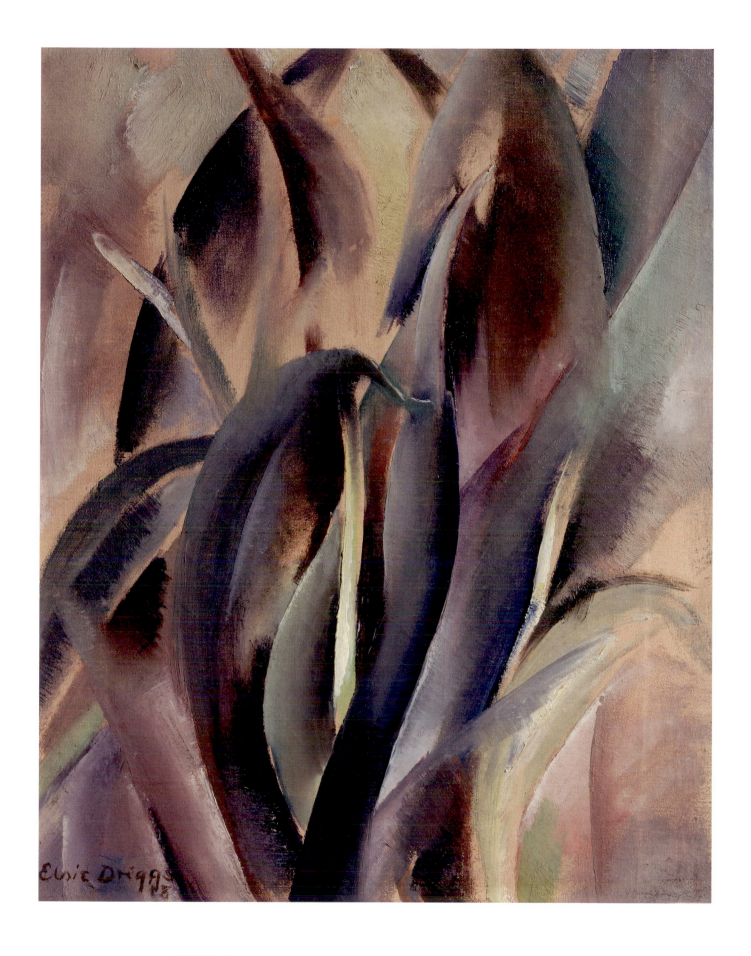

4. LEAF FORMS, 1918
 Oil on canvas
 11 x 9 inches
 Private collection

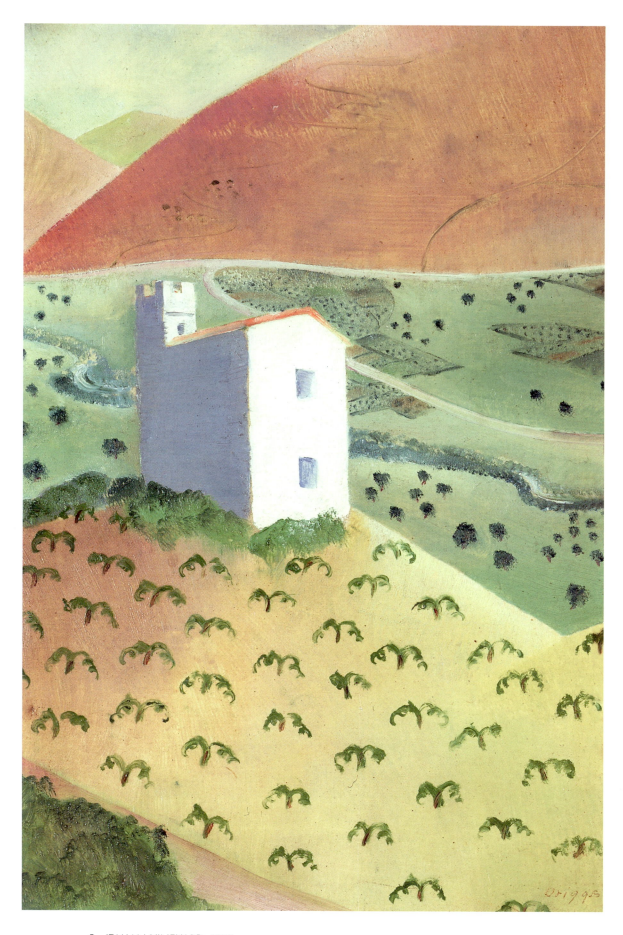

5. ITALIAN VINEYARD, 1923
 Oil on canvas
 12 x 8 inches
 Private collection

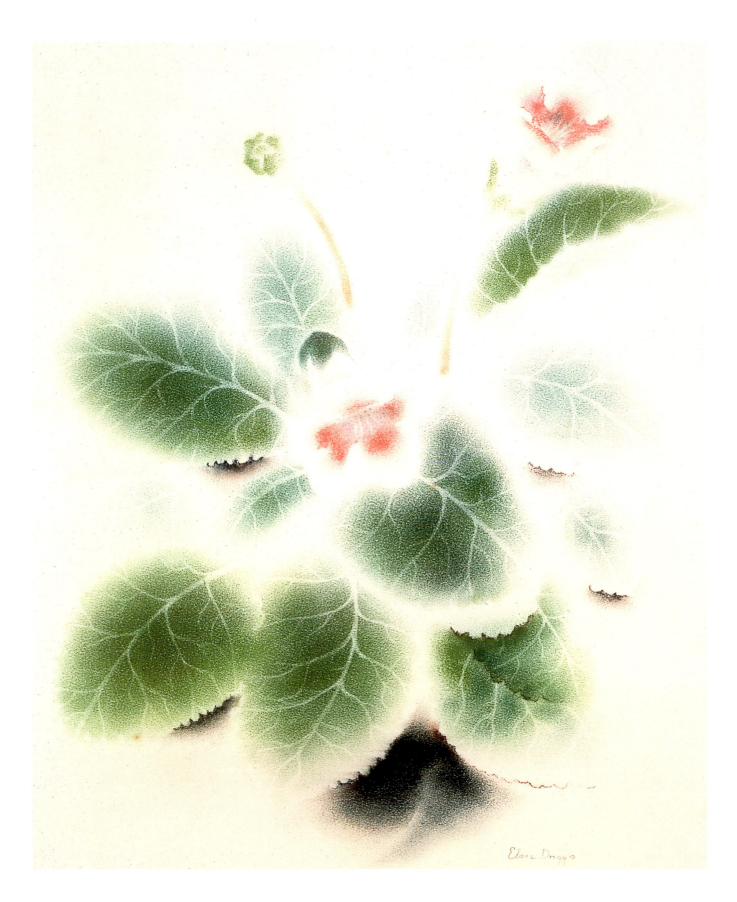

6. GLOXINIA, 1925
 Pastel on paper
 16 x 12 ¾ inches
 Collection of Margery and Maurice Katz

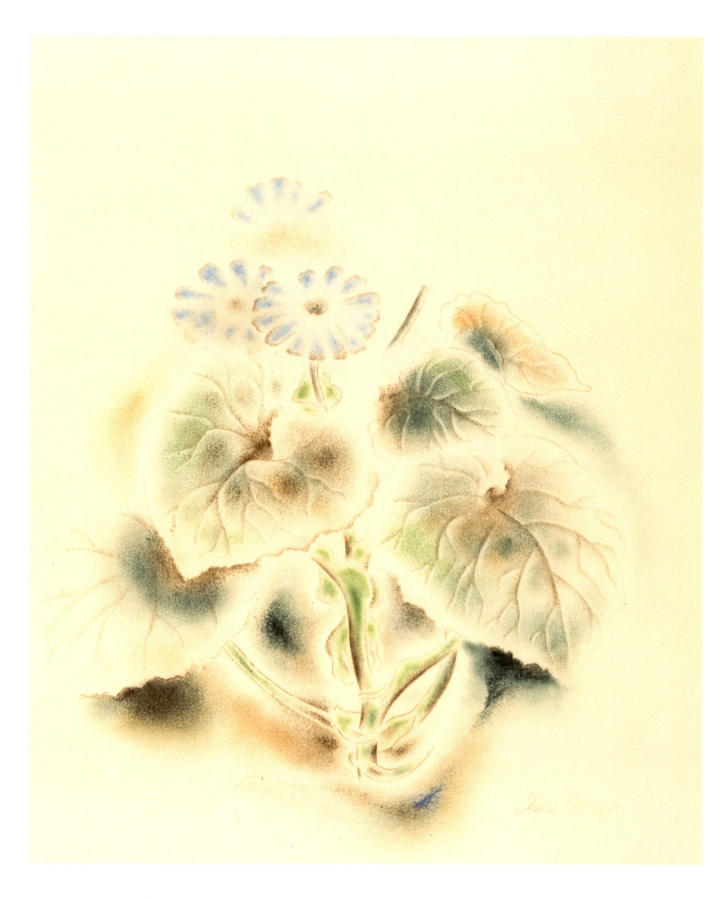

7. CINERARIA, ca. 1926
 Pastel on paper
 16 ⅝ x 13 ⁵⁄₁₆ inches
 Columbus Museum of Art, Ohio; Gift of Ferdinand Howald 1931.168

8. THE BATTLE OF ANGHIARI, ca. 1925
 After the Peter Paul Rubens copy of Leonardo da Vinci's original
 Pencil on paper
 8½ x 9½ inches
 Collection of Tom Folk

opposite:

9. UNTITLED (portrait of girl in chair), ca. 1922–25
 Oil on canvas on Masonite
 38 x 27¼ inches
 Private collection

10. UNTITLED (portrait of Natalie Van Vleck), ca. 1922–25
Oil on canvas on Masonite
39 x 28 inches
Collection of Roy and Jennifer Pedersen

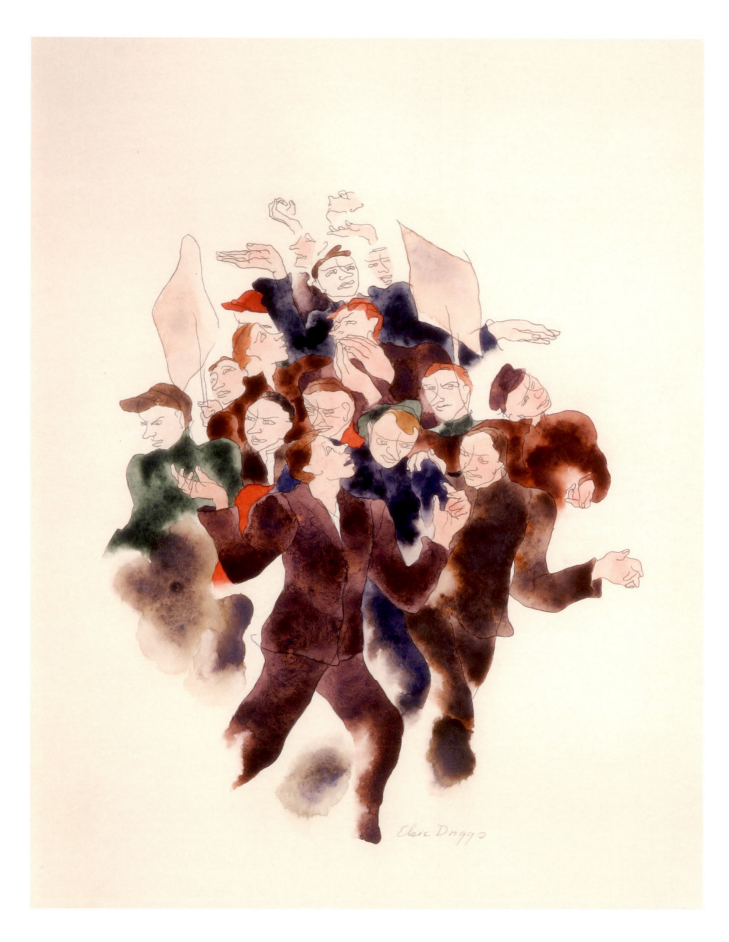

11. THE MOB, ca. 1925
 Watercolor on paper
 13 ½ x 9 ¼ inches
 Private collection

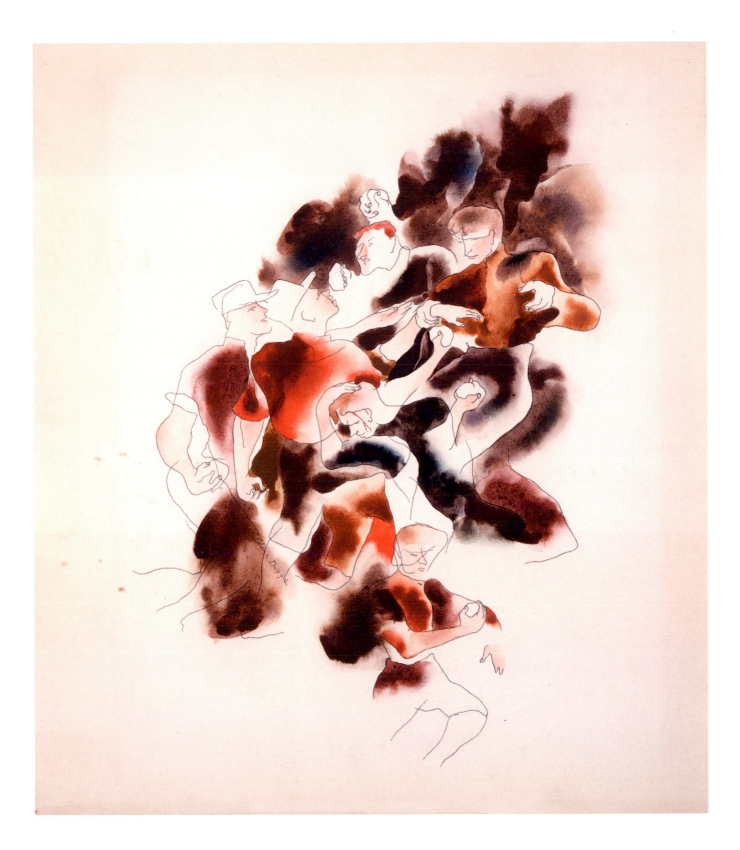

12. RIOT, 1929
 Watercolor and pencil on paper
 11 ½ x 9 inches
 Heckscher Museum of Art. Gift of Martin, Richard, Nancy and James Sinkoff in loving
 memory of their parents, Alice and Marvin Sinkoff

opposite:

13. WALKERS IN THE CITY, ca. 1928
 Watercolor on paper
 13 ½ x 9 ¼ inches
 Private collection

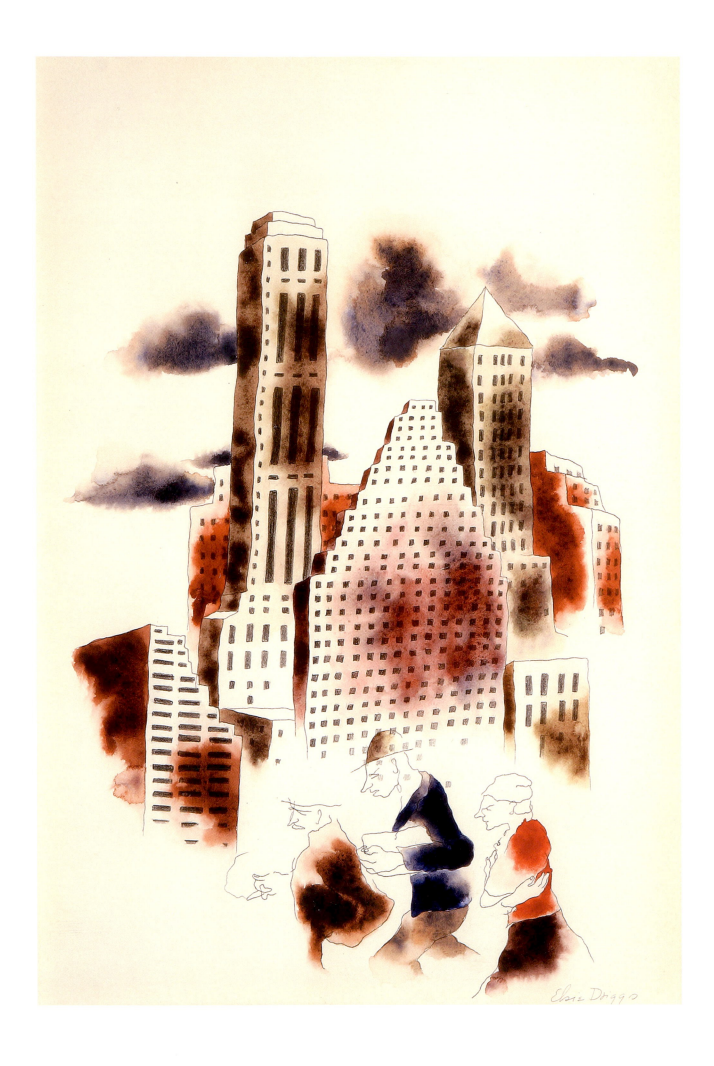

14. DANTE'S INFERNO (also known as MILLING WORKERS), 1925
 Watercolor on paper
 11 x 8 inches
 Private collection

15. ILLUSTRATION FOR DANTE'S INFERNO, ca. 1932
 Watercolor and graphite on paper
 11 ¾ x 9 ⅞ inches
 Columbus Museum of Art, Ohio: Gift of Robert Schoelkopf Gallery 1965.024

16. SOON THEY OVERTOOK US; WITH SUCH SWIFTNESS MOVED THE
 MIGHTY CROWD—PURGATORY, CANTO XVIII, n.d.
 Graphite and wash on paper
 7 ½ x 7 inches
 Sheldon Memorial Art Gallery and Sculpture Garden, University of Nebraska–
 Lincoln UNL—Gift of Robert Schoelkopf

17. CHILDREN IN THE SUNSET, n.d.
 Watercolor and pencil on paper
 12 ¼ x 11 inches
 James A. Michener Art Museum. Michener Endowment Challenge.
 Gift of Margaret B. Oschman

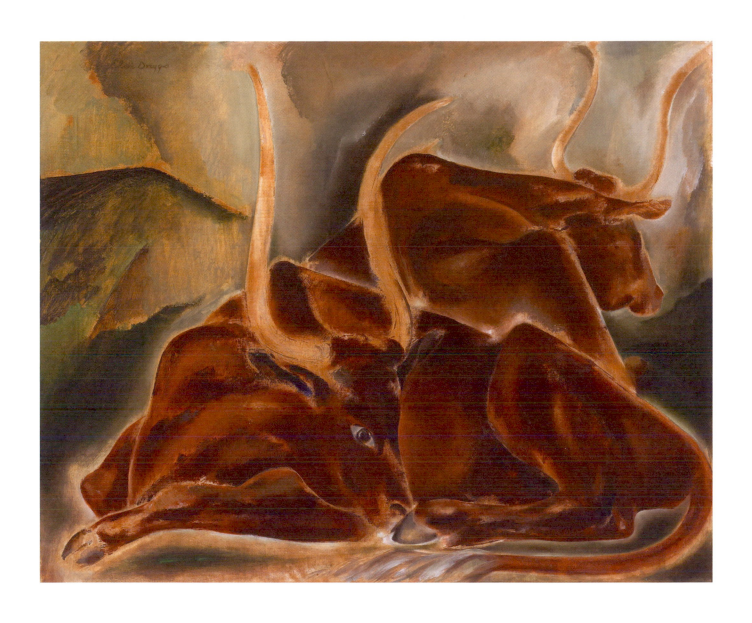

18. THE OXEN, 1926
 Oil on canvas
 24 x 30 inches
 Allentown Art Museum, Purchase:
 The Reverend and Mrs. Van S. Merle-Smith, Jr., Endowment Fund, 1998 (1998.18)

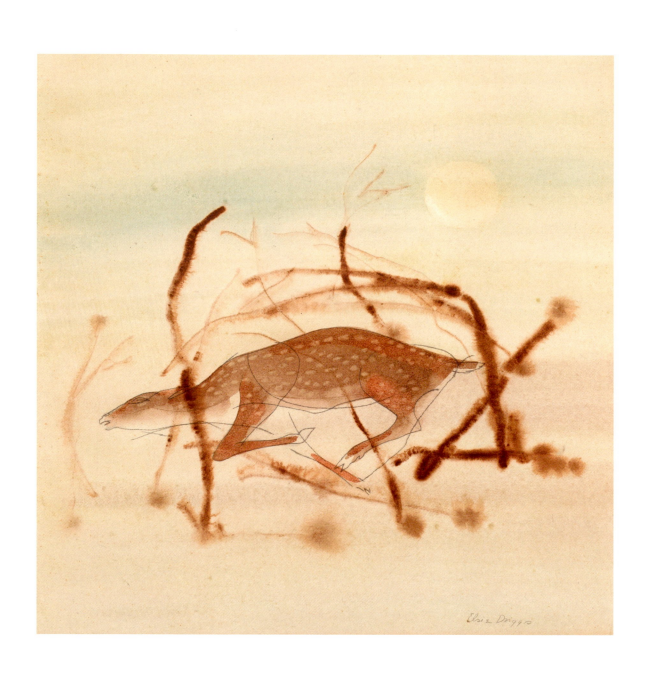

19. SPOTTED DEER, n.d.
 Watercolor and pencil on paper
 17 x 15 inches
 James A. Michener Art Museum. Michener Endowment Challenge.
 Gift of Margaret B. Oschman

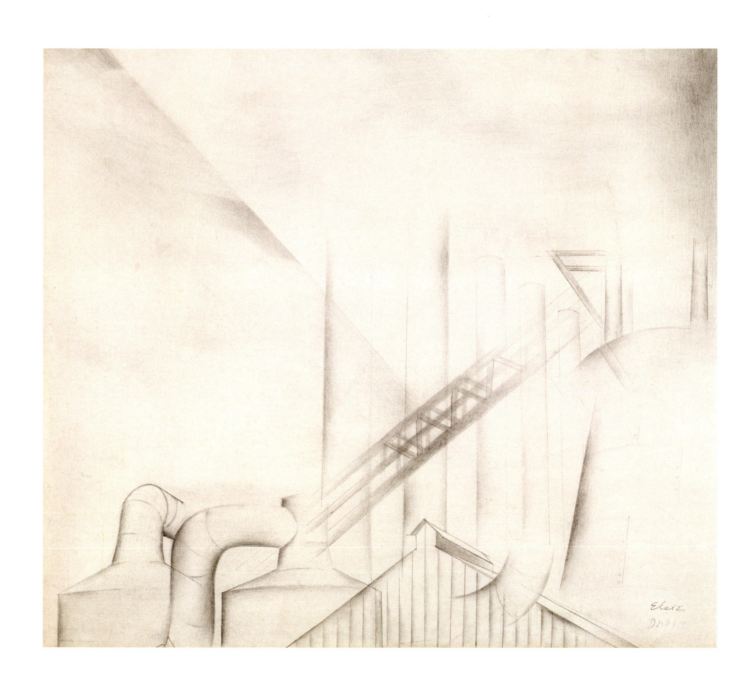

20. IMAGES OF PITTSBURGH, 1927
 Graphite on paper
 12 x 13 ⅜ inches
 Whitney Museum of American Art, New York.
 Fiftieth Anniversary Gift of Mr. and Mrs. Julian Foss 80.6.4

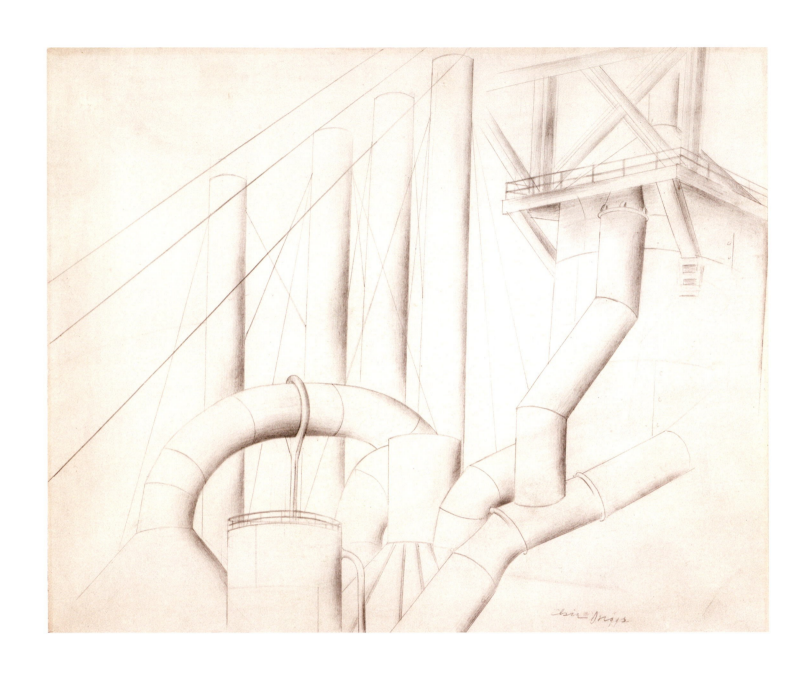

21. STUDY FOR PITTSBURGH, 1927
 Graphite on paper
 12 x 14½ inches
 Whitney Museum of American Art, New York.
 Fiftieth Anniversary Gift of Mr. and Mrs. Julian Foss 80.6.3

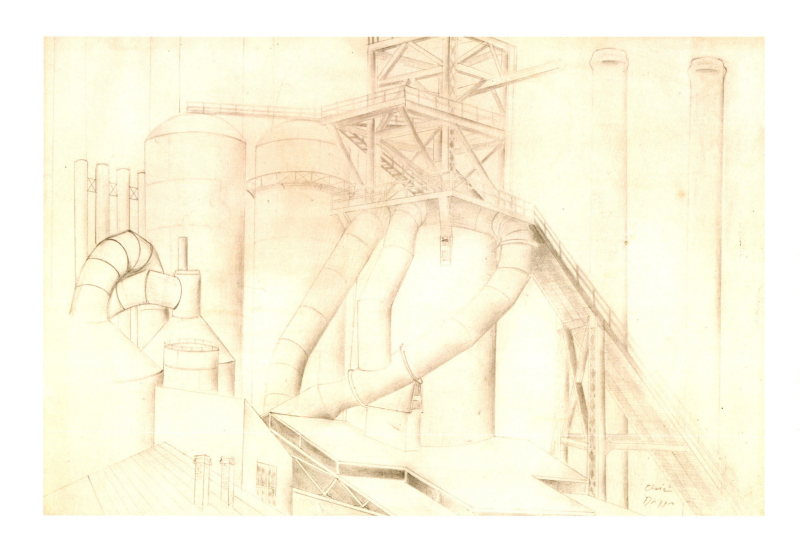

22. STUDY FOR BLAST FURNACE, 1927
 Graphite on paper
 12 x 18 inches
 Whitney Museum of American Art, New York. Fiftieth Anniversary
 Gift of Mr. and Mrs. Julian Foss 80.6.2.

opposite:

23. QUEENSBOROUGH BRIDGE, 1927
 Oil on canvas
 40¼ x 30¼ inches
 Collection of the Montclair Art Museum, Montclair, N.J.
 Museum purchase; Lang Acquisition Fund, 1969.4

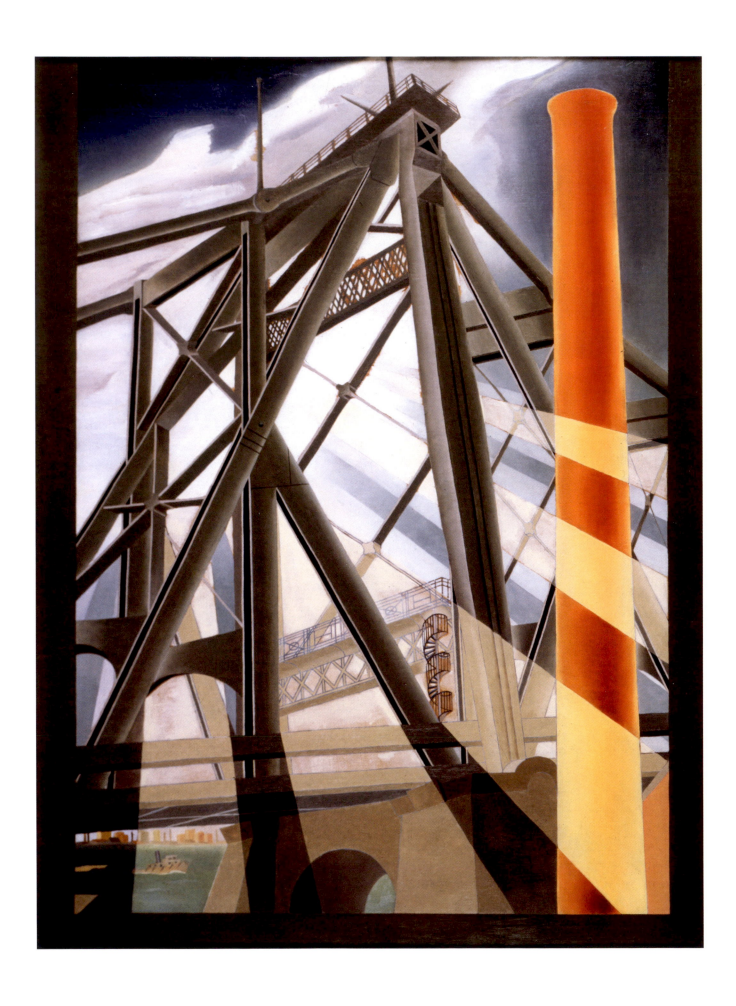

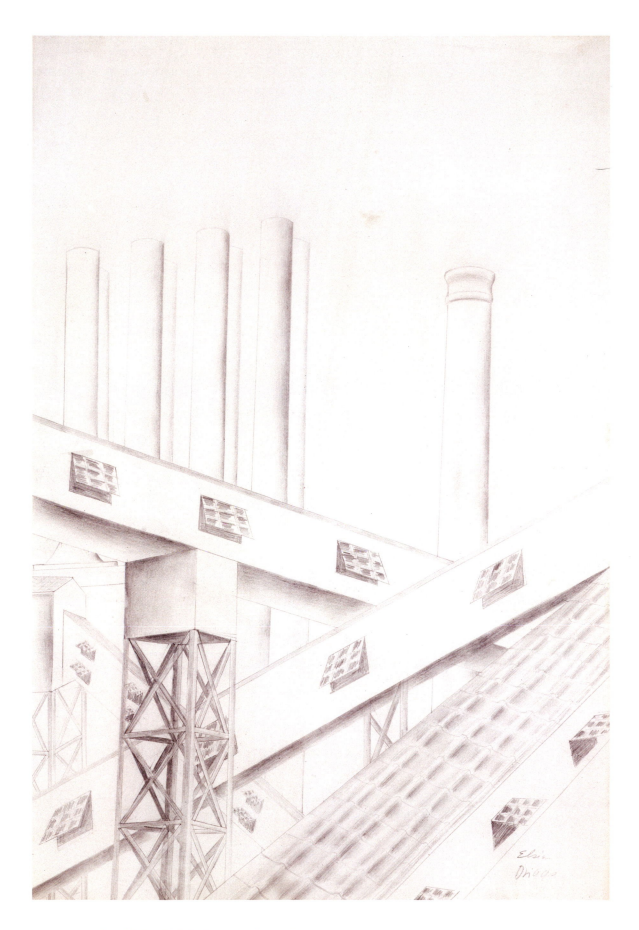

24. STUDY FOR RIVER ROUGE PLANT, 1928
 Graphite on paper
 18 x 12 inches
 Whitney Museum of American Art, New York.
 Fiftieth Anniversary Gift of Mr. and Mrs. Julian Foss 80.6.1

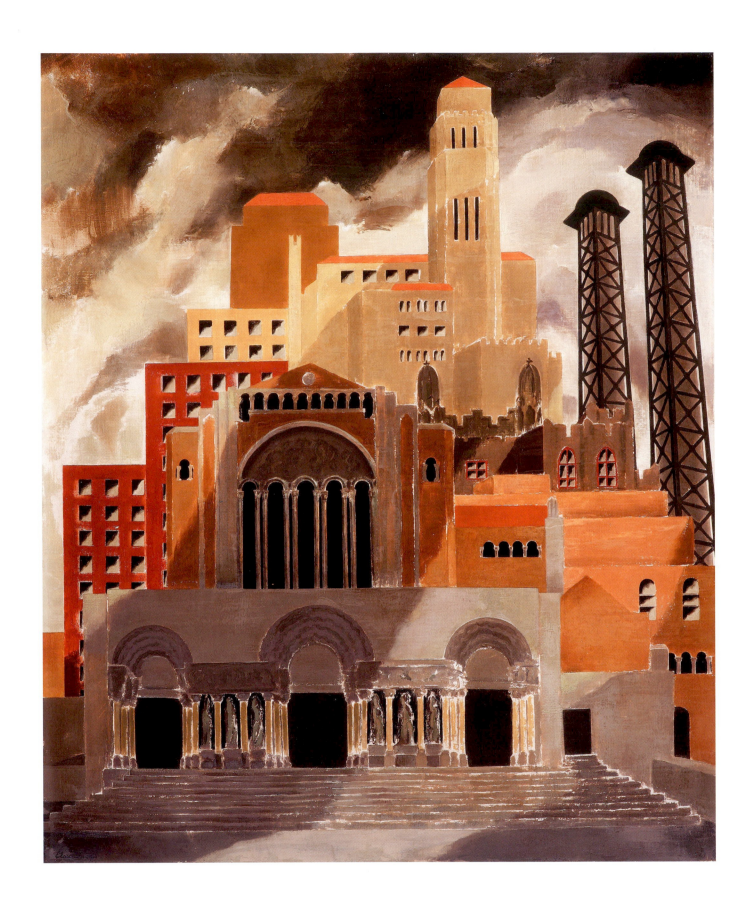

25. SAINT BARTHOLOMEW'S CHURCH, 1929
 Oil on canvas
 36 x 30 inches
 Collection Citigroup

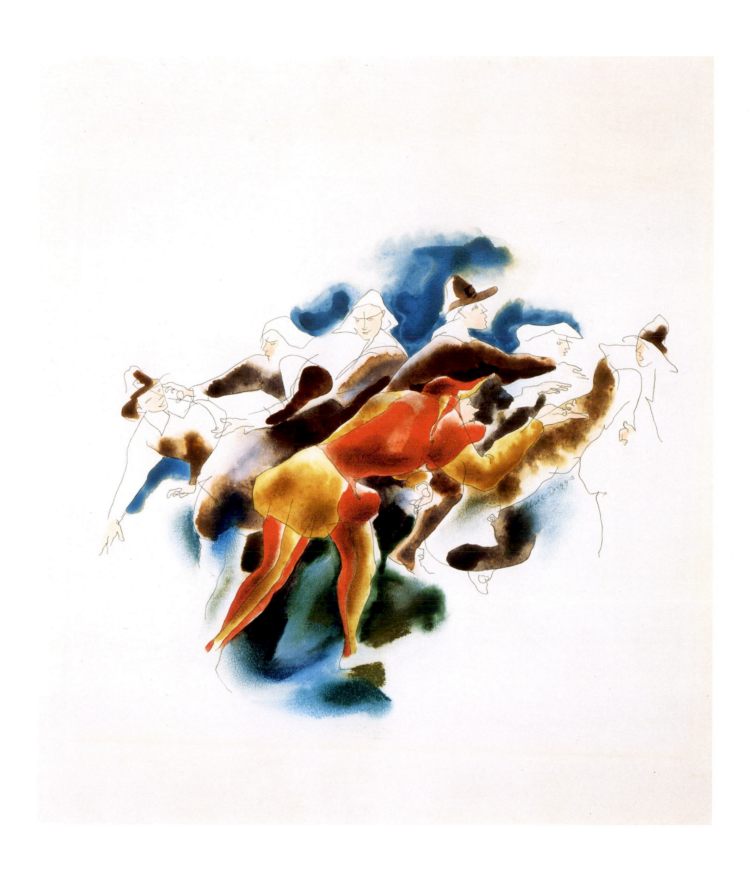

26. MERRYMOUNT, 1934
 Watercolor, pencil, colored chalk, and picture varnish on paper
 12 ⅜ x 10 ¹⁵⁄₁₆ inches
 Collection of the Corcoran Gallery of Art, Washington, D.C.
 Museum Purchase through a gift of Mrs. G. V. Fox

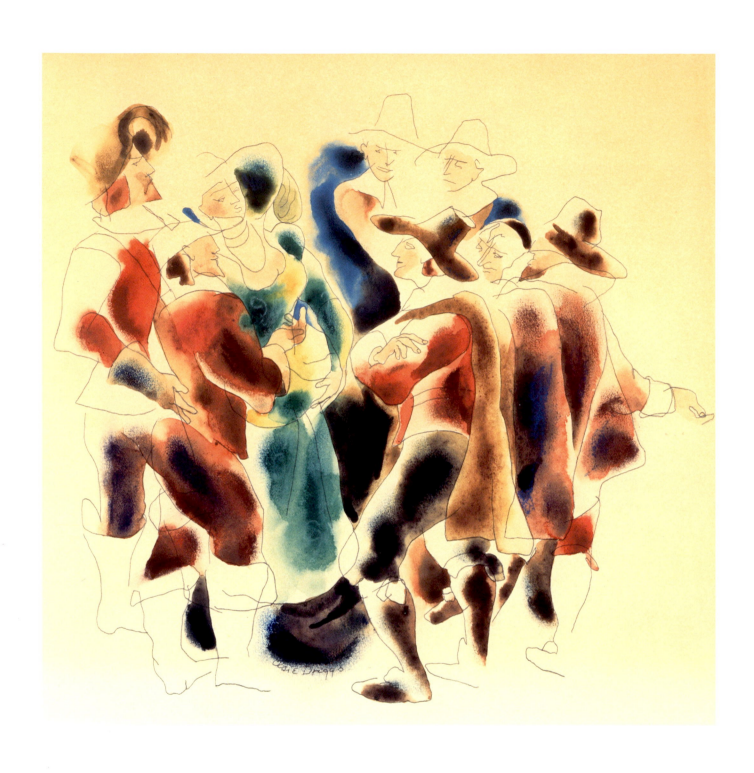

27. PILGRIMS, ca. 1934
 Watercolor and pencil on paper
 10 x 10 inches
 Dr. Tom Folk Gallery

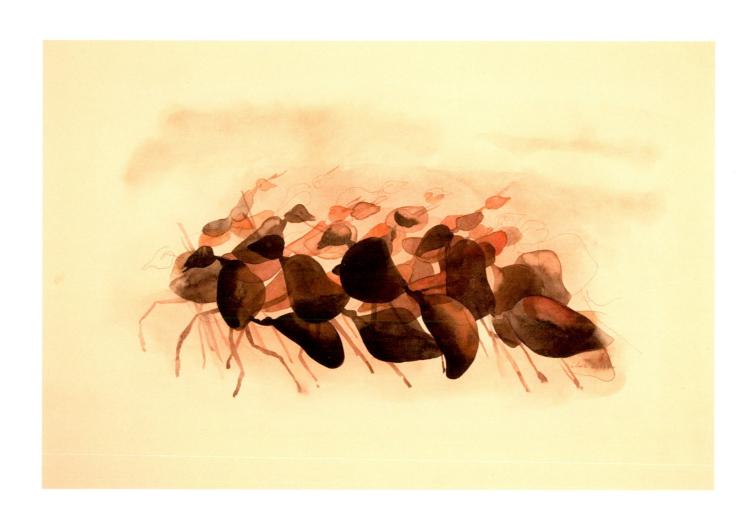

28. MARCHING ANTS, 1935
 Watercolor and pencil on bristol board
 8 ⅞ x 16 inches
 Courtesy of the Syracuse University Art Collection

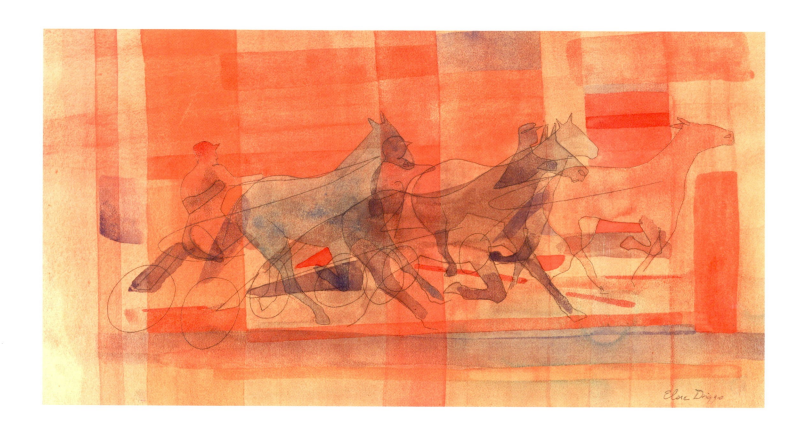

29. THE SULKY, 1935
 Watercolor and pencil on paper
 9 x 16 inches
 Private collection

30. YOUNG MAN SLEEPING (also known as MEXICAN PEASANT
 RECLINING), ca. 1935
 Oil on canvas
 20 x 48 inches
 Collection of Chris Walther and Susan Stockton

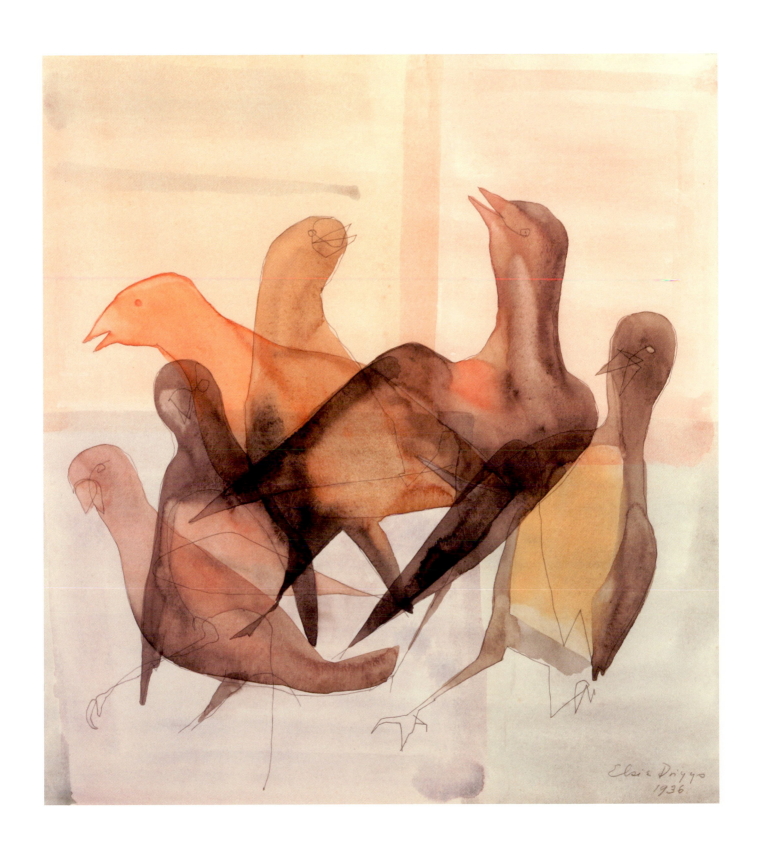

31. WHO KILLED COCK ROBIN? 1936
 Watercolor on paper
 11¼ x 10⅞ inches
 Collection of Robert and Jan Anderson

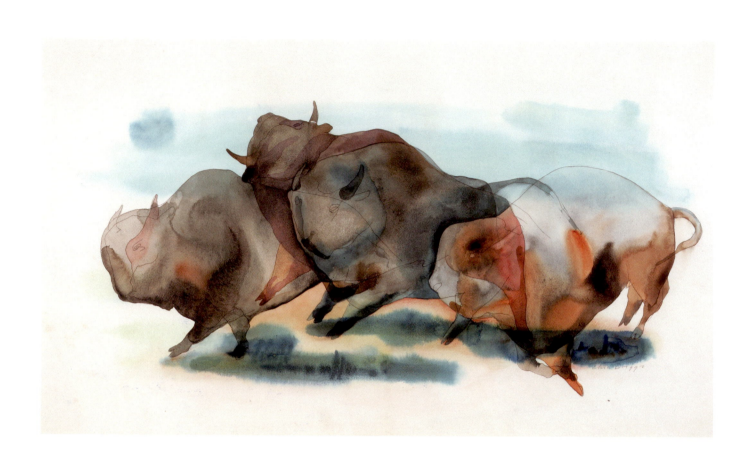

32. THREE BISON, 1935
 Watercolor on paper
 12 x 9 ½ inches
 Collection of Peter Franko

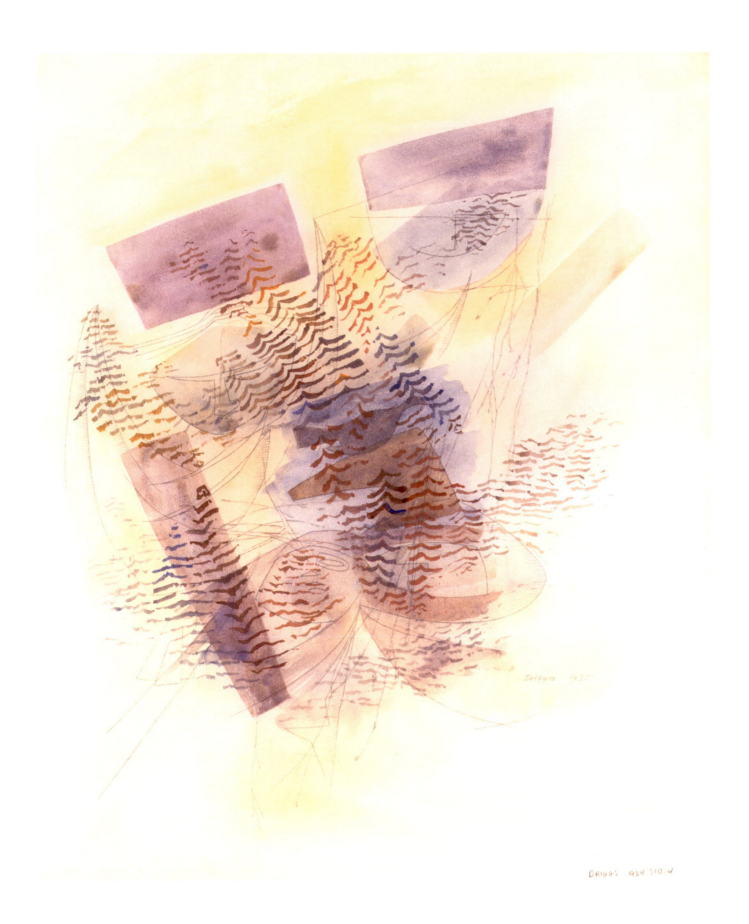

33. GARDEN ON CEDAR ROAD, 1938
 Watercolor and pencil on paper
 22 ⅝ x 18 ½ inches
 The Metropolitan Museum of Art, Gift of Murray D. Garson,
 in memory of Margaret S. Garson, 1984 (1984.310.4)
 Photograph © 2007 The Metropolitan Museum of Art

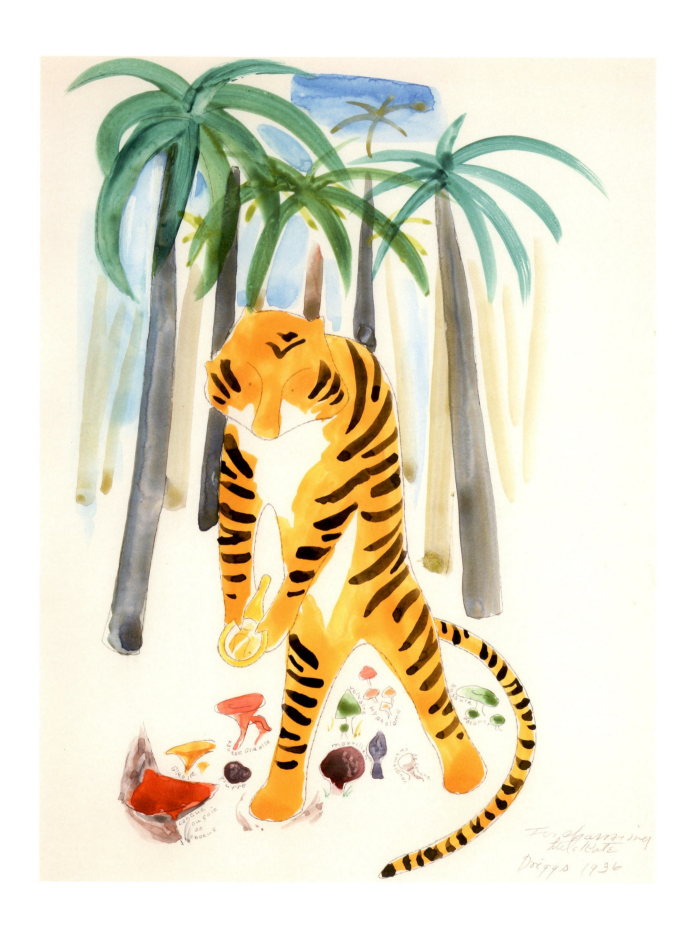

34. BENJI-BEN-ALI-BENGAL, 1936
Watercolor and pencil on paper
19 x 15 ½ inches
Private collection

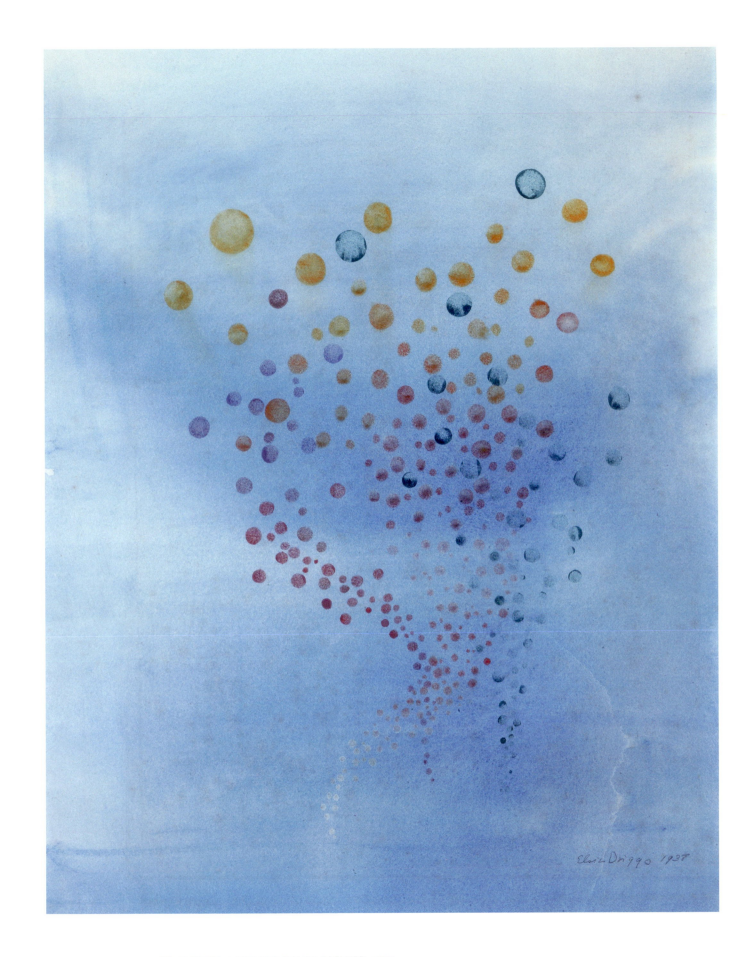

35. I TASTE A LIQUOR NEVER BREWED, 1938
 Watercolor on paper
 14 ½ x 11 inches
 Collection of Peter Franko

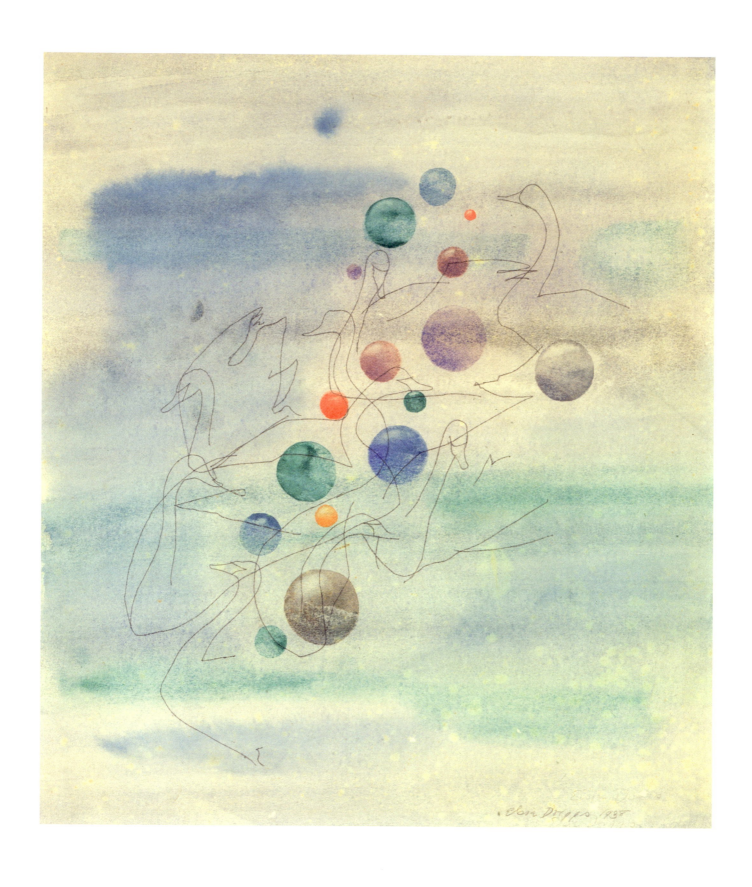

36. BALLOONS, 1938
 Watercolor and pencil on paper
 11 x 13 inches
 Private collection

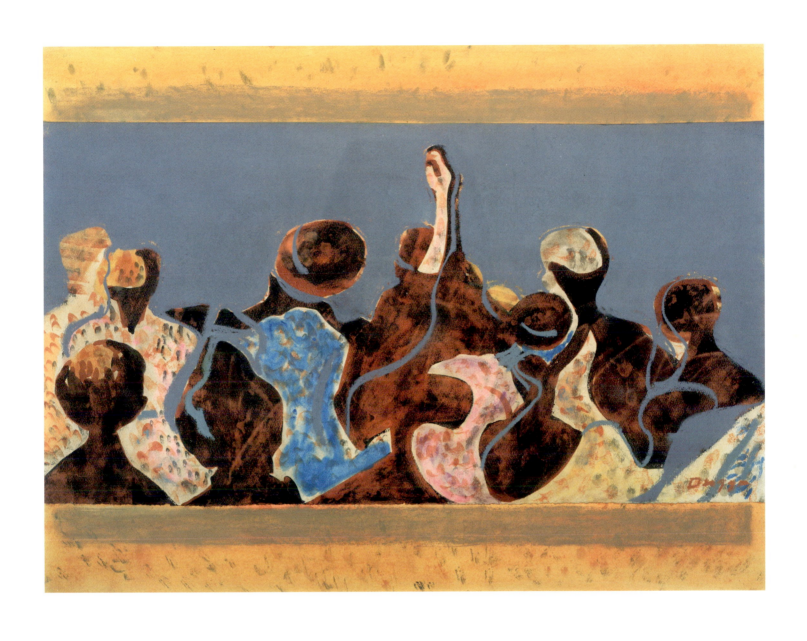

37. AT THE RACES, n.d.
 Watercolor and pastel on paper
 15 ⅝ x 24 inches
 The Phillips Collection, Washington, D.C.

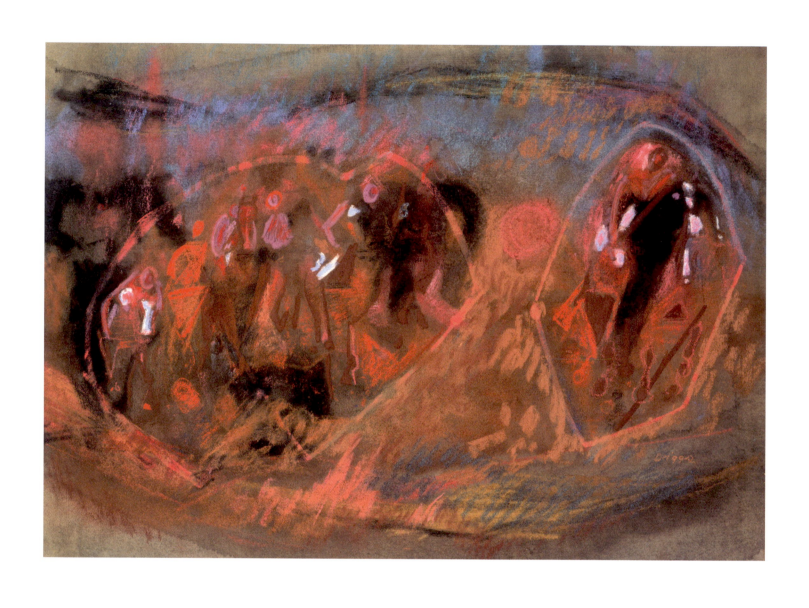

38. BIRDS, n.d.
 Watercolor and pastel on paper
 17 x 23 inches
 Collection of Martin and Judy Stogniew

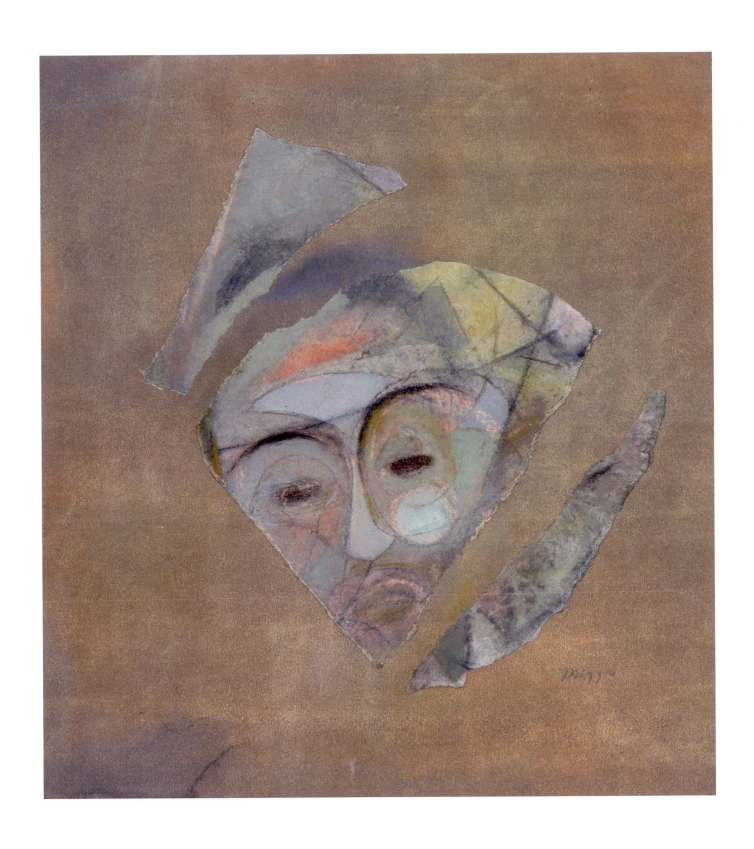

39. HARLEQUIN, ca. 1940
 Watercolor and pastel collage
 15 x 13 inches
 Collection of Merriman Gatch

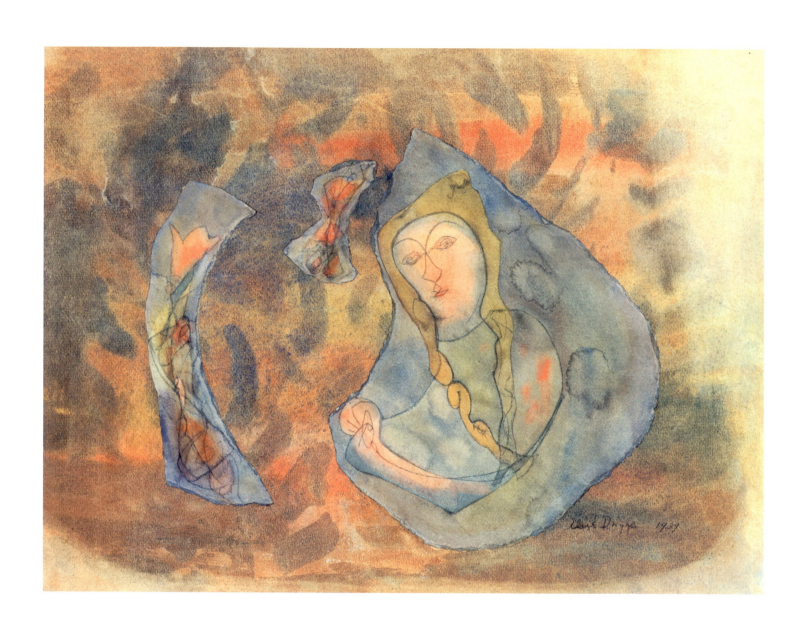

40. FROM FAUST, 1939
 Watercolor collage
 15 x 20 inches
 Collection of Martin and Judy Stogniew

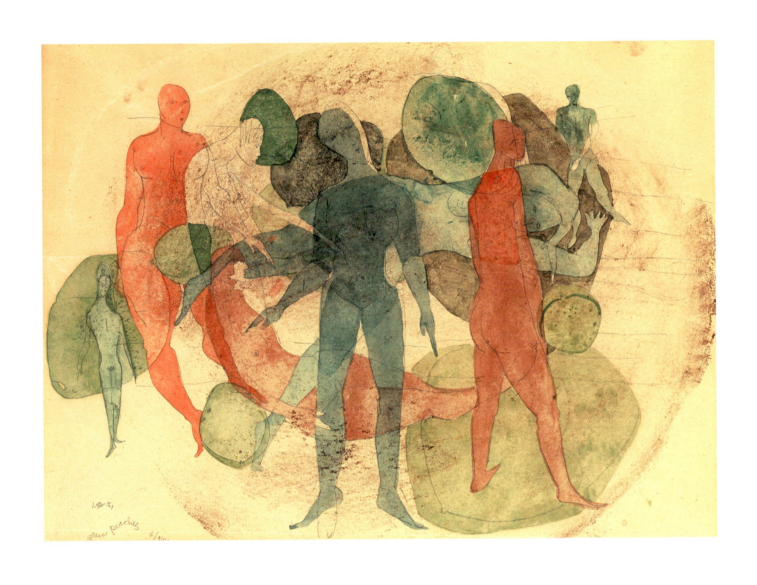

41. GREEN PEACHES, June 9, 1951
 Watercolor and pencil on paper
 8 x 10 inches
 Collection of Martin and Judy Stogniew

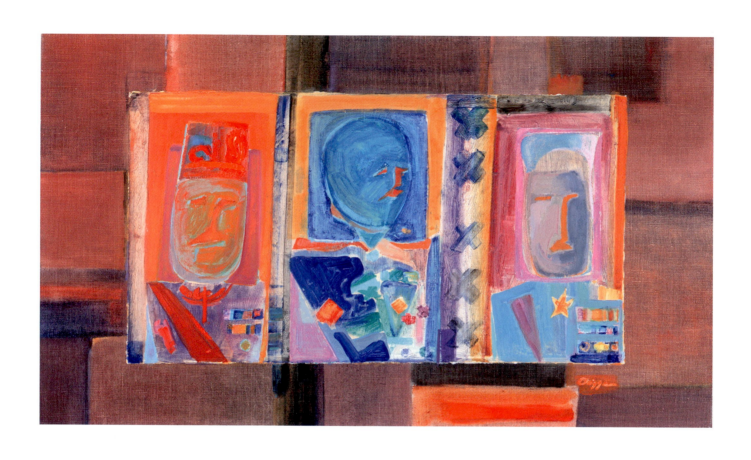

42. UNUSUAL POSTAGE, n.d.
Oil on canvas
19 ¾ x 33 ¾ inches
The Baltimore Museum of Art:
Edward Joseph Gallagher III Memorial Collection BMA 1959.14

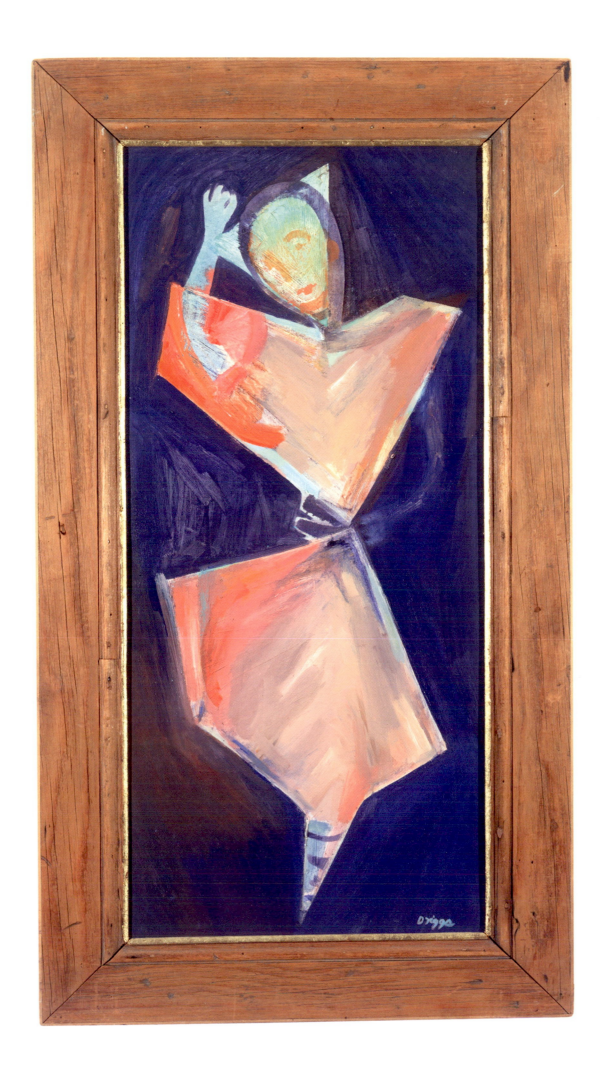

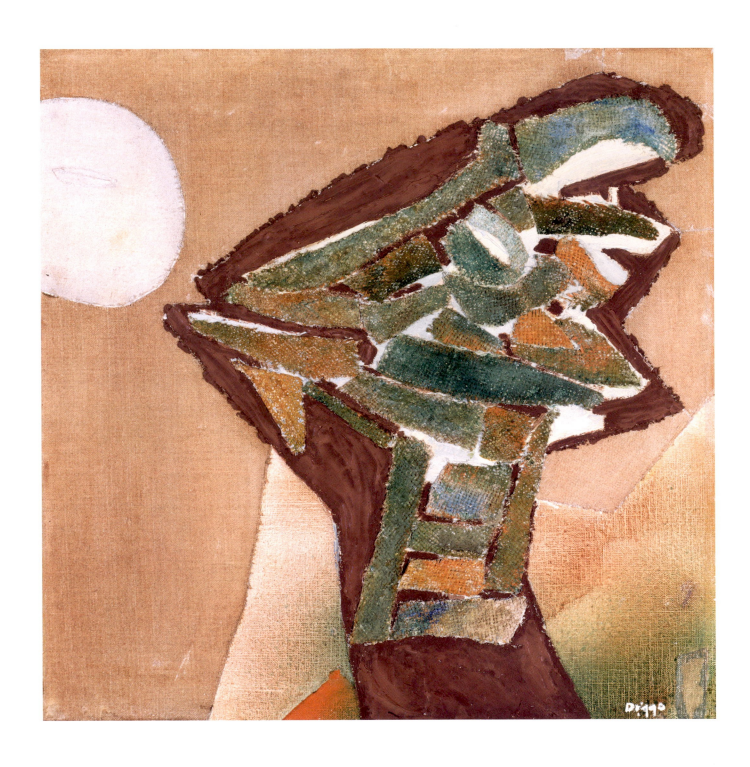

opposite:

43. DANCER, ca. 1953
 Oil on canvas
 30 x 14 inches
 Private collection
 Frame crafted by Lee Gatch

44. MOONSTRUCK GOAT, 1957
 Oil on canvas collage
 16 x 16 inches
 James A. Michener Art Museum.
 Museum purchase funded by Agnes and Robert Hagan

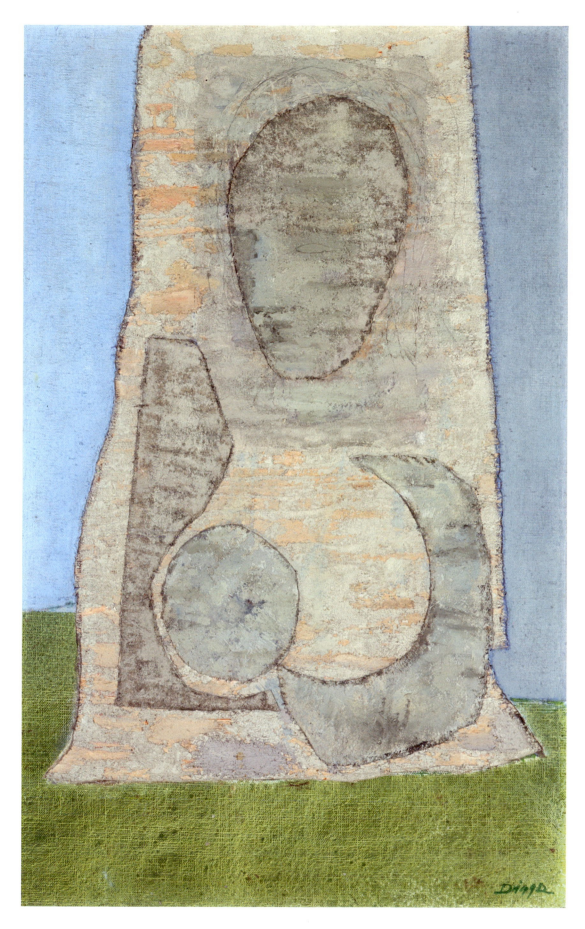

45. BIRCH IMAGE, 1957
 Oil on canvas collage
 20 x 13 inches
 Collection of Mary Lou and Andrew Abruzzese

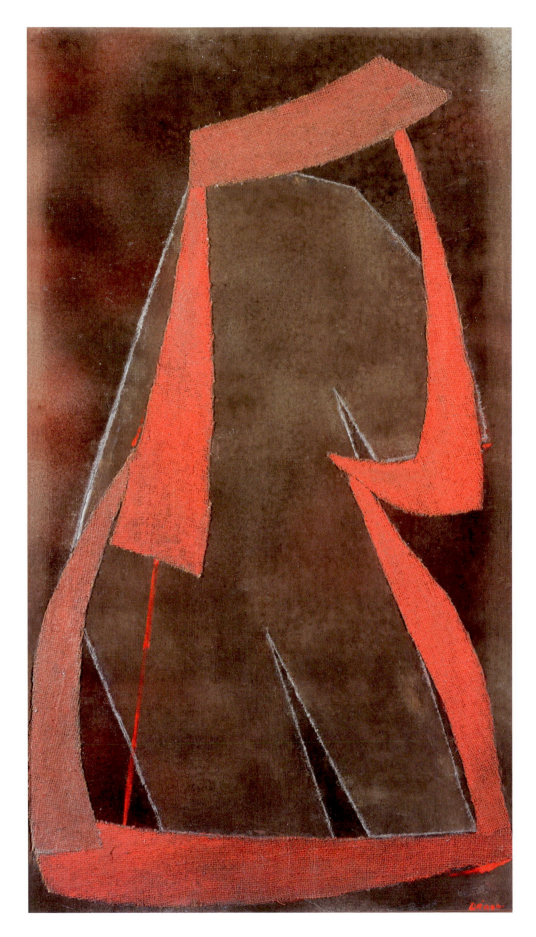

46. CANVAS COLLAGE, n.d.
 Oil on canvas collage
 35 x 19 inches
 Collection of Martin and Judy Stogniew

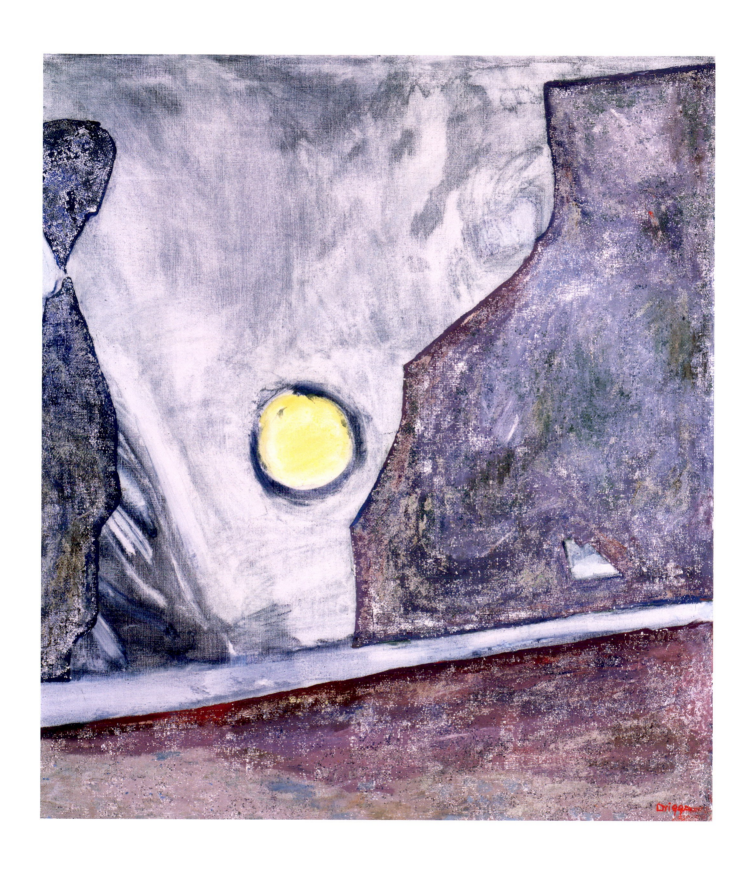

47. THE SAGE, ca. 1964
 Oil on canvas
 40 x 35 inches
 James A. Michener Art Museum.
 Museum purchase funded by Agnes and Robert Hagan

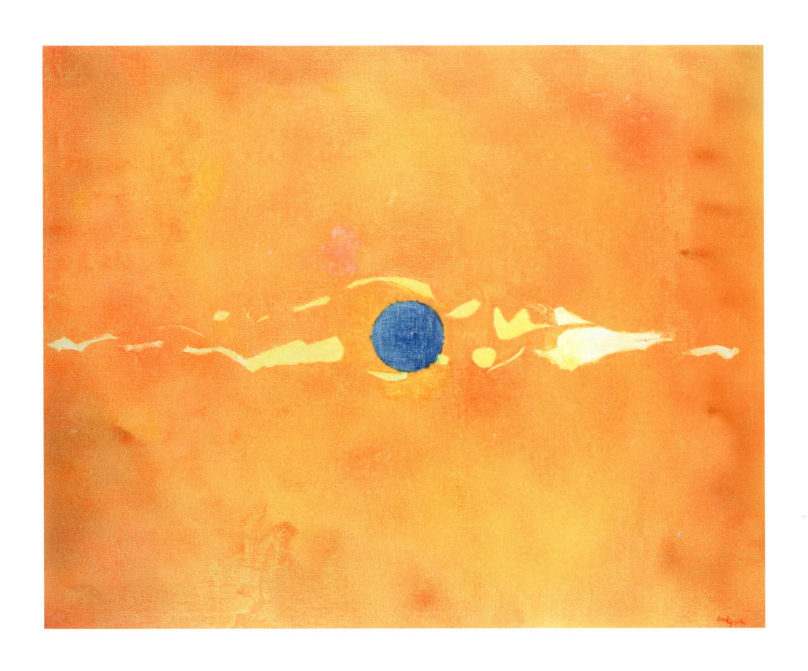

48. CALLIGRAPHY, ca. 1965
 Oil on canvas
 36 x 43 inches
 Collection of Martin and Judy Stogniew

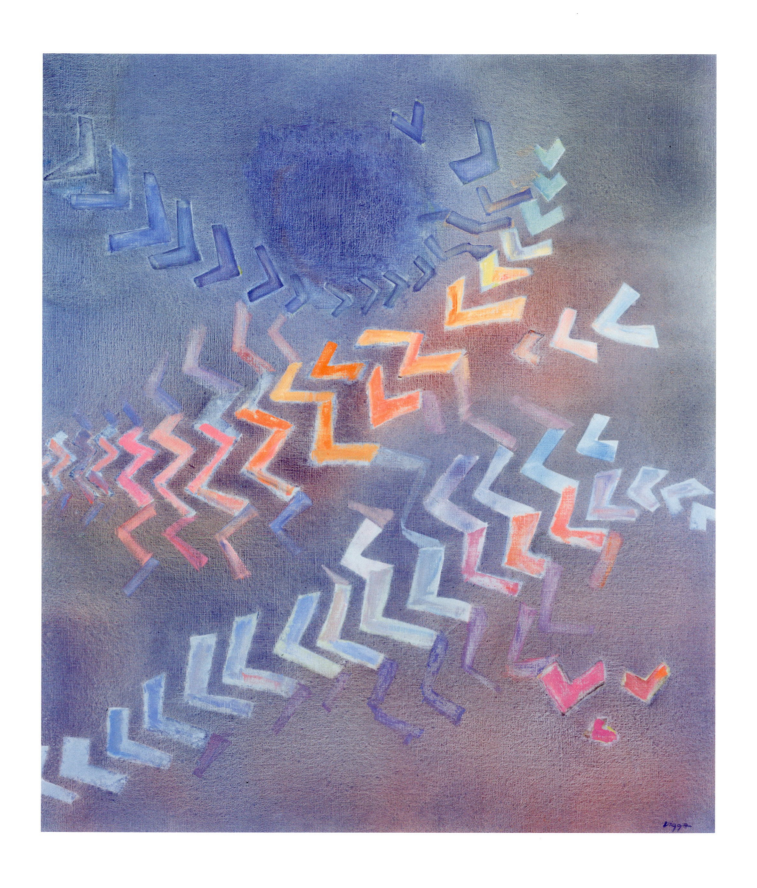

49. HERRINGBONE SKY, 1965
 Oil on canvas
 41 x 36 inches
 Collection of Martin and Judy Stogniew

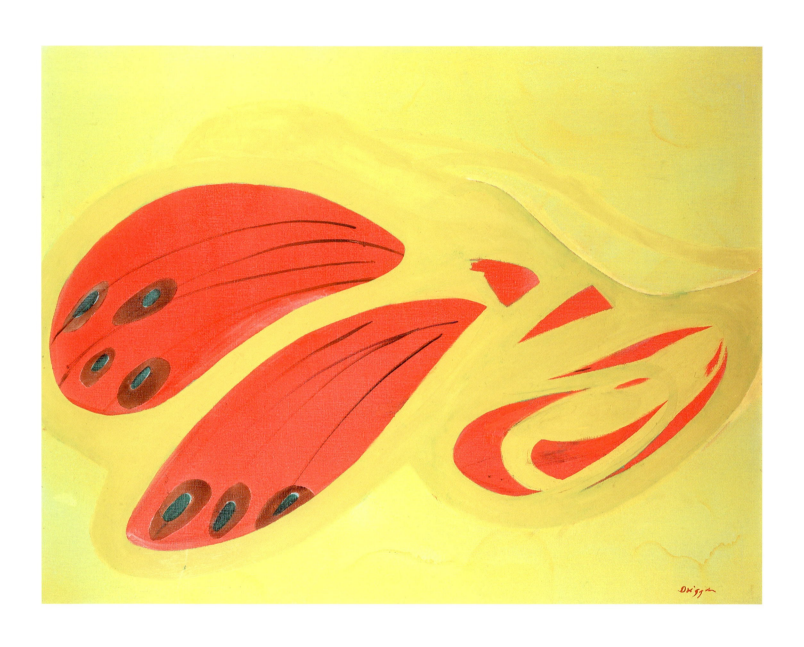

50. DEITY II, ca. 1965
 Oil on canvas
 36 x 46 inches
 Collection of Martin and Judy Stogniew

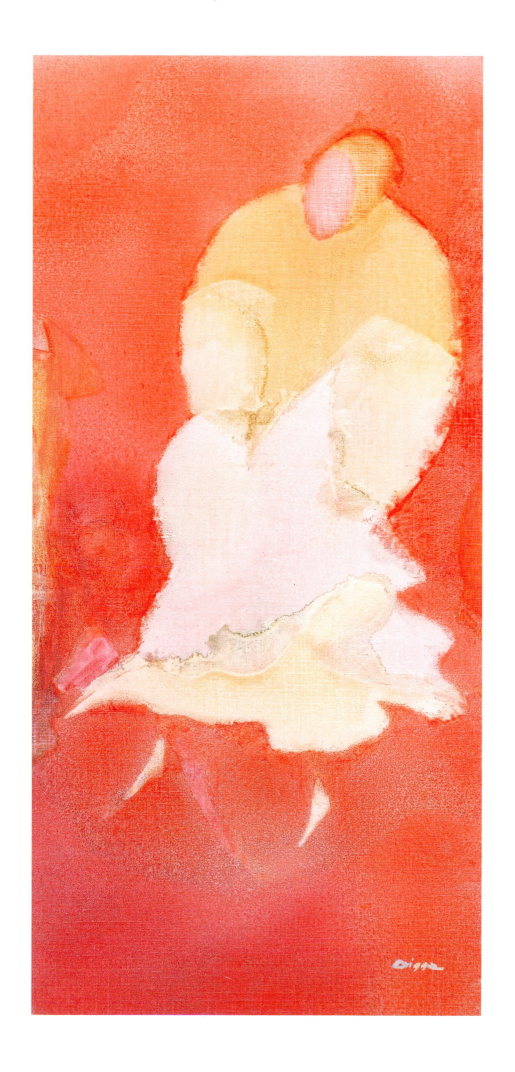

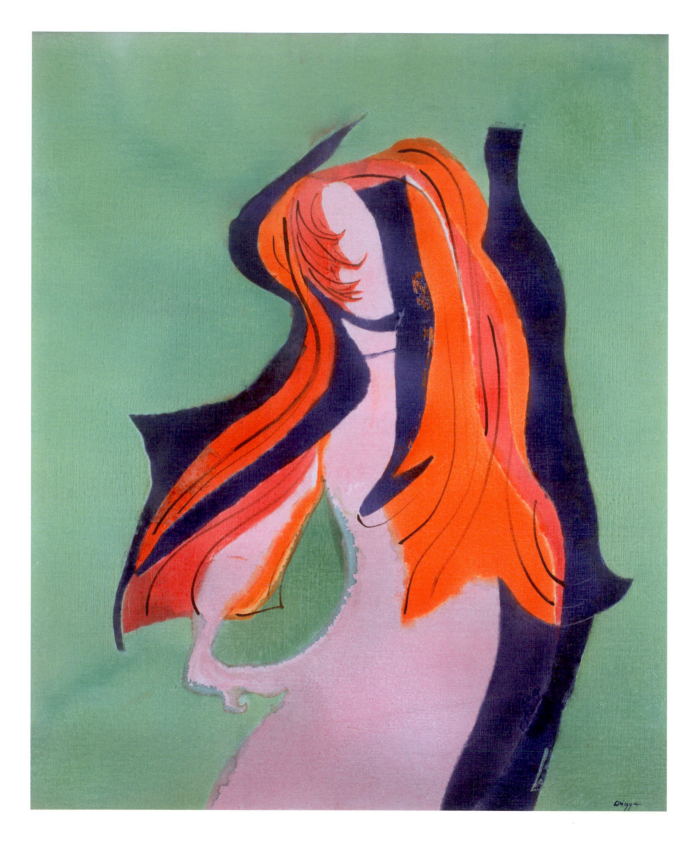

opposite:

51. SHE DANCES, 1968
 Oil on canvas
 33 x 37 inches
 James A. Michener Art Museum.
 Museum purchase funded by Agnes and Robert Hagan

52. MOD, 1969
 Oil on canvas
 43 x 36 inches
 Private collection

53. WOMAN WITH A PINK, 1968
 Oil on canvas
 33 x 37 inches
 Collection of Marcy and Michael Monheit

opposite:

54. PASSENGER FIGURE, ca. 1970
 Oil on canvas
 36 x 21 inches
 Collection of Martin and Judy Stogniew

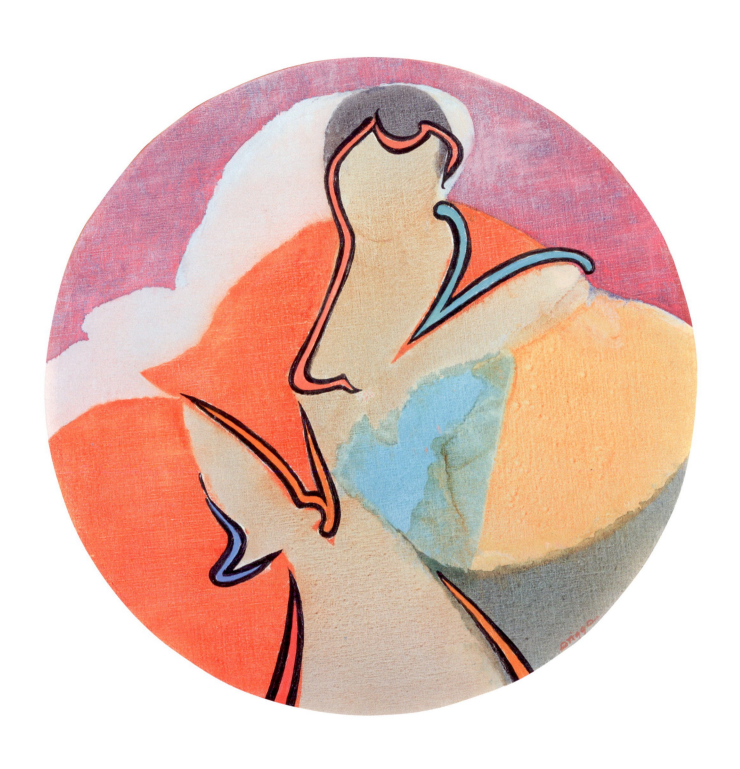

55. MADAME RIVIÈRE—AFTER INGRES, n.d.
 Oil on canvas
 24 inches diameter
 Collection of Martin and Judy Stogniew

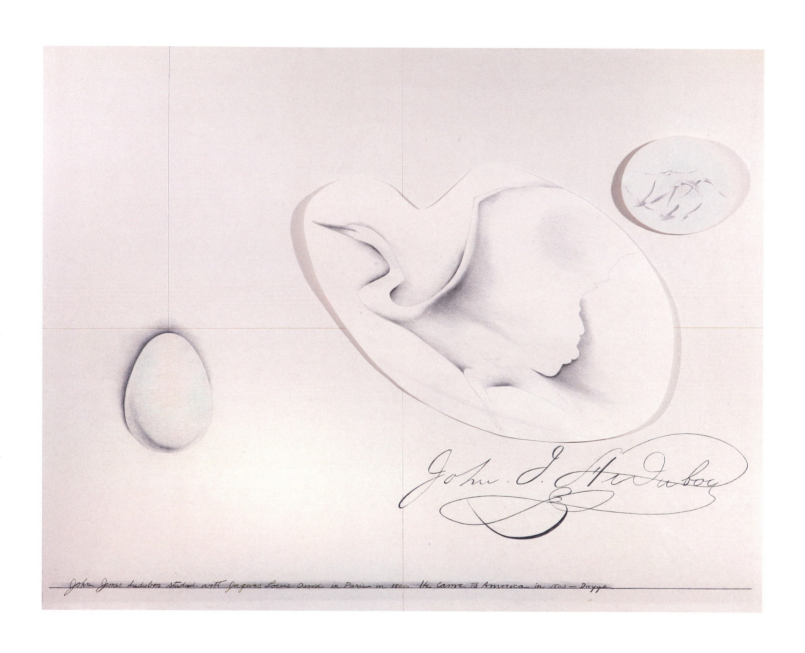

56. AUDUBON, ca. 1978
 Standing collage: graphite and crayon on handmade paper
 33 7/8 x 43 1/16 inches
 Collection of Merriman Gatch

57. ODALISQUE, 1975
Graphite on paper
18 x 24 inches
Private collection

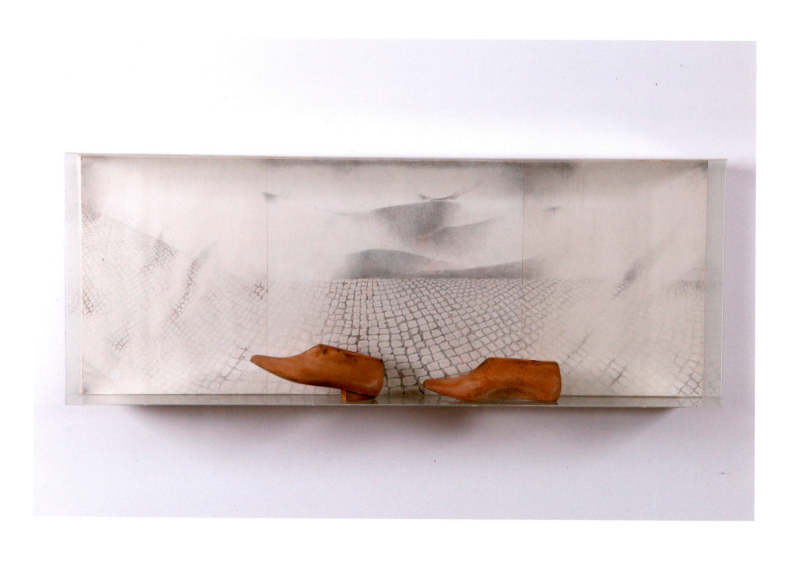

58. COBBLES, 1979
Graphite on paper drawing and assemblage
18 ¼ x 48 ¼ x 5 ¾ inches
Collection of Robert and Jan Anderson

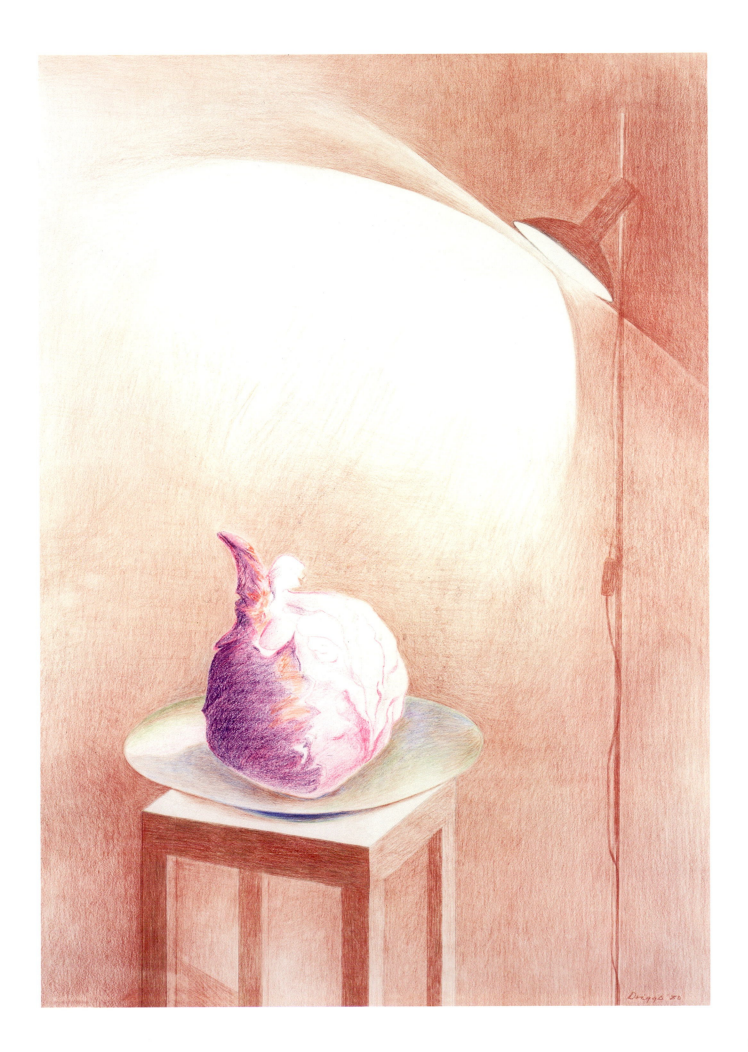

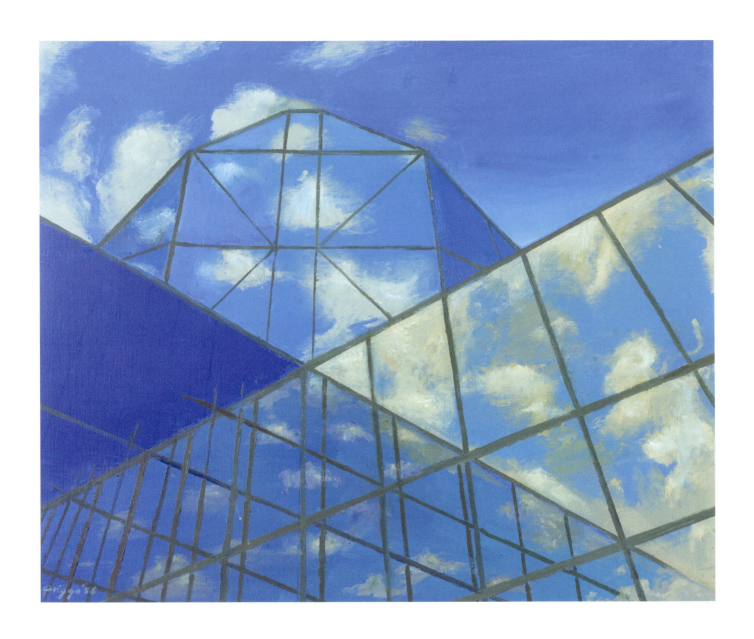

opposite:

59. THE RED CABBAGE, 1980
 Conté crayon on paper
 30 x 26 inches
 Private collection

60. THE JAVITS CENTER, 1986
 Oil on canvas
 25 x 30 inches
 Private collection

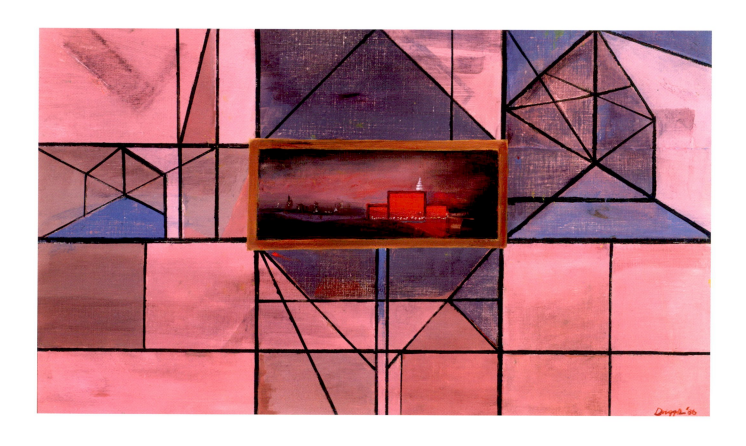

61. THE JAVITS CENTER ABSTRACTED, 1986
 Oil on canvas
 22 x 38 inches
 James A. Michener Art Museum. Michener Art Endowment Challenge.
 Gift of Ms. Merriman Gatch

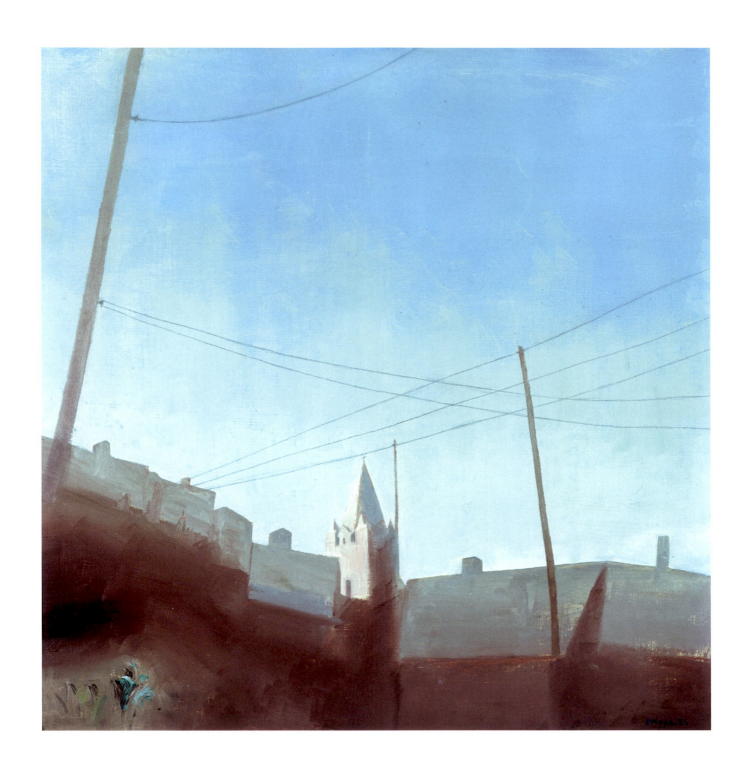

62. HOBOKEN, 1986
Oil on canvas
30 x 30 inches
Private collection

CHRONOLOGY

1898 Born August 5 in a farmhouse in Hartford, Connecticut.

1903 Driggs family moves from Central Park West in New York City to Philadelphia.

1904 Driggs family moves to Sharon, Pennsylvania, where Elsie's father, Louis, works as an engineer in a steel company.

1907 Driggs family moves to New Rochelle, New York.

1914 Elsie and her sister, Elizabeth, take painting lessons with George Glenn Newell on Saturdays while attending New Rochelle Public High School. Summer: Elsie and Elizabeth study with George Glenn Newell on a farm in Dover Plains, New York.

ca. 1915 Elsie and Elizabeth study nursing at the New York Post Graduate Medical School and Hospital.

1916 Elsie and Elizabeth travel to Santa Fe, New Mexico, to paint the desert landscape.

1918 Creates her first plant-form paintings: *Lilacs* and *Leaf Forms*.

1918–22 Attends the Art Students League, New York, where she studies with Frank Vincent DuMond, George B. Bridgman, George Luks, Robert Henri, and Maurice Sterne. Studies privately with John Sloan but continues living at home in New Rochelle.

1922–23 Travels with other female classmates of Maurice Sterne to Italy, where she studies in Rome, Arezzo, Florence, and Anticoli Corrado. Meets Leo Stein and sees the frescoes of Piero della Francesca in Arezzo.

1923 Paints *Chou* and *Italian Vineyard* while staying in Anticoli Corrado.

1924 Returns to the United States. February: Exhibits *Chou* in a group show at the Daniel Gallery, New York, where critic Forbes Watson singles it out as one of the most sensitive works in the show. Begins copying art at the Metropolitan Museum of Art and works as a slide assistant in the museum's lecture department.

1924–29 Exhibits regularly at group shows held at the Daniel Gallery and receives positive reviews from Forbes Watson, Margaret Breuning, Murdoch Pemberton, and Henry McBride.

1926 Ferdinand Howald purchases *Cineraria* (pastel, ca. 1926) and subsequently donates it to the Columbus Museum of Art. Exhibits *Deer* at Eleventh Annual Exhibition of Paintings and Sculpture of the Whitney Studio Club at Anderson Galleries, New York. December: Visits the Jones and Laughlin steel mills in Pittsburgh and returns to New Rochelle to paint *Pittsburgh*, her first major precisionist work of a steel mill she had seen as a girl.

1927 Finishes *Pittsburgh* and *Blast Furnaces*, an industrial scene that combines forms of the blast furnaces she had seen on her trip to Pittsburgh. Paints *Queensborough Bridge*. Exhibits *Cabbage* at Twelfth Annual Exhibition of Paintings and Sculpture of the Whitney Studio Club.

1928 Travels to Cleveland, where she takes her first plane ride from Cleveland to Detroit. Visits the Ford River Rouge plant and sketches new planes in their hangar as well as the plant's coke and coal conveyors. Returns to New Rochelle and creates *Aeroplane* and *River Rouge Plant*. Edward W. Root purchases *Cineraria* (pastel, 1925) and *Hydrangeas* (pastel, 1925) from the Daniel Gallery and donates them to the Munson-Williams-Proctor Arts Institute.

1929 Gertrude Vanderbilt Whitney purchases *Pittsburgh* at Driggs's first solo exhibition at the Daniel Gallery (November 18–December 14). *River Rouge Plant* is destroyed in a railcar fire while being returned from an exhibition at the Cleveland Museum of Art.

1930 Work is exhibited at Museum of Modern Art's *Forty-six Painters and Sculptors Under Thirty-five* (April 11–27) and the Cincinnati Art Museum Annual. Stephen C. Clark donates one of Driggs's still life pastels to the Yale University Art

Gallery. Paul Klee's work is exhibited at the Museum of Modern Art in a show organized by J. B. Neumann and Alfred Barr.

1931–32 *Pittsburgh* is included in opening exhibition of the Whitney Museum of American Art, New York.

1932 *Leaves* is included in Whitney Museum of American Art's *Watercolors, Drawings, Prints from the Permanent Collection* (January 5–February 4).

1932–35 Daniel Gallery closes in 1932 and Driggs is represented by New Art Circle, a New York City gallery operated by J. B. Neumann.

1933 Meets future husband, abstract painter Lee Gatch (1902–1968), at a tea honoring Georg Grosz at the New Art Circle.

1934 Participates in First Municipal Art Exhibition at Rockefeller Center.

1935 February: Solo exhibition at Frank K. M. Rehn Galleries, New York. May: Receives Grant Award for illustrations of Colonel T. E. Lawrence's *The Odyssey* from the New Rochelle Art Association's Annual Illustrators Exhibition. Summer: Receives fellowship to study at Yaddo, an artists' community in Saratoga Springs, New York. December: Marries Lee Gatch.

ca. 1935–40 Writes and creates illustrations for *Benji-Ben-Ali-Bengal*, a children's short story.

1936 Settles in an apartment at West Ninth Street for the next two winters. Creates mural for nursery wall in Harlem River Houses for Treasury Relief Art Project in New York.

1936–37 Spends summer of 1936 in a New Hope, Pennsylvania, farmhouse rented from Harry Worthington (previously the home of Pennsylvania impressionist Robert Spencer). Returns to New Hope in summer of 1937 to live in a house on Eagle Road on Jericho Mountain. Lee and Elsie purchase a stone house in Lambertville, New Jersey, where they live for the next thirty-one years.

1938 Elsie and Lee's only child, Merriman, is born. March: Solo exhibition at Frank K. M. Rehn Galleries. Obtains a copy of Emily Dickinson's poetry and creates watercolors inspired by Dickinson's verse.

1939 Creates a mural for the Rayville, Louisiana, post office, commissioned by the U.S. Treasury Department. Begins creating watercolor and pastel collages. Exhibits at the Eighteenth International Watercolor Exhibition of the Art Institute of Chicago.

1944 Exhibits at the Fifty-fifth Annual American Exhibition, Watercolors and Drawings, of the Art Institute of Chicago.

1947–48 Lives in New York City with daughter, Merriman. Teaches at the Hewitt School, a private high school for young women on Seventy-ninth Street.

1948 January–February: Solo exhibition at Artists Gallery, New York.

1952–53 Exhibits in the Metropolitan Museum of Art's juried show *American Watercolors, Drawings, and Prints*.

1953 April–May: Solo exhibition at Frank K. M. Rehn Galleries.

1960 November–December: Exhibits in *The Precisionist View in American Art* show at the Walker Art Center, Minneapolis. Exhibition travels to Whitney Museum of American Art, New York; the Detroit Institute of Arts; Los Angeles County Museum of Art; San Francisco Museum of Art.

Early 1960s The Gatches add an extension to their Lambertville house and Elsie gains her own studio.

1964 Exhibits in *An Exhibition of American Watercolors* at Robert Schoelkopf, New York.

1968 Begins a series of figurative abstract oil studies of women, using watercolor techniques. November: Lee Gatch dies.

1969 Moves to New York City.

1971 February: Solo exhibition at La Boetie, New

York, includes oils, watercolors, collages, and standing drawings.

1977 March–April: Work is included in *Lines of Power* at Hirschl and Adler Galleries, New York. June–July: Work is shown in *American Collage* at Davis and Long Company, New York. August–September: Work is included in *The Modern Spirit: American Painting 1908–1935* at the Royal Scottish Academy in Edinburgh. Exhibition travels to Hayward Gallery, London.

1977–78 Work is shown in *American Art 1920–1945*, Whitney Museum of American Art.

1978 July–August: Work is included in *The Precisionist Painters 1916–1949: Interpretations of a Mechanical Age* at the Heckscher Museum, Huntington, New York.

late 1970s Writes "The Search for Piero della Francesca." Begins creating assemblages in shadow boxes that include crayon drawings of classical architectural features and actual shoe forms.

1980 May: Solo exhibition at Martin Diamond Fine Arts, New York.

1980–81 November–December: Work is shown in *America—Traum und Depression 1920/40* at Akademie der Künst, West Berlin. Exhibition travels to Kunsteverein, Hamburg.

1981–82 November–February: Work is included in Jersey City Museum Invitational, New Jersey.

1982 February 25: Receives National Lifetime Achievement Award from the Women's Caucus for Art, an affiliate society of the College Art Association, New York City.

1982–83 September–November: Work is included in *Images of America: Precisionist Painting and Photography* at the San Francisco Museum of Modern Art. Exhibition travels to Saint Louis Art Museum; Baltimore Museum of Art; Des Moines Art Center; Cleveland Museum of Art.

1983 November–December: Work is included in *Three American Modernists* at Martin Diamond Fine Arts.

1988 April–May: Work is included in *Visions of Tomorrow: New York, 1920s and 30s* at Isetan Museum of Art, Tokyo, Japan. Exhibition travels to Daimaru Museum, Osaka; Fukuoka Prefecture Museum of Art, Fukuoka; Tochigi Prefectural Museum of Fine Arts, Utsunomiya.

1990–91 October–January: Solo exhibition at the New Jersey State Museum, Trenton, New Jersey. Exhibition travels to the Phillips Collection, Washington, D.C.

1992 Dies July 12.

Remembering Elsie

Thomas C. Folk

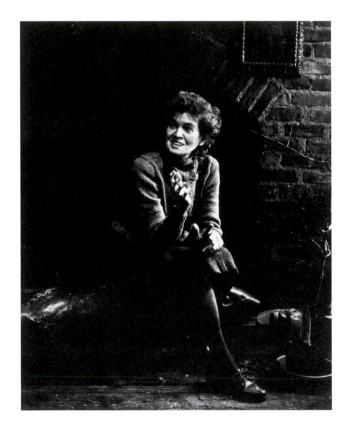

Elsie Driggs, 1980
Courtesy of Thomas C. Folk

KNOWING ELSIE DRIGGS WAS AN EXPERIENCE that I will always treasure. She was the kind of artist that historians dream about. She was easy to get along with and was always a friend, warm and inviting. She did not have a huge ego—she was grounded and down to earth. She was enthusiastic about all kinds of art, from Roman graffiti to the New York graffiti movement of the 1980s. But her favorite artist was her husband, Lee Gatch, whom she publicly described as "one of the greatest artists that ever hit this country."[1] Her love of art was infectious. It kept her going through adverse times: through the Depression, when her family lost its wealth and her dealer Charles Daniel permanently closed his doors, to the loss of her husband in 1968. There were periods when she was largely forgotten as well as periods of triumph, when her work was praised by critics like Murdoch Pemberton, who wrote: "Miss Driggs has a fine sensitivity and there are many who believe that she ranks among the first in this land."[2]

I first contacted Elsie in 1985 when I was completing my dissertation on the Pennsylvania impressionists with my mentor, William Gerdts, at City University of New York. Driggs was by then one of the few surviving artists who could remember the New Hope art colony from the 1930s on. I recall our first meeting at her home in Chelsea. Elsie was a likeable and honest artist who told it like it was. Although she was eighty-seven years old, she was still attractive. There was a resemblance to Katharine Hepburn that can in fact be seen in early photographs. I had the pleasure of meeting Elsie's daughter, Merriman, who lived with her. Merriman is an actress and an artistic spirit like her mother. Elsie's memory was lucid, and the hours rapidly passed. However, Elsie did not know much about the Pennsylvania impressionists, as she and her husband, the painter Lee Gatch, had avoided them. They were both established in the New York art world and were not interested in becoming local art figures. (More about the Lambertville years later.)

I got to know Elsie better during my research for her 1990–91 retrospective at the New Jersey State

Museum and at the Phillips Collection in Washington, D.C.[3] By that time I was working on a master's degree at New York University in Greenwich Village, which was close to Elsie's apartment in Chelsea. It is a charming place, and Merriman still lives there. I visited Elsie almost weekly. Among the few letters I have from Elsie, of particular interest is her vivid description of a 1987 robbery at her apartment, which she fortunately missed, that had left her more excited than upset. She wrote:

> Two hours earlier two men came into our building, grabbed a trash bag full of garbage, hauled it upstairs, broke two locks in our apartment, emptied the garbage on the floor and made off with the TV set and the VCR , ridiculously picked up a blow hairdryer (I suppose for the girlfriend), then went into the front bedroom, ripped up the bed, dumped out the contents of the bureau drawers and found nothing they wanted. They were in such a wild rush they never looked behind them, where there was a new radio a friend had given Merry, and a new radio she had bought as a gift for a little boy.[4]

While working on the retrospective catalogue essay, I became very interested in the machine age and in the precisionists. Elsie's most famous precisionist work is *Pittsburgh* (1927; cat. 1). At that time Elsie was part of the Daniel Gallery, the leading showplace for the precisionists in the 1920s. Other artists included Charles Demuth, Charles Sheeler, Preston Dickinson, and Niles Spencer. But as Elsie stated several times, seldom did these artists know each other. Driggs did meet Spencer in the summer of 1927 in Provincetown, Massachusetts, but she never met the two giants of the movement, Sheeler or Demuth. She jokingly said it was a weird movement, where the artists never formally met, not even at the gallery that exhibited their work. No doubt precisionism and the machine age were "in the air," as she would say.

Elsie's role in precisionism is important, because the artists who exhibited at the Daniel Gallery in the 1920s were the seminal figures in the movement.

Many other precisionists, like Ralston Crawford and Louis Lozowick, as significant as they are, came on the American art scene in the 1930s after Elsie had unfortunately abandoned the style. According to Elsie, "Arshile Gorky talked my ear off trying to get me to go back to such paintings as 'Pittsburgh' and you know how many times he changed his course!"[5] Sadly, Gorky's advice to Elsie was right!

Elsie spoke more about *Pittsburgh* than any other of her paintings. Throughout her precisionist period, she was unmarried and living with her parents in New Rochelle, New York. She came from a wealthy family. Interestingly, her father had designed a gun as well as designs for the steel industry; machine-age images would haunt her mind. I thought of the art of Joseph Stella, the American futurist painter, whose industrial, New York City, and Brooklyn Bridge images appeared in the late teens and would be an obvious influence on her as well as on the other precisionists, all of whom developed a bit later. Did she know Stella's work? Yes, but he was not an influence. In fact, according to Elsie, modern art—European or American—was not the major inspiration for her precisionist works. Instead, it was the old masters—particularly the work of fifteenth-century Italians like Piero della Francesca—who had the greatest impact on her precisionist works and particularly on her *Pittsburgh*.

Elsie had studied at the Art Students League in New York City from 1918 until 1922. Her teachers included George Bridgman and Frank Vincent DuMond, who were more traditional in their approach, as well as the more radical painters Robert Henri, John Sloan, and George Luks, who rocked the New York art world in 1908 with their scenes of urban realism in an exhibition at the Macbeth Gallery. Although Elsie became close to Henri, Sloan, and Luks, the Art Students League teacher who would have the greatest effect on her was Maurice Sterne. She spent her last classes at the league working exclusively with Sterne and Henri. Sterne's art reflected the influence of Paul Cézanne, in whose work Driggs became most interested.

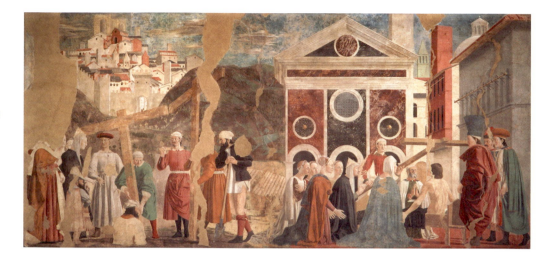

Piero della Francesca, *Finding of the Three Crosses and the Verification of the True Cross*. From the *Legend of the True Cross*, ca. 1450–65, fresco. Prerestoration. San Francesco, Arezzo, Italy. Licensed by Scala / Art Resource, N.Y.

From late 1922 to early 1923, Driggs and a class of other young women studying at the league accompanied Sterne to Italy. In Rome Elsie met Leo Stein and his wife, Nina, who were also staying at the Santa Chiara Hotel. Stein was the brother of Gertrude Stein, and both were noted for their support of modern masters. Through the tutelage of the connoisseur and scholar Bernard Berenson, Leo Stein had become interested in Italian old masters. Elsie had been interested in Cézanne, but from this point she shifted to Piero della Francesca. She traveled to Arezzo to see the fifteenth-century master's fresco the *Legend of the True Cross* in the church of San Francesco. The mural depicts Saint Helena, the mother of Constantine, in the Holy Land, rediscovering the three crosses from Calvary. Significantly, other major modernists, such as Georges Seurat and Charles Sheeler, were also influenced by Piero's frozen, monumental figures. Elsie wrote, "The talk was of Piero della Francesca. It was not just enthusiasm. It was a cult."[6]

After her return to New York in early 1924, Elsie continued to live with her parents in New Rochelle but began to work at the Metropolitan Museum of Art in the lecture department and as a copyist. This led to spending more time studying the old masters. Elsie was proud of her essay "The Search for Piero della Francesca" that she created for a writing class at New York University. She kept an old photograph of a detail of women's heads from Piero's mural the *Legend of the True Cross*.[7]

One of the paintings Driggs copied at the Metropolitan was Hans Memling's *Portrait of Maria Portinari*. Memling was Netherlandish, not Italian, but he was also from the fifteenth century, and his Maria has a solemn and pious character, much like Piero's figures. Regarding this copy (now lost), Elsie wrote, "At that time I did not know that when I painted the veil from Maria's hat, I was learning how to paint the steam in my Precisionist painting, 'Pittsburgh.' "[8]

In 1927 the brooding, frozen and monumental figures of Piero became the powerful smokestacks of Elsie's *Pittsburgh*. If Elsie's western Pennsylvania factory was based on a religious mural, it is not surprising. In the machine age, the factory was seen as the new church. Elsie cited D. H. Lawrence: "Since churches are all museum stuff, since industry is our business, now then let us make our places of industry our art . . . Art should interpret industry as art once interpreted religion."[9]

Elsie created only five major precisionist works. The Depression, which bankrupted her family, and the closing of the Daniel Gallery in 1932 had a profound effect on her. Some thought the change came as a result of her marriage to painter Lee Gatch, whom she met in 1933 and married in 1935. But her final precisionist painting, *Saint Bartholomew's Church* (cat. 25), was created in 1929, the year of the crash.

During the summer of 1936, Gatch and Driggs rented a car and visited Lambertville, New Jersey, and New Hope, Pennsylvania. On their first night there, they stayed at the Lambertville House (still in business today). Then they decided to rent Rabbit Run in New Hope for the summer. Unknown to them, this had been the home of the impressionist painter Robert Spencer, who had committed suicide there in 1931. They spent the following summer at nearby Jericho Mountain and subsequently purchased Coon Path in Lambertville,

a three-room farmhouse with an outdoor privy. Originally occupied by stonecutters, it had been left abandoned for several years. Elsie had come from a wealthy family, and she had difficulty acclimating to her surroundings. Conditions were primitive, and at first the couple had to carry water in buckets from a nearby brook. Lee was most influenced by the rugged beauty of the area, but Elsie often told me that she "felt like an Indian." She would paint watercolors on the kitchen table for the Works Progress Administration while Lee used the studio. Elsie and Lee each produced a post office mural for the WPA. Elsie's was titled *La Salle's Quest for the Mississippi* (1939; fig. 26), which she executed for the post office in Rayville, Louisiana. Husband and wife helped each other in painting both murals, working on the floor of the Lambertville Station, a picturesque building originally designed by Thomas Walter, the architect of the dome of the U.S. Capitol. Merriman, their daughter and only child, was born in 1938.

One day in 1940, Merriman was playing with watercolors and began to rip paper and to paint the pieces. From this Elsie got the idea to do watercolor collages, which became a major focus of her work. She then began to create canvas collages, where she would attach cutout pieces of canvas to a canvas and paint over them. This idea was picked up by Lee, who began to incorporate the same process in both his paintings and his frames. (In contrast, Elsie really did not pay much attention to her frames.) The collage technique would eventually lead to Lee's final, monumental stone collages. Elsie's career faded in Lambertville, although I feel that her collage pieces from the 1940s represent some of her finest work, and I now regret that I did not pay more attention to them in my exhibition essay.

Lee Gatch had several important exhibitions, and he developed a national reputation that ironically began to fade after his death. The Lambertville style for both artists was expressionist, with bold, loosely painted abstract forms; although Elsie was more cerebral and Lee, more emotional. But at this time, their art was closely related. Lee became regarded as a major precursor of abstract expres-

sionism. Elsie rarely exhibited her paintings in the forties and fifties. The focus was on Lee, and she was largely forgotten.[10]

Elsie always felt isolated in Lambertville and did not socialize with other artists. Lee would meet other local modernists, such as Charles F. Ramsey, Charles Evans, and Louis Stone, at Ledger's Inn in Lambertville. Elsie, who did not feel comfortable with male drinking company, stayed at home.

I was fortunate to have Peggy Lewis as editor for my catalogue essay on Driggs. She had lived in the area, had been a significant figure in local art circles, and knew Elsie and Lee quite well. She told me things that Elsie deliberately avoided mentioning. Elsie never had a negative comment about her husband. But Lee was a heavy drinker and, while there were times when he was social and approachable, there were other times when he was hostile to Elsie and Merriman. Today we might consider him to be bipolar because of his wide mood swings. Elsie could have divorced him, but she struggled through a toxic marriage that, according to Merriman, had become platonic.[11] What Elsie and Lee had in common was a love of art that got them through difficult times. Elsie's great admiration for Lee's art led her to forge on. Even in light of a difficult marriage, Elsie's Lambertville work was often whimsical, never somber, and she employed brilliant colors throughout the Lambertville years. Her art came from her intuitive mind, not usually from her immediate surroundings.

Lee died suddenly on November 11, 1968. Although distraught, Elsie was free at last. She sold the Lambertville house. Merriman, a budding actress, had moved to California but returned to be with her mother and to pursue a career in New York City. They rented a series of three apartments before purchasing an apartment in Chelsea. Elsie began exhibiting again, and by the seventies she had once again changed her style. There was now a renewed interest in the precisionists; Elsie ceased to create expressionist forms and collages, drawings, and assemblages—including precisely executed Conté crayon drawings—that were at times quite linear in quality. This may be seen as a

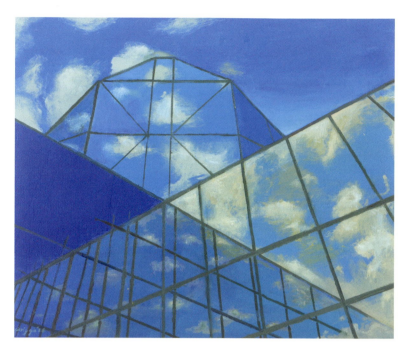

Catalogue 60
Elsie Driggs, *The Javits Center*, 1986

subconscious reaction against Lee, or perhaps she was again relating to "changes in the air," as she would say. In fact, the seventies saw a major return to realism in the art of Richard Estes, Audrey Flack, and Duane Hanson.

In the spring of 1980, Marty Diamond, an art dealer in New York City, mounted a retrospective exhibition of Elsie's work that included both early and new pieces. Once again Elsie came to the attention of art scholars, collectors, and museum curators. Diamond's exhibition brought her for the first time into art historical focus. (Interestingly, Diamond was noted for bringing downtrodden, neglected artists, many of whom survived the Depression, to renewed public light. He said that Elsie was the only one who was not bitter.[12]

By the late eighties, Diamond began to slow down, and was not as active as an art dealer. This is where I came into the picture. Edward Nygren, curator at the Corcoran Gallery in Washington, D.C., told me that the Corcoran would be interested in my guest curating a Driggs retrospective. Elsie was thrilled. Then the Mapplethorpe controversy erupted. Nygren left the Corcoran, the director was fired, and the proposed Driggs retrospective was cancelled. Elsie was delighted that the Corcoran

dropped her show because she thought Mapplethorpe was a great artist, and she supported the integrity of this artist over middle-class, simpleminded, uninformed concepts of what good art should be. In the end the New Jersey State Museum sponsored the exhibition, and to Elsie's great joy the exhibit did travel to Washington, to the Phillips Collection in 1991.

I was responsible for commissioning two of her last major works from 1986. Rather than ask Elsie to create works whose elements recall precisionism, as she had been doing, I thought, why not ask her to simply create new works in the precisionist style? I am certain that Elsie would have never taken these on if I had not commissioned them. Her first idea was to paint the Jacob Javits Center on West Thirty-fourth Street. Designed by I. M. Pei and completed in 1986, the structure had become the leading convention center in the city and was close to Elsie's apartment. With its multifaceted glass panes, it resembled a huge diamond. Elsie went to sketch and to photograph the building with great enthusiasm. She was glad it was a new building, so that no one could confuse her *The Javits Center* (cat. 60) with one of her earlier precisionist works. She focused on a small segment, on windows that reflect a bright blue sky with passing clouds. It is a very optimistic painting.

The second painting (cat. 62) developed from an old photograph of the buildings of Hoboken, New Jersey, taken by my uncle, Anthony Nappi in the 1960s. My family came from this Italian-American town. In the background is the tower of Our Lady of Grace, at one time my family's church. I showed the old photo to Elsie, and she thought it might make a terrific painting. I took her to Hoboken, and we looked at the actual buildings. By the fifties and sixties, Hoboken had suffered from urban deterioration, but by the eighties, it was becoming gentrified, although it still retained a gritty character in certain areas. Elsie's *Hoboken* is a blue gray atmospheric work, none too optimistic—but a small green plant grows on the left, which she added to show that something can grow and survive in a difficult environment. The painting

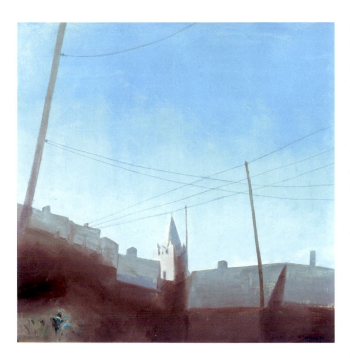

Catalogue 62
Elsie Driggs, *Hoboken*, 1986

reminded Elsie of her earlier studies in Italy, but this was now an Americanized Italy.

There was to be a third painting, depicting the Pulaski skyway, as Elsie once again wanted to produce an industrial landscape. She started it but gave up. She had the ideas but no longer had the ability to depict her ideas effectively. She was having problems with her hands. In the period of only a few months, drawing straight lines had become impossible.

The 1990 opening of her retrospective at the New Jersey State Museum, which Elsie attended, had been a simple affair. In 1991, on opening night at the Phillips, curator Eliza Rathbone asked me to interview Elsie before a large audience of museumgoers. It proved to be her final public appearance and, sadly and triumphantly, an unannounced public farewell.

Elsie had been preparing for this event. For months she had warned me that older artists have been known to pass away after their retrospectives. On the night of the opening, she was suffering from a fever, and I had symptoms of a flu. Elsie managed to pull through and to speak clearly and answer my

questions. But I was secretly surprised to find her forgetting information from my exhibition essay that she herself had provided. I attributed it to her fever and from a natural anxiety about public speaking.

After the exhibition ended, Elsie started a downhill spiral. Merriman told me that Elsie would carry the retrospective catalogue with her, and Merriman came to realize that Elsie was using the catalogue to recall her life because she was rapidly forgetting the details.

Elsie died on July 12, 1992, at St. Vincent's Hospital at the age of ninety-three. Merriman asked me to organize a memorial, which was held at the Whitney Museum on August 25, 2002. I invited other art historians and Merriman's theatrical friends to express their thoughts about Elsie. I recall speaking in front of Elsie's *Pittsburgh*, which the museum had set as a memorial in the center of the room. She would have been a remarkable artist even if she had only produced this one great painting. Sheeler and Demuth were important, but *Pittsburgh* may be the archetypical precisionist painting. It is the one that haunts your memory the longest and the most.

I was delighted to have given Elsie encouragement and enthusiasm in her last years by curating her retrospective and commissioning two paintings. My efforts with Elsie were and are a labor of love, which is why I have intended this essay to be more personal than strictly art historical. I will never forget Elsie. And I am pleased to share these fond memories with you.

Notes

1. Elsie Driggs, quoted in the videotaped interview with the author at the opening of the retrospective exhibition *Elsie Driggs: A Woman of Genius* at the Phillips Collection, Washington, D.C., January 26, 1991.

2. Murdoch Pemberton, "The Art Galleries—A Good Run of New Spring Sap," *The New Yorker* 4 (May 5, 1928): 72.

3. Thomas C. Folk, *Elsie Driggs: A Woman of Genius*, exhibition at the New Jersey State Museum, Trenton, October 3, 1990–January 6, 1991; the Phillips Collection, Washington, D.C., January 26–March 17, 1991.

4. Driggs, letter to author, March 10, 1987.

5. Ibid.

6. Cited by Driggs in her essay "The Search for Piero della Francesca" in Folk, *Elsie Driggs: A Woman of Genius*, 52.

7. For Driggs's essay, "The Search for Piero della Francesca," see appendix 3 of this book; see also the appendix and Driggs's photo of a detail from Piero della Francesca's fresco the *Legend of the True Cross* in Folk, *Elsie Driggs: A Woman of Genius*, 51.

8. Cited by Driggs in Folk, *Elsie Driggs: A Woman of Genius*, taken from an interview between Driggs and the author, July 8, 1988. She also wrote on the reverse of a print of her copy of Hans Memling's *Portrait of Maria Portinari*: "This print lacks full clarity. It is made from a 62 year old snapshot of my copy of Hans Memling's Maria Portinari. I didn't know that when I painted the veil which falls from Maria's hat, I was learning how to paint the steam that rises from the base of 'Pittsburgh.' Also, I studied and used underpainting, which I still use today. Elsie Driggs," n.d. Driggs's lost copy of Memling's portrait is illustrated in Folk, *Elsie Driggs: A Woman of Genius*, 16.

9. D. H. Lawrence, *Women in Love* (New York: Knopf, 1992 ed.). Although it was not commercially printed in the United States until 1933, *Women in Love* had been privately printed in New York in 1920. Driggs had an interest in Lawrence's work because he was a houseguest of Mabel Dodge, a major patron of American art, in Taos, New Mexico, and since Dodge married Driggs's art instructor, Maurice Sterne.

10. Leah P. Sloshberg, who had been fine arts curator of the New Jersey State Museum, wrote: "I long have had a curiosity about the artistic career of Elsie Driggs Gatch. The curiosity dates back to a 1966 visit to the Gatch House in Lambertville. The occasion was to view works by her husband, Lee Gatch, for possible acquisition. I recall knowing at the time that the shy and soft spoken hostess had experienced great success in the art world in the 1920s and that her 'Pittsburgh' in the collection of the Whitney was considered the quintessential Precisionist work. I wondered, as she served cups of tea to her guests, why she had put her career on the back burner, so to speak. This, of course, was from the point of view of a young curator struggling to juggle house and office. Needless to say, she gave no information about the work she was doing in her newly completed studio." Foreword from Sloshberg as director of the New Jersey State Museum, in Folk, *Elsie Driggs: A Woman of Genius*, 7.

11. Merriman Gatch, interview with the author, July 4, 2007, at her Chelsea apartment.

12. Ibid.

APPENDIX 2

Selected Exhibition History and Critical Responses

An asterisk () indicates a solo exhibition.*

1922　Society of Independent Artists, Waldorf Astoria, New York. Sixth Annual Exhibition of the Society of Independent Artists. March 11–April 2.

1924　Daniel Gallery, New York. *A Group of Modern Painters*. February.

> Forbes Watson, "Painters Form a Lively Group," (New York) *World*, February 17, 1924, metropolitan section, 7.

> Elsie Driggs, a newcomer, is a distinct addition to the gallery's group; her painting of the spread out leaves of a cabbage being one of the most sensitive pieces of painting in the entire exhibition.

1926　Anderson Galleries, New York. Whitney Studio Club. Eleventh Annual Exhibition of Paintings and Sculpture by the Members of the Club. March 8–20.

> News clipping in Elsie Driggs artist file, Martin and Harriette Diamond Collection of American Art, Special Collections and University Archives, Rutgers University Libraries. [Handwritten in script: "*The Arts*. April 1926."] Illus. Elsie Driggs, *Deer*. Whitney Studio Club.

Daniel Gallery, New York. Group exhibition. October.

> Margaret Breuning, "Art Season Nearing Full Swing," *New York Evening Post Literary Review* 7 (October 30, 1926): 10.

> Elsie Driggs is represented by two of her exquisite water colors —"Mullen" and "Rattlesnake Plantain"—the very essence and being of the plants expressed in evanescence of line and color. An oil by her is a departure. It is a delightful one. Two strange, red oxen with horns like lyres, are made into an arresting design that is rich in color.

> Murdoch Pemberton, "The Art Galleries," *The New Yorker* (October 30, 1926): 67–69.

> Elsie Driggs, who has gone in for flower forms in pastel, a lovely, and we imagine, unappreciated product, has in this show an oil of two oxen. We suppose Miss Driggs could never paint anything that is not lovely; her oxen at rest are not beasts of great burden but a problem of rhythms in repose. It is an interesting treatment, full of poetry and design. A hippopotamus, under Miss Driggs' caressing fingers, would become Pavlova herself.

1927　Whitney Galleries, New York. Whitney Studio Club. Twelfth Annual Exhibition of Painting and Sculpture by the Members of the Club. February 16–March 5.

Daniel Gallery, New York. Group exhibition. April.

> Forbes Watson, "Native Moderns Hold Group Exhibit," (New York) *World*, April 3, 1927, metropolitan section, 11.

> Of the two surprises in the exhibition, one is the *Queensborough Bridge* by Elsie Driggs, a painting in which Miss Driggs waves good-by to her old master Maurice Sterne and embraces for the moment the age of machinery. Miss Driggs could not be heavy-handed if she tried and her portraying of a portion of a steel sculpture soars upward in subtle transitions.

Anderson Galleries, New York. New York Society of Women Artists. Annual.

> Margaret Breuning, "Women Painters and Sculptors Open their Annual Exhibition," *New York Evening Post*, March 19, 1927, section 5, 12. Illus. *Deer* and *Calla Lily*.

Daniel Gallery, New York. Group exhibition. November.

> Margaret Breuning, "A Group of Painters at the Daniel Gallery—French Work at Two Exhibits, Some Americans and Notes on Coming Events of the Season," *New York Evening Post*, November 12, 1927, section 3, 13.

> Elsie Driggs is getting less evanescent in her beautiful studies of cabbabes [*sic*]. This present one is firm and botanically correct, but with a subtlety of design that makes you think of many Chinese paintings of the same subject. She also presents one of her street scenes with all sorts of complicated planes accounted for deftly.

1928 Whitney Galleries, New York. Whitney Studio Club. Thirteenth Annual Exhibition of Paintings by the Members of the Club. April 29–May 26.

Anderson Galleries, New York. New York Society of Women Artists. Annual.

> Henry McBride, "Women's Art Display Exclusive," (New York) *Sun*, April 28, 1928, 8.

> In the way of pure painting Miss Elsie Driggs bears off the honors, just as she did last year. I see I have achieved; quite unconsciously I hope, it is needless to explain, a pun, for Miss Driggs's picture is a study of "Bears." It is painted dexterously, with a nervous, sensitive touch, and carries all the imprint of fresh observation.

> Murdoch Pemberton, "The Art Galleries—A Good Run of New Spring Sap," *The New Yorker* 4 (May 5, 1928): 72.

> Elsie Driggs, individualist in her own right, with two brown bears. This is one of the best things we have seen from Miss Driggs. It has more vigor than the perfect mullen leaves and the mystic deer and oxen that she has dwelt with all these years. Miss Driggs has a fine sensitivity and there are many who believe that she ranks among the first in this land.

Daniel Gallery, New York. Group exhibition. November.

> "Immaculate School Seen at Daniels," *Art News* 27, no. 5 (November 3, 1928): 9.

> Factories, sheds, bridges, and smokestacks loom large in the current Daniel showing, all rendered in the precise line, flat color, and clearly defined pattern that have become trademarks of the immaculate school. The limitations of this group are obvious and in the present show it is only Elsie Driggs who in her stunning "Pittsburgh" surmounts them. Done in sooty blacks and velvety grays, she has woven her factory chimney into a beautiful pattern, truthful, yet imaginative.

1929 Little Gallery of Contemporary Art of the New Students League, 1525 Locust Street, Philadelphia. Group exhibition. January.

> (Philadelphia) *Public Ledger*, January 20, 1929, women's section, 9.

> "The Bridge" is another finely conceived, well-patterned intellectual art reaction to contemporary forms, utilizing the geometric pattern of the modern bridge, the diagonals of light shafts, gray-blue as they cut across metal superstructure, light orange-yellow as they cross the burnt-orange tone of a tall smokestack.

> Curiously enough, there is something in Elsie Driggs' approach to art that suggests the less morbid traditions of the Orient. In so simple an object as a cabbage she has found material for a particularly fine composition, expressed in pulsating paint and line rhythms. Her work, in fact, like the skirt of the modern woman, lifts itself well above the mire of things. To the Elsie Driggs who conceived "The Bridge"

there is not only pattern but a certain large nobility in the world of today. Her point of view as a human being is entirely different from that of young Peter Blume, whose "Maine Coast," with its sinister coloring, its weird face at the window and eye in the tree mass, its curious aching hardness belongs to that phase of modern art so eloquent of a fierce desire to escape.

Daniel Gallery, New York. Group exhibition. May.

News clipping in Elsie Driggs artist file, Martin and Harriette Diamond Collection of American Art, Special Collections and University Archives, Rutgers University Libraries. [Handwritten in script: *The Sun*, May 1929]

Miss Driggs' contribution is the "American Scene," which was shown earlier at the exhibition of the Hundred Paintings in the Architectural League. It is a somber statement of one of the great agents of American prosperity—a view of a steel plant. There is no hint of reproach or satire in the painting. Miss Driggs paints it with the same seriousness with which she paints a flower and the time may come, if certain prophets may be believed and the machine age increases its scope that such "plants" may become as prevalent in the landscape as flowers and may really be regarded as flowers. Miss Driggs is but slightly in advance of the age, that's all.

Cleveland Museum of Art. Ninth Exhibition of Contemporary American Oil Painting. June 6–July 7.

*Daniel Gallery, New York. *Elsie Driggs*. November 18–December 14.

"Elsie Driggs–Daniel Gallery," *Art News* 28, no. 9 (November 30, 1929): 15.

Elsie Driggs, following the spirit of the age, has gone up in the air. In the current exhibition of her work at the Daniel Gallery both old and new paintings are shown and the latest is a very exact picture, almost a mechanical drawing of an airplane. However mechanically correct the latter may be it seems less successful as a picture than the pair from Pittsburgh. The canvases, one of them shown in an earlier group show, are of smokestacks and blast furnaces, large, black pipe twisted into patterns. They really convey a sense of energy of vast mechanical forces at work.

These three represent, with a disjointed version of Queensborough Bridge, the modern age. The other eight pictures include still lifes, portrait studies and one of two brown oxen lying on the ground. In subject this has, of course, as much relation to the middle ages as to the XXth century but the free movement, the solidity of form and power of composition make this a picture which needs no dated mechanisms to spur interest.

1930 Museum of Modern Art, New York. *Forty-six Painters and Sculptors Under Thirty-five*. April 11– 27.

Elizabeth Luther Cary, "Varied Adventures in the Local Realm of Art: The Lexicon of Youth; a Stimulating Mixed Exhibition Is Now Presented at the Museum of Modern Art," *New York Times*, April 13, 1930, section 10, 10.

Elsie Driggs, at 32 seems to have reached an impasse in her earlier style, which is represented by the powerful and gloomy "Blast Furnaces," with its morose color, red, black and gray. Her latest work is of this year, a "Portrait of a Girl," subtle in characterization, broad in handling, high in key, with an interesting panel of green back of the figure and recording the geometrical shape in which it could be enclosed. This notion of making a kind

of box of distinctive color or line for the principal elements of a composition is found in early paintings and is not new among the moderns, but its effectiveness depends upon the artist's feeling for an integral aspect. In this case it neither interrupts nor distracts attention from the design as a whole, but strengthens it and adds significance to the pictorial motive.

Cincinnati Art Museum, Cincinnati. Annual.

"Cincinnati's Annual Turns Out to Be a Modernist Exhibition," *Art Digest* 4, no. 17 (June 1930): 32.

1931 Society of Independent Artists, Grand Central Palace, New York. Fifteenth Annual Exhibition of the Society of Independent Artists. March 7–30.

1931–32 Whitney Museum of American Art, New York. *Opening Exhibition–Part I of the Permanent Collection: Painting and Sculpture.* November 18–January 2.

1932 Whitney Museum of American Art, New York. *Watercolors, Drawings, Prints from the Permanent Collection.* January 5–February 4.

Art Institute of Chicago. The Twelfth International Watercolor Exhibition. March 31–May 30.

1933 Whitney Museum of American Art, New York. *Summer Exhibition: Paintings, Sculpture, Prints and Watercolors,* May 4–June 30.

Whitney Museum of American Art, New York. First Biennial Exhibition of Contemporary American Painting. January.

Dorothy Grafly, "The Whitney Museum's Biennial," *The American Magazine of Art* 26, no. 1 (January 1933): 8.

Clear-cut presentations of the contemporary scene in which the artist is face to face with visual realities are balanced by reversions to mythological or Biblical subject matter . . . Much the same

emotional chasm exists also, between "The Prodigal Son," an illustrative composition by Bryson Burroughs, with its diluted Chavannes influence, and "Inciting the Mob" by Elsie Driggs, developing through movement of composition an intense blue flame of bodies that rises upward through flicker of hands. Daumier in feeling if not in pigmentation, the canvas stems from a rugged rather than a fanciful art.

1934 The Forum, RCA Building, Rockefeller Center, New York. First Municipal Art Exhibition. February 28–March 31.

News clipping in Elsie Driggs artist file, Martin and Harriette Diamond Collection of American Art, Special Collections and University Archives, Rutgers University Libraries. [Handwritten in script: "*Art News,* Mar 17, 1934."]

Illustration of *Horses* by Elsie Driggs. Outstanding in the First Municipal Art Exhibition now on view at Rockefeller Center.

Cleveland Museum of Art. Eleventh Annual Exhibition of Watercolors and Pastels. February 14–March 11.

Art Institute of Chicago. The Thirteenth International Watercolor Exhibition. March 29–April 29.

1935 *Frank K. M. Rehn Galleries, New York. Elsie Driggs exhibition. February.

Laurie Eglington, "Elsie Driggs, Rehn Galleries," *Art News* 33, no. 21 (February 23, 1935): 13.

The watercolor impressions of certain dramatic productions, including *The Emperor Jones* **and** *Merry Mount* exhibited by Elsie Driggs at the Rehn Galleries reveal a strange antithesis. When seen from a little distance the effect of these curiously compact compositions is one of general liveliness, although each mass looks like the next, owing to a

similarity of shape and the impossibility of distinguishing individual forms. A closer study reveals a fine, vibrant line and flowing washes of brilliant color that provide telling accents . . . One is above all conscious of terrific compression which threatens at any minute to burst the bounds imposed. We know from other works of this artist, how she is able to sing when not confined within a cage.

New Rochelle Art Association, New Rochelle, New York. Annual Illustrators Exhibition. May.

> News clipping in Elsie Driggs artist file, Martin and Harriette Diamond Collection of American Art, Special Collections and University Archives, Rutgers University Libraries. [Handwritten in script: "*The Standard Star*, May 24, 1935"] Illus. for Col. T. E. Lawrence's *The Odyssey*.

> Miss Elsie Driggs is winner of the Grant Award. Miss Driggs pictures are among the most unusual in the exhibition and contrast strikingly with the conventional work.

1938 Whitney Museum of American Art, New York. *Permanent Collection, 1937–1938.* May 17–27.

*Frank K. M. Rehn Galleries, New York. Elsie Driggs exhibition. March.

> Martha Davidson, "Elsie Driggs, A Draughtsman of Rare Imagination," *Art News* 36, no. 25 (March 19, 1938): 14.

> The exquisite phantasmagoria spun from the imagination of Elsie Driggs in a network of thin, wiry pencil lines and washes with tints of extraordinary delicacy creates a rare showing at Rehn Galleries. The artist with unerring taste and magnificent control comparable to Klee, the German master of lyrical abstractions, conjures up genial phantoms . . . with cinematographic rapidity. The

nuances of line, tone, and texture have an inimitable refinement.

> Margaret Breuning, "Art in New York," *Parnassus* 10, no. 4 (April 1938): 24–26, 30–31.

> Watercolors by Elsie Driggs at the Rehn Gallery are to be heartily recommended. At a moment when propaganda art has spread its dull opacity over the local horizon it is a refreshing experience to encounter the work of a painter whose sole concern is art. This painter presents original conceptions with gaiety and wit. Consequently, her work makes definite demands on the observer, since wit is more difficult to appreciate than humor . . . Her approach to art is serious. The incisive linear patterns that cut through the fusing planes of exquisite color make firm armatures for her fluent designs. She gives back to us her imaginative ideas on her own terms, for she can afford to let us forget about her solution of technical problems.

> News clipping in Elsie Driggs artist file, Martin and Harriette Diamond Collection of American Art, Special Collections and University Archives, Rutgers University Libraries. [Handwritten in script: "Sun, Mar 19, 38"]

> Miss Driggs seems to have gone back to the cave man drawings for the basis of her gayly personal semi-abstract style. This element, coupled with a whimsical fancy and a feeling for movement gives her little improvisations an elfish sort of charm.

> News clipping in Elsie Driggs Papers, 1924–1979, Archives of American Art, microfilm reel D160. [Handwritten in script: "*NY Tribune*, Mar 13, 1938"]

> Elsie Driggs, who showed her watercolors here the last time three years ago, is exhibiting now at the Rehn Gallery. Her subjects include horses, birds, dinosaurs;

but it is not so much what she has painted as how she has painted them. Miss Driggs suggests, for instance, that a fragile line or two, and a touch of color, if motivated by wit and taste, may awake a genuine response in the observer.

1939 Art Institute of Chicago. The Eighteenth International Watercolor Exhibition. March 23–May 14.

1944 Art Institute of Chicago. Fifty-fifth Annual American Exhibition, Watercolors and Drawings, June 8–August 20.

1948 *Artists Gallery. New York. *Elsie Driggs*. January 17–February 6.

News clipping in Elsie Driggs artist file, Martin and Harriette Diamond Collection of American Art, Special Collections and University Archives, Rutgers University Libraries. [Handwritten in script: "*Art News*. Jan 1948"]

Elsie Driggs [Artists Gallery: Jan. 17–Feb. 6], Connecticut-born wife of painter Lee Gatch . . . has her first showing in more than ten years . . . In most paintings, backgrounds are vaporous watercolor washes, from which the central images emerge, drawn with Klee-like sensitivity on torn, mounted scraps of paper. It is hard to say exactly what this collage technique contributes, yet the scraps, overpainted and recomposed into the picture, seem absolutely right in their intuitive shape and evocative power.

1952–53 Metropolitan Museum of Art, New York. *American Watercolors, Drawings, and Prints. A National Competitive Exhibition*. December 5–January 25.

1953 Metropolitan Museum of Art, New York. Edward Root Collection. February 12–April 12.

*Frank K. M. Rehn Galleries, New York. *Paintings: Elsie Driggs*. April 27–May 16.

Margaret Breuning, "New York," *Art Digest* 27, no. 15 (May 1, 1953): 17.

Painting with a dry brush and a fairly restricted palette this artist manages to impart a glowing depth to mat surfaces. Her semi-abstractions are fantasies from which themes emerge sometimes tenuously, sometimes with an authoritative emphasis. A curious yet successful device of enclosing designs in painted rectilinear or trapezoidal frames lends intensity to these fantasies.

News clipping in Elsie Driggs Papers, 1924–1979, Archives of American Art, microfilm reel D160. [Handwritten in script: "Carlyle Burrows, *New York Herald Tribune*, May 3, 1953"]

After some years' absence from the art shows, Elsie Driggs is showing new work at the Frank Rehn Gallery, a group of pictures of provocative interest. Feeling and expression characterize the paintings far more than representation; in fact, some leave nature rather far behind. And only with patience does one pick up the threads of form and meaning, in order to perceive a definite poetic, partially Oriental statement.

News clipping in Elsie Driggs Papers, 1924–1979, Archives of American Art, microfilm reel D160. "Artists Burst Out in Spring Activity," *New York Times*.

In striking contrast with Miss Helsey's work are recent paintings at the Rehn Gallery by Elsie Driggs, whose early work was shown in 1938 and whose last show was held, if memory serves, at the Artists Gallery about five years ago has come far a field since her early realistic figure compositions. "Juggler" employs semi-abstract, wedge-shaped loose planes. "Dancer" makes use of reversed plane forms for the suggestion of swirling costume with curiously oriental effect, and a calligraphic swirl of form in another of

the paintings is even more oriental . . .
Fantasy is explicit in all, the work and
color is high and dramatically employed.

1960 The Walker Art Center, Minneapolis.
The Precisionist View in American Art.
November 13–December 25. Traveled to
the Whitney Museum of American Art,
New York; the Detroit Institute of Arts;
Los Angeles County Museum of Art; San
Francisco Museum of Art.

1964 Provincetown Art Association,
Provincetown, Massachusetts. *Golden
Anniversary Exhibition.* August 2–October 6.

Robert Schoelkopf, New York. *An
Exhibition of American Watercolors.*
September 15–October 3.

1965 The Newark Museum, New Jersey. *Women
Artists of America, 1707–1964.* April
1–May 16.

1969 Whitney Museum of American Art, New
York. *Seventy Years of American Art,
Permanent Collection, Section 1, 1900–
1949.* July 3–August 28.

1970 Whitney Museum of American Art, New
York. *Selections from the Permanent
Collection.* July 10–November 25.

1971 *La Boetie, New York. *Elsie Driggs.* February
2–20.

Jerry G. Bowles, "Elsie Driggs," *Art
News* 69, no. 10 (February 1971): 18.

Elsie Driggs alternates between an
abstract and semi-representational style in
her paintings, watercolors, and collages.
Even those pictures which contain
suggestions of figure, however, still have
a strong abstract quality. Miss Driggs
knows how to use color; her tones and
textures are extraordinary.

"Elsie Driggs (Gatch) Has One-Man
Show," *Beacon and Lambertville Record,*
February 4, 1971, 13.

Except for a large black and yellow
collage done about six years ago, the
works on exhibit date from 1968 and
1970. They include a series of oils
handled like watercolors, with a wash-
like sprayed background, giving them a
polished look, which is accentuated by
small areas of impasto; five watercolors
[*sic*] collages, and six standing drawings.

1972–73 Whitney Museum of American Art,
New York. *The City as a Source.* November
22–January 1.

1973 Whitney Museum of American Art, New
York. *Selections from the Permanent
Collection, 1900–1950.* July 30–September 9.

1974 McNay Art Institute, San Antonio.
Collector's Gallery 8. November 1–
December 25.

1975 Whitney Museum of American Art, New
York. *American Abstract Art, A Survey
from the Permanent Collection.* July 24–
October 26.

1976 New Jersey State Museum, Trenton. *This
Land Is Your Land.* April 17–September 6.

1977 Hirschl and Adler Galleries, New York.
Lines of Power. March 12 –April 9.

Davis and Long Company, New York.
American Collage. June 6–July 1.

The Royal Scottish Academy, Edinburgh.
*The Modern Spirit: American Painting
1908–1935.* August 20–September 11.
Traveled to Hayward Gallery, London.

1977–78 Whitney Museum of American Art, New
York. *American Art: 1920–1945, Part I,
Selections from the Permanent Collection.*
October 29–February 12.

News clipping in Elsie Driggs artist file,
Martin and Harriette Diamond Collection
of American Art, Special Collections and
University Archives, Rutgers University
Libraries. [Handwritten in script:

"11/4/77–NYT"] Vivian Raynor, "Art: Two Decades at the Whitney."

> Most interesting in this category [precisionism] is a fine monochromatic study of Pittsburgh steel mills by Elsie Driggs, an artist hitherto unknown to this reviewer.

1978 Whitney Museum of American Art, New York. *American Art: 1920–1945, Part II, Selections from the Permanent Collection*. February 15–April 5.

Heckscher Museum, Huntington, New York. *The Precisionist Painters 1916-1949: Interpretations of a Mechanical Age*. July 7–August 20.

> News clipping in Elsie Driggs artist file, Martin and Harriette Diamond Collection, of American Art, Special Collections and University Archives, Rutgers University Libraries. [Handwritten in script: "*New York Times*, July 21st, 1978."] John Russell, "L. I. Museum Celebrates Yankee Art."

> In the 1920's there was real soot, real smog and a readiness to tackle the true facts of the matter in a painting like Elsie Driggs's "Pittsburgh" of 1927. Miss Driggs, 80 this year, but still enviably spry, is one of the stars of the show.

1978–79 Whitney Museum of American Art, New York. *Introduction to 20th Century American Art: Selections from the Permanent Collection*. October 10– September 16.

1979 Whitney Museum of American Art, New York. *Tradition and Modernism in American Art, 1900–1930*. September 11–November 11.

1980 *Martin Diamond Fine Arts, New York. *A Tribute to Elsie Driggs: Works from 1918 to the Present*. May 5–30.

> Susan Fillin-Yeh, "Elsie Driggs," *Arts 54*, no. 9 (May 1980): 3.

> The exhibition, a mini retrospective, should be full of surprises for those who may have known Driggs only as a Precisionist painter of industrial subjects of the 1920s.

> Paintings of the 1920s aside, Driggs' show is not a statement about Precisionism. If the exhibition shows us how the artist's vision helped create that particular early modern style, it also reveals an imagination buoyant enough to have moved beyond it.

Whitney Museum of American Art, New York. *Fiftieth Anniversary Gifts and Promised Gifts*. June 3–August 31.

Hirschl and Adler Galleries, New York. *Buildings, Architecture, and American Modernism*. October 29–November 29.

1980–81 Akademie der Künst, West Berlin, Germany. *America–Traum und Depression 1920/40*. November 9–December 28. Traveled to Kunsteverein, Hamburg.

1981 Whitney Museum of American Art, New York. *Drawing Acquisitions 1978–81*. September 17–November 15.

1981–82 Jersey City Museum, New Jersey. Invitational. November 20–February 28.

> Vivien Raynor, "Eschewing Boosterism in Jersey City," *New York Times*, December 6, 1981. New Jersey section, 48.

> Heading the contingent of "known" artists, Elsie Driggs offers three large architectural themes drawn in a mixture of graphite, sanguine and colored inks and accompanied by a row of antique shoe forms along the bottom.

> Miss Driggs . . . now stands closer to surrealism than Cubism, notably in her view of an empty room with an open door, she contributes a presence that is historically as well as aesthetically stimulating.

1982 Barbara Mathes Gallery, New York. *Charles Demuth and His Circle.* May 18–June 25.

1982–83 San Francisco Museum of Modern Art. *Images of America: Precisionist Painting and Photography*, September 9–November 7. Traveled to Saint Louis Art Museum; Baltimore Museum of Art; Des Moines Art Center; Cleveland Museum of Art.

1983–84 One Penn Plaza, New York. *Vintage New York: Contemporary Art at One Penn Plaza.* October 3–January 13.

1983 Martin Diamond Fine Arts. New York. *Three American Modernists.* November 23–December 18.

> Ilene Susan Fort, "Three American Modernists," *Arts* 57, no. 6 (February 1983): 35.
>
> Most of Driggs' 1930s watercolors though fluid, simplified renderings, are actually complex conceptual statements, as in *The Soul Selects her Own Society*, where a horse and chariot are painted over a large profile of a Greek looking man. They are ancestors of her recent multi-media pieces, delicately drawn city views set behind wooden objects which are in the shape of feet or hands. Although the two components of these pieces never interact physically, their relationship is always suggested . . . Driggs . . . more enigmatic surreal works . . . suggest different levels of reality.

1986–87 Brooklyn Museum, Brooklyn, New York. *The Machine Age in America 1918–1941.* October 17–February 16.

1988 Whitney Museum of American Art at Philip Morris, New York. *Precisionist Perspectives, Prints and Drawings.* March 2–April 28.

> Isetan Museum of Art, Tokyo. *Visions of Tomorrow: New York, 1920s and 30s.* April 21–May 10. Traveled to Daimaru Museum, Osaka; Fukuoka Prefecture

Museum of Art, Fukouka; Tochigi Prefectural Museum of Fine Arts, Utsunomiya.

> *Image Gallery, Stockbridge, Massachusetts. *Elsie Driggs.* Opened August 6.

1990 *Artfull Eye, Lambertville, New Jersey. *Elsie Driggs: The Lambertville Years. The New York Years.* October 21–November 25.

1990–91 *The New Jersey State Museum, Trenton. *Elsie Driggs: A Woman of Genius.* October 13–January 6. Traveled to the Phillips Collection, Washington, D.C.

> William Zimmer, "A Precisionist's Unexpected Turns," *New York Times*, December 2, 1990, New Jersey section, 22.
>
> Miss Driggs has cut a wide path through the twentieth-century art world. The unexpected turns she takes make this an absorbing show.

1993 Kraushaar Galleries, New York. *Significant Others: Artist Wives of Artists.* January 9–February 13.

1994–95 Montclair Art Museum, New Jersey. *Precisionism in America 1915–1941: Reordering Reality.* November 20–January 22. Traveled to Norton Gallery of Art, West Palm Beach; Columbus Museum of Art; Sheldon Memorial Art Gallery, Lincoln, Nebraska.

1996 Whitney Museum of American Art, New York. *An American Story.* March 20–October 6.

1997 Whitney Museum of American Art, New York. *Views from Abroad: European Perspectives on American Art 3—American Realities.* July 11–October 5.

"The Search for Piero della Francesca"

Elsie Driggs

From the Elsie Driggs Papers, 1924–1979, Archives of American Art, Smithsonian Institution

During the late 1970s, while taking a course in writing at New York University, Elsie Driggs wrote an essay describing some of the highlights of her studies in Italy as a young student. The essay focuses on her search for murals in Borgo San Sepolcro of the fifteenth-century Italian artist Piero della Francesca, whose work was admired by such critics as Bernard Berenson, Roger Fry, and Leo Stein and who became almost a cult figure for many American modernist artists.

The essay in the Elsie Driggs Papers at the Archives of American Art is in the form of a typescript draft with numerous handwritten revisions. It is reproduced here with minimal editing to clarify names and geographical places.

I F I HAD BEEN GIVEN THREE WISHES when I went to Europe as an art student, I should have said, "Let the sun shine as I go through southern France. Let me see Cézanne's paintings as I look out the window of my train, and let me meet Leo Stein who made the art world see Cézanne through his eyes, and interpreted his paintings for us from his aesthetic experience." The sun shone as I traveled south and I did see the dovecots, the pines, and those angular fields that lie like patches . . . all pure Cézanne.

When I arrived in Rome, I took the advice of Maurice Sterne, the American artist I was to study with, and signed for a room in the ancient little Santa Chiara Hotel that stands in the protective shadow of the Pantheon. Across from it, in a small cobblestone piazza, sits Michelangelo's Moses thoughtfully stroking his beard.

But there was a practical consideration that winter. I remember a very cool radiator, and the pitcher of warm water my cameriera (room service, Italian style) brought me was not comforting. For the older guests of the hotel it was an arthritic winter. For me it was an introduction to chilblains.

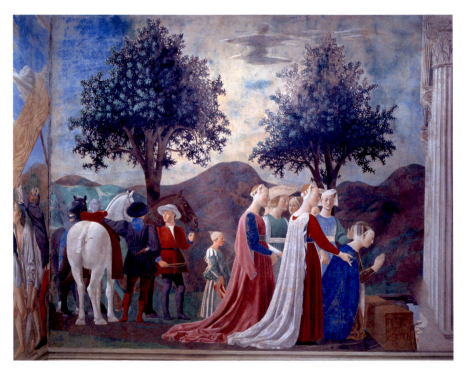

Piero della Francesca, *Adoration of the Sacred Piece of Wood.* From the *Legend of the True Cross*, ca. 1450–1465, fresco. Postrestoration. San Francesco, Arezzo, Italy. Scala/Art Resource, NY.

February, which started dank and depressing, was suddenly warmed during two remarkable weeks when Leo and Nina Stein took the room next to mine. They were on their way home from Europe, stopping in Rome before going on to Settignano, across the Arno from Florence.

My day would start with Nina knocking on my door. She would then continue the story of her life. Leo spent the morning in their room psychoanalyzing himself. I came to know him in the evenings when we would be joined by another student, Louise Maloney, and all four would go for a leisurely dinner at our favorite restaurant on the Via delle Botteghe Oscure.

The high point of Nina's saga was her meeting with Leo. As she told it, she used to make a small living singing under the windows of the well-to-do, and gathering the coins they threw down to her. The Steins lived in a handsome house on a fashionable street in Paris. One day, Leo saw Nina singing beneath his window, and being a man of sensibility, he brought his centimes to her. Thus their romance began.

I could not say that our evenings were conversational. Stein conducted a monologue. Not only was he a born teacher, but listening had become a trial for him. He was rapidly becoming very deaf. A doctor had sold him on the idea that his difficulty was neurotic, not functional, hence the psychoanalysis. His deafness was the reason for his bowing out of the salon he had started and loved, and turning it over to the aggressive Gertrude.

To my surprise, though he talked a great deal of Cézanne, his chief enthusiasm was for the early Italian master Piero della Francesca. As Sterne's class was held in a building close to the shop of the photographer, Anderson, I spent hours pouring over his wares and buying many prints. I told myself that Piero had nothing to do with my vision. I liked life and movement. He was too static and classical, and yet I was drawn to him, and in the end bought more photographs of his paintings than any other artist.

When the two weeks were up, the Steins left. It was not until spring that a friend and I decided to travel up the Italian boot, she to go to Paris, and I to absorb more art before settling down to a summer of work. At Perugia my companion developed a heavy cold. So, leaving her on a rainy Sunday, I departed for Borgo San Sepolcro to see two frescos of Piero della Francesca.

When I arrived I found no one in town had heard of the paintings. I entered the church but there were no frescos. A statue of the artist stood in the churchyard, but no one had troubled to look at it. Someone suggested I try the Municipali Building. There I found the rooms on either side of the center hall locked. "Who would have the keys?" The people said, "The Mayor." "Where is he?" My question, "Where is the Mayor?" was convulsing the town, and my innocent mind finally tumbled to the fact that if the Mayor were not in the wrong bed he was at least in the wrong house. I withdrew to the hall in the Municipali Building, and looking from a window, watched the rain falling on the fields below till it was time to take the train for Perugia. When I consulted my photographs, I found the frescos were in the building where I had spent most of the day.

My friend recovered and we parted. I traveled to Florence, was met by the Steins, and found myself in the company of scholars and collectors. The talk was of Piero della Francesca. It was not just an enthusiasm. It was a cult. A few days later I was joined by Louise. We saw private collections and museums, and on account of the group we were with, curators brought out paintings seldom put on exhibition. After ten days Louise and I set out for Anticoli Corrado, the small hill town in the Sabine Hills where we would paint that summer.

When the fall came I took a train for Naples where I boarded a ship for America. It was not until I reached the haven of my own house that I realized what a state I was in. The clock on the stair landing ticked too loudly, and I went for a walk to escape it . . . But I recovered.

Two years later I went to Pittsburgh to paint the inferno of a night sky I had seen as a child, and found the steel industry had discontinued the Bessemer process that had colored the ceiling of smoke. But one day while I was there, I was going up Squirrel Hill Road, which runs on the edge of a cliff, and I looked into the great velvet forms of the Jones and Laughlin Mills, which rise from a level below. I found them beautiful. They were cool and classical. Later, back home I made a painting from my sketches and called it *Pittsburgh*. My gallery hailed it as "the new classicism," but when people would ask me about it, I would say, "That is my Piero della Francesca," and they would say, "Who is he?" Now Piero is the *in* old master. He is every artist's favorite.

When I went to Europe it was the end of an era. Cézanne is still great, but not as necessary to us as he was then. My awakening to the beauty of the mills (which unbeknownst to me, was happening to other painters) marked the beginning of a new era of art in America. Now there is a turning back to that period, which is in part nostalgia. But the Italian master is divorced from that. It must be a desire for structure and order, for simplicity and strength. There is as yet, no one direction that expresses these times. My feeling is that it will be a wedding of the quick and the classical. There is too much electricity to remain benign.

Photograph of Maurice Sterne's students in Anticoli Corrado, ca. 1920. Courtesy of the Elsie Driggs Papers, 1924–1979, Archives of American Art, Smithsonian Institution. Elise Driggs is leaning against the tree on the left and the man wearing a hat behind her is Edward Bruce. Elsa Schmidt is the third figure from the left, Louise Maloney is in the center against the tree, and seated in front of Louise is Mario Topi. Against the tree on the right is Peggy Bruce. Standing in the back on the right are Maurice Sterne, Vera Sterne, and Gertrude Tiemer-Wille.

APPENDIX 4

"Benji-Ben-Ali-Bengal"

Elsie Driggs

From the Elsie Driggs artist file, The Martin and Harriette Diamond Collection of American Art, Rutgers University Archives, New Brunswick, New Jersey.

During the mid-1930s, Elsie Driggs wrote a short story for children that was never published. She created several illustrations for the story, including *Monkey in the Tree*, *The King's Equerry*, and *Benji-Ben-Ali-Bengal* (1936; cat. 34).

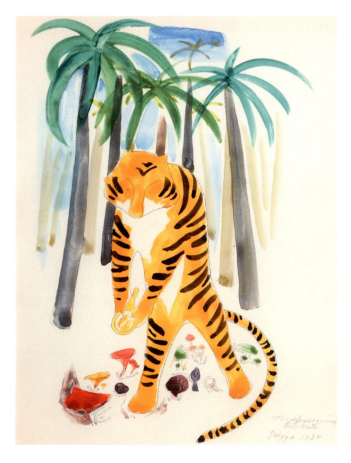

Benji-Ben-Ali-Bengal, 1936
Watercolor and pencil on paper
19 x 15 ½ inches
Private collection

(1)

Elsie Driggs
The Coon ~~Patti~~ *Path*
Lambertville, N.J.

BENJI-BEN-ALI-BENGAL

There was once a tiger named Benji-Ben Ali-Bengal who lived
in a very great forest. There were more trees in that forest
than there were stripes on all the coats of all the tigers in the whole
world. And all the animals who dwelt in the forest lived together
so happily that if a slight growl were occasionally heard you might
say that it was a tiger or a leopard turning in his sleep--
certainly nothing more serious than that.

One day Benji-Ben-Ali-Bengal walked softly through the woods
all the way to the place where the grass and the houses begin and
there shining in the grass was a mirror. "This is indeed a very
beautiful thing" said Benji-Ben-Ali-Bengal and he picked it up in
his mouth and went softly through the forest all the *way* back to his
home. Then and only then did he stop to look into it. He took
a step backward in surprise. "I have here" he said, " a wonderful
The Tiger in The mirror seemed To say, "I have here a wonderful little Tiger"
little tiger," but he made no sound.

Then Benji-Ben-Ali-Bengal called to a very green snake who
was passing by and said "Go as quickly as you can and ask the
first lion you meet to come here to this spot tomorrow two hours
before sundown. Tell him that I have found a wonderful thing and
I wish an opinion. Give the same message to the first leopard,
the first fox, the first monkey and so on and so forth till you
have invited one of every animal in the whole forest. Now please
go quickly." *The snake moved swiftly this way and That way
and soon disappeared.*

147

Elsie Driggs
The Coon Patti Path
Lambertville, N.J.

At four o'clock sharp on the following day came the lion, the leopard, the monkey, the fox and more and more animals but always one of a kind. Then Benji-Ben-Ali-Bengal drew forth his mirror from under some roots and handing it to the lion he said proudly, "I have here a wonderful little tiger". The lion looked into the mirror and then took a step backward. "Tiger?" he roared. "A lion you mean." He passed it quickly to the monkey. "Lion"shrilled the monkey, "anyone can see it is a monkey!". He passed the mirror to the leopard. "Monkey?", snapped the leopard.

"A lion", "A fox", "A tiger", "A monkey"--louder and louder grew the din. Then suddenly a silence fell. The lion stalked away through the forest, then the leopard and the monkey till all the animals had melted away. Only Benji-Ben-Ali-Bengal was left.

For awhile there was absolute silence. Then away off in the distance there was a soft growl, like a lion or a leopard turning in his sleep. There was another growl, and another. Nearer and nearer it came.

g-r-r -g-r-r-r g-r-r-r

g-r-r -g-r-r-r g-r-r-r

G-R-R- -G-R-R-R G-R-R-R

G-R-O-W-L R-O-A-R!!!

The very sky seemed to burst upon Benji-Ben-Ali-Bengal. Out of the forest into the clearing sprang a tiger and a lion and a leopard, a monkey and a fox and so on and so forth by the hundreds they came, till the sky and the earth and the trees were one roar.

Elsie Driggs
The Coon Patti Path
Lambertville, N.J.

Benji-Ben-Ali-Bengal as he listened could hear through all
the tumult and din an angry song. It went:

 A lion, a tiger

 A lion, a tiger

 A leopard, a leopard

 A monkey, a fox

and so on and so forth they fought and they clawed, swaying this
way and that till one small monkey seeing the wonderful mirror
lying forgotten, snatched it quickly and scampered up a tall slim
tree till at the very top he rested breathlessly and gazed into the
mirror. "A monkey it is", said he. Then how it happened I do not
know, but the beautiful mirror slipped from his grasp. Down it sped
like a falling star till at the bottom of the tree it dashed against
a stone and broke into five glistening pieces. A great silence
fell upon all the animals. So great was the silence that you
could have heard a worm turning in that forest. Benji-Ben-Ali-
Bengal walked slowly up to the ~~broken~~ mirror and touched the pieces
with his soft paw. "It is broken" he said, as if all the animals
did not know it was broken, "It is quite spoiled." Then looking
more closely he noticed that in each shining piece he saw a tiger.
In fact there were now five little tigers like himself.

Elsie Driggs
The Coon Patti Farm
Lambertville,N,J.

Then Benji-Ben Ali-Bengal began to think and he thought up a
truly great idea, but he did not tell the other animals. All he said
was "I invite you tomorrow night to this spot in this clearing;
the King of the lions, the King of leopards, the monkeys, the foxes
and I myself as King of the tigers will spread a feast upon the
ground and when we five kings who rule this forest have eaten, I
will tell you my plan". Then slowly the other animals went back
through the forest for they were all very tired, sore and hoarse
from biting and snarling and scratching and they were very glad to
go home and sleep and perhaps dream of the strange and beautiful mirror.

The next day at the appointed hour the kings met. The coat
of each was carefully put in order, so that few of the marks of
yesterday's battle could be noted. The animals were very polite,
one to the othere, but each looked with longing at the great feast
spread before him and it was hard indeed to remember his manners
and not snatch a pomagranet, a banana or a carefully prepared fowl.
It was Benji-Ben-Ali-Bengal who suggested that first of all they
settle down to the feast. The business of the meeting could wait.
So the five kings sampled the wonderful food, each watching the
others manners, but gradually they forgot. There was some grabbing
and snatching and the lion was secretly sure that the leopard had
gotten more than his share and the monkey felt that the fox had
gone much too far with his third helping. But in the end they did
remember tha t after all they were kings, besides the appetites of
all of the animals were finally satisfied.

(5)

Elsie Driggs
The Coon ~~Patti~~ Path
Lambertville, N.J.

When every last scrap was gone and for awhile the guests had
talked about this and that, Benji-Ben Ali-Bengal cleared his
throat and said, "There are five of us, are there not?" All agreed
that the King of tigers had spoken correctly. "We are the five
kings
who rule this forest, are we not?" Again the other animals agreed.
 Should _hare_
"Then", continued the host, "are we not of all the animals ~~entitled~~
This
~~to the~~ mirror?" The leopard, the fox, the lion and the monkey
nodded their heads. "But before this mirror broke there seemed no
way of dividing it", the tiger said softly and looked at the others
slyly with a sideways glance to see if they were beginning to under-
stand. "Now", said Benji-Ben-Ali-Bengal triumphantly, "I will give
and each King can set his mirror in his crown. When he does not wear his crown
you each a piece and he may look into the mirror and there see
himself. He may even consult himself on affairs of state being sure
the while that he will have complete agreement in all matters".
 about
The other animals lept to their feet. They crowded the King
of the tigers ~~congratulating him~~ and with many bows, paw shaking,
and this and that, they went home. Now there was much talk in the
forest. You might say there was _speculation_ and when you _speculate_
you say, for instance, "I think there is a great secret", or "I
think something most unusual is about to happen." or even "Each
of us will soon be receiving a Royal invitation." This is the way
the animals talked, sometimes in whispers and sometimes I must admit
quite loudly so that a few of the small animals who must nap by
day started to complain.

(6) Elsie Driggs
 The Coon Patti Path
 Lambertville, N.J.

It is always hard to wait and when you wait time passes
slowly, but actually it was not very long before all through
the woods darting this way and that came rabbits and rabbits and
still more rabbits carrying envelopes large and square with
postage stamps in the upper right corner. As each of the animals
took his envelope do you think for a moment he tore it open?
With a "Thank you kindly," he placed a claw just under the flap
and carefully cut the edge of the paper, for he knew that inside
was the answer to all his speculation. It was-------an invitation,
in short, a Royal command on a white sheet of paper with a golden
crown. It stated in so many words, in fact it commanded his presence
the very next day at a Royal Reception two hours before sundown.

Now at last there was no talk, just a hurrying and a scurrying,
coat brushing, and nail polishing. Every one rose early next day
and every one had breakfast with eggs, for there was much to be done
and a long day ahead. One must never be late for a Royal Reception
two hours before sundown, so with time to spare the animals set out
from all of their homes with shining coats and their very best
manners. Each particular animal moved toward the place in the forest
where his particular King held sway. And as he approached the
particular clearing he saw a beautiful red carpet stretching all
the way to a throne, which was really a mound of moss set all
about with gems and flowers, with the birds and butterflies lending
their presence. All admitted they never had seen a robe with
ermine trim. A sceptre of gold was in his paw and a ring on one
claw with a golden seal.

Elsie Driggs
The Coon Path
Lambertville, N.J.

In the center of his crown the King had set his piece of the mirror for all to see. As his subjects gazed up on him they thought, "How splendid and regal our great King looks. What a beautiful crown!" They crowded forward and as each knelt before his monarch the King inclined his head graciously and the subject was pleased to see himself mirrored in the King's crown the while he thought, "How great and wise must be the head which wears a crown with such a wonderful jewel!"

Not one animal this day was forgotten. No matter how small or unimportant, he bent his knee and payed his homage to the King in his particular part of the forest. And now the King, being good and kingly, knew he must do a royal act of generosity, one might say kindness, for each of his subjects, large or small. So as every animal backed away from the Royal Presence, he was tapped on the arm by the King's Equerry who then led him to a clearing that was set all about with Eucalyptus trees and there on the ground on a white table cloth were row upon row of plates of ice cream. And that wasn't all , for a full moon that night, like a lamp in the sky, cast a soft white glow on the dancing floor of moss and fern and everyone danced, even the King, till the early hours of the following day. And each one agreed his Particular King was quite the most gracious and Royal King of all! And that didn't worry the Tiger King Benji-Ben-Ali-Bengal-----at all.

So it came to pass that a quiet fell upon that forest and if a growl were occasionally heard you might say that it was a tiger or a leopard turning in his sleep, certainlly nothing more serious than that.

BIBLIOGRAPHY

Art Digest. "Cincinnati's Annual Turns Out to Be a Modernist Exhibition." Vol. 4, no. 17 (June 1930): 32.

Art News. "Elsie Driggs–Daniel Gallery." Vol. 28, no. 9 (November 30, 1929): 15.

Art News. "Immaculate School Seen at Daniels." Vol. 27, no. 5 (November 3, 1928): 9.

Barr, Alfred Hamilton, Jr. "Introduction." In *Paul Klee*. Exhibition catalogue. New York: Museum of Modern Art, 1930.

Baur, John I. H. *Revolution and Tradition in Modern American Art*. Cambridge, Mass.: Harvard University Press, 1951.

Beacon and Lambertville Record. "Elsie Driggs (Gatch) Has One-Man Show." February 4, 1971, 13.

Bergson, Henri. *Creative Evolution* (1907). Translated by Arthur Mitchell. New York: Random House, 1944; London: 1911.

———. *Matter and Memory* (1896). Translated by W. S. Palmer and N. M. Paul. New York: Zone Books, 1988.

Born, Wolfgang. *American Landscape Painting*. New Haven, Conn.: Yale University Press, 1948.

———. *Still Life Painting in America*. New York: Oxford University Press, 1947.

Bowles, Jerry G. "Elsie Driggs." *Art News* 69, no. 10 (February 1971): 18.

Breuning, Margaret. "Art in New York." *Parnassus* 10, no. 4 (April 1938): 24–26, 30–31.

———. "Art Season Nearing Full Swing." *New York Evening Post Literary Review* 7 (October 30, 1926): 10.

———. "A Group of Painters at the Daniel Gallery—French Work at Two Exhibits, Some Americans and Notes on Coming Events of the Season," *New York Evening Post*, November 12, 1927, section 3, 13.

———. "New York." *Art Digest* 27, no. 15 (May 1, 1953): 14–17.

———. "Women Painters and Sculptors Open Their Annual Exhibition." *New York Evening Post*, March 19, 1927, section 5, 12.

Brock, Charles. *Charles Sheeler: Across Media*. Exhibition catalogue. Washington, D.C.: National Gallery of Art in association with University of California Press, 2006.

Brown, Milton. *American Painting from the Armory Show to the Depression*. Princeton, N.J.: Princeton University Press, 1955.

———. "Cubist–Realism: An American Style." *Marsyas* 3 (1943–45): 139–160.

———. "Precisionism and Mechanism." In *The Modern Spirit: American Painting, 1908–1935*. Exhibition catalogue. London: Arts Council of Great Britain, 1977.

Cary, Elizabeth Luther. "Varied Adventures in the Local Realm of Art: The Lexicon of Youth, a Stimulating Mixed Exhibition Is Now Presented at the Museum of Modern Art." *New York Times*, April 13, 1930, section 10, 10.

Cheles, Luciano. "A Century Old Passion: Piero della Francesca in America." In *Milton Glaser nella cittá di Piero* (forthcoming).

Cheney, Sheldon. *The Story of Modern Art*. Revised and enlarged edition. New York: Viking Press, 1958.

Corcoran Gallery of Art. *Treasury Department Art Projects: Painting and Sculpture for Federal Buildings*. Exhibition catalogue. Washington, D.C.: Corcoran Gallery of Art, 1936.

Crary, Jonathan. *Suspensions of Perception: Attention, Spectacle, and Modern Culture*. Paperback edition. Cambridge, Mass.: MIT Press, 2001.

Cummings, Paul. *Drawing Acquisitions 1978–81*. Exhibition catalogue. New York: Whitney Museum of American Art, 1981.

Davidson, Abraham A. *Early American Modernist Painting: 1910–1935*. New York: Harper and Row, 1981.

Davidson, Martha. "Elsie Driggs, A Draughtsman of Rare Imagination." *Art News* 36, no. 25 (March 19, 1938): 14.

Diamond, Martin. *Who Were They? My Personal Contact with Thirty-Five American Modernists Your Art History Course Never Mentioned*. Privately printed, 1995.

Eglington, Laurie. "Elsie Driggs, Rehn Galleries." *Art News* 33, no. 21 (February 23, 1935): 13.

Eliot, T. S. *Collected Poems 1909–1962* (1934). New York: Harcourt Brace, 1991.

Falk, Peter Hastings, ed. *The Annual Exhibition Record of the Art Institute of Chicago, 1888–1950*. Madison, Conn.: Sound View Press, 1990.

Fillin-Yeh, Susan. "Charles Sheeler and the Machine Age." Ph.D. diss., City University of New York, 1981.

———. "Elsie Driggs." *Arts* 54, no. 9 (May 1980): 3.

———. *The Precisionist Painters 1916–1949: Interpretations of a Mechanical Age*. Exhibition catalogue. Huntington, N.Y.: Heckscher Museum, 1978.

———. *The Technological Muse*. Exhibition catalogue. Katonah, N.Y.: Katonah Museum of Art, 1990.

Folk, Thomas C. *Elsie Driggs: A Woman of Genius*. Exhibition catalogue. Trenton, N.J.: New Jersey State Museum, 1990.

Fort, Ilene Susan. "Three American Modernists." *Arts* 57, no. 6 (February 1983): 35.

Friedman, Martin. "The Precisionist View." *Art in America* 48, no. 3 (fall 1960): 30–37.

———. *The Precisionist View in American Art*. Exhibition catalogue. Minneapolis: Walker Art Center, 1960.

Fuller, Edmund, ed. *Journey into the Self: Being the Letters, Papers, and Journals of Leo Stein*. New York: Crown, 1950.

Gasquet, Joachim. *Joachim Gasquet's Cézanne: A Memoir with Conversations*. Translated by Christopher Pemberton. London: Thames and Hudson, 1991.

Gerdts, William H. *Women Artists of America 1707–1964*. Exhibition catalogue. Newark, N.J.: Newark Museum, 1965.

Goodenough, Robert. "Elsie Driggs." *Art News* 52, no. 3 (May 1953): 56.

Grafly, Dorothy. "The Whitney Museum's Biennial." *The American Magazine of Art* 26, no. 1 (January 1933): 5–12.

Hartley, Marsden. *Adventures in the Arts: Informal Chapters on Painters, Vaudeville, and Poets*. New York: Boni and Liveright, 1921.

Haskell, Barbara. *Charles Demuth*. Exhibition catalogue. New York: Whitney Museum of American Art in association with Harry N. Abrams, 1987.

———. *Joseph Stella*. Exhibition catalogue. New York: Whitney Museum of American Art; distributed by Harry N. Abrams, 1994.

Heap, Jane. "Machine Age Exposition." *The Little Review* 11, no. 1 (spring 1925): 22–24. Reprint, New York: Kraus Reprint Corporation, 1967.

Helfenstein, Josef, and Elizabeth Hutton Turner, eds. *Klee and America*. Exhibition catalogue. Ostfildern-Ruit: Hatje Cantz, 2006.

James, William. "Are We Automata?" *Mind* 4 (1879): 1–22.

Kalonyme, Louis. "The Art Makers." *Arts and Decoration* 26, no. 2 (December 1926): 63.

Klee, Paul. "On Modern Art." In *Art in Theory, 1900–1990, an Anthology of Changing Ideas*. Edited by Charles Harrison and Paul Wood. Oxford: Blackwell, 2000. Reprint of 1992 edition.

———. *Pedagogical Sketchbook*. Paperback edition. London: Faber and Faber, 1968. Reprint edition, London: Faber and Faber, 1984.

———. *The Thinking Eye*. Edited by Jürg Spiller. Translated by Ralph Manheim. New York: George Wittenborn, 1961.

Kootz, Samuel M. *Modern American Painters*. New York: Brewer & Warren, 1930.

Lanchner, Carolyn. "Klee in America." In *Paul Klee 1879–1940*. Exhibition catalogue. New York: Museum of Modern Arts; Boston: Little Brown; distributed by New York Graphic Society Books, ca. 1987, 83–111.

Lears, T. J. Jackson. *No Place of Grace: Antimodernism and the Transformation of American Culture, 1880–1920*. Chicago: University of Chicago Press, 1983.

Loughery, John. "Blending the Classical and the Modern: The Art of Elsie Driggs." *Woman's Art Journal* 7, no. 2 (fall 1986/winter 1987): 22–26.

Lubowsky, Susan. *Precisionist Perspectives, Prints and Drawings*. Exhibition catalogue. New York: Whitney Museum of American Art at Phillip Morris, 1988.

Lucic, Karen. *Charles Sheeler and the Cult of the Machine*. Cambridge, Mass.: Harvard University Press, 1991.

Lyle, Cindy. "An Interview with Elsie Driggs: Return from 30 Years 'at the Edge of a Ravine.'" *Women Artists News* 6, no. 1 (May 1980): 1, 4–5.

Marlor, Clark S. *The Society of Independent Artists: The Exhibition Record, 1917–1944*. Park Ridge, N.J.: Noyes Press, 1984.

Maroney, James H. *Lines of Power*. Exhibition catalogue. New York: Hirschl and Adler Galleries, 1977.

Mayerson, Charlotte Leon. Introduction by George Biddle. *Shadow and Light: The Life, Friends and Opinions of Maurice Sterne*. New York: Harcourt, Brace and World, 1965.

McBride, Henry. "Women's Art Display Exclusive." (New York) *Sun*, April 28, 1928, 8.

McCausland, Elizabeth. "The Daniel Gallery and Modern American Art." *Magazine of Art* 44, no. 7 (November 1951): 280–285.

Michener, James. "Introduction." In *Lee Gatch: Stone Paintings*. Exhibition catalogue. New York: Staempli Gallery, 1967.

Montclair Art Museum. *Precisionism in America 1915–1941: Reordering Reality*. Exhibition catalogue. New York: Harry N. Abrams in association with the Montclair Art Museum, 1994.

Mumford, Lewis. "The City." In *Civilization in the United States*. Edited by Harold E. Stearns. New York: Harcourt, Brace, 1922.

Oresman, Janice C. *Twentieth Century American Watercolor*. Exhibition catalogue. Hamilton, N.Y.: The Gallery Association of New York State, 1983.

Park, Marlene, and Gerald E. Markowitz. *Democratic Vistas: Post Offices and Public Art in the New Deal*. Philadelphia: Temple University Press, 1984.

Pemberton, Murdoch. "The Art Galleries." *The New Yorker* (October 30, 1926): 67–69.

———. "The Art Galleries—A Good Run of New Spring Sap." *The New Yorker* 4 (May 5, 1928): 72.

Peterson, Brian H. *Form Radiating Life: The Paintings of Charles Rosen*. Exhibition catalogue. Doylestown, Penn.: James A. Michener Art Museum; Philadelphia: University of Pennsylvania Press, 2006.

Phillips, D. C. "Organicism in the Late Nineteenth and Early Twentieth Centuries." *Journal of the History of Ideas* 31, no. 3 (July–September 1970): 413–432.

Raynor, Vivien. "Art: Two Decades at the Whitney." *New York Times*, November 4, 1977.

———. "Eschewing Boosterism in Jersey City." *New York Times*, December 6, 1981.

Rilke, Rainer Maria. *Letters on Life*. Translated and edited by Ulrich Baer. New York: Modern Library, 2006.

Rourke, Constance. *Charles Sheeler: Artist in the American Tradition*. New York: Harcourt, Brace, 1938.

Russell, John. "L. I. Museum Celebrates Yankee Art." *New York Times*, July 21, 1978, section c, 1 and 18.

Saffon, Inga. "Rediscovered at 92." *Philadelphia Inquirer Daily Magazine*. November 20, 1990, 1.

Scharf, Aaron. *Art and Photography*. New York: Viking Penguin, 1974.

Simmel, Georg. "The Metropolis and Mental Life." In *Art in Theory, 1900–1990, an Anthology of Changing Ideas*. Edited by Charles Harrison and Paul Wood. London: Blackwell, 1992.

Stavitsky, Gail. "Reordering Reality: Precisionist Directions in American Art, 1915–1941." In *Precisionism in America, 1915–1941: Reordering Reality*. New York: Harry N. Abrams in association with the Montclair Art Museum, 1994.

Stein, Leo. *Appreciation, Painting, Poetry and Prose*. New York: Crown, 1947. Reprint edition, Lincoln: University of Nebraska Press, 1996.

Stebbins, Theodore E., and Carol Troyen. *The Lane Collection: Twentieth Century Paintings in the American Tradition*. Exhibition catalogue. Boston: Museum of Fine Arts, Boston, 1983.

Troyen, Carol. "Photography, Painting and Charles Sheeler's *View of New York*." *Art Bulletin* 87, no. 4 (December 2004): 731–749.

Troyen, Carol, and Erica E. Hirshler. *Charles Sheeler: Paintings and Drawings*. Exhibition catalogue. Boston: Museum of Fine Arts, Boston, 1987.

Tsujimoto, Karen. *Images of America: Precisionist Painting and Modern Photography*. Exhibition catalogue. San Francisco: San Francisco Museum of Modern Art, 1982.

Venn, Beth, and Adam Weinberg, eds. *Frames of Reference: Looking at American Art, 1900–1950: Works from the Whitney Museum of American Art*. New York: Whitney Museum of American Art, 1999.

Watkins, Eileen. "90-plus Year Old Woman's Paintings Reflect her Vast Experiences and Precisionist Focus." (Newark) *Sunday Star-Ledger*, December 30, 1990, section 4, 11.

Watson, Forbes. "Native Moderns Hold Group Exhibit." (New York) *World*, April 3, 1927, metropolitan section, 11.

———. "Painters Form a Lively Group; an Enjoyable Exhibition of Moderns at the Daniel Gallery." (New York) *World*, February 17, 1924, metropolitan section, 7.

Wilson, Richard Guy, Dianne H. Pilgrim, and Dickran Tashjian. *The Machine Age in America*. Exhibition catalogue. Brooklyn, N.Y.: Brooklyn Museum Brooklyn, 1987.

York, Richard. *Buildings, Architecture, and American Modernism*. Exhibition catalogue. New York: Hirschl and Adler Galleries, 1980.

Zimmer, William. "A Precisionist's Unexpected Turns." *New York Times*, December 2, 1990, New Jersey section, 22.

Institutional Archives

Archives of American Art, Smithsonian Institution, Washington, D.C.

Elsie Driggs transcribed audiotaped interview by Francine Tyler, October 30–December 5, 1985

Elsie Driggs Papers, 1924–1979

Lee Gatch essay to Duncan Phillips, 1949

Lee Gatch Papers, 1925–1979

Lee Nordness Gallery files relating to Lee Gatch

Lily Harmon Papers, 1930–1996

Katherine Kuh Papers, 1908–1994

Robert Schoelkopf Gallery Records

Elsie Driggs artist file, James A. Michener Art Museum, Doylestown, Pennsylvania

Elsie Driggs artist file, Martin and Harriette Diamond Collection of American Art, Special Collections and University Archives, Rutgers University Libraries, New Brunswick, New Jersey

Elsie Driggs artist file and archival file, The Phillips Collection, Washington, D.C.

J. B. Neumann Papers, Museum of Modern Art, New York